COAL DUST IN MY BLOOD

The Autobiography of a Coal Miner

Bill Johnstone

oolichan books

1993

ROYAL
BRITISH
COLUMBIA
MUSEUM

ISBN 0-88982-128-3

Canadian Cataloguing In Publication
Johnstone, Bill 1908—
 Coal Dust in My Blood

 Co-published by: Royal British Columbia Museum.
 First published by: British Columbia Provincial Museum, 1980. (Heritage record ; no. 9)
 ISBN 0-88982-128-3

 1. Johnstone, Bill, 1908– . 2. Coal miners — British Columbia — Cumberland — Biography. I. Royal British Columbia Museum. II. Title.

HD8039.M615J63 1993 331.7 ' 622334 ' 092 C93-092199-2

First edition 1980
Second edition 1993

Publication of the 1993 edition has been assisted by Fred Martinelli and the Cumberland and District Historical Society.

Cover illustration by Rene Knowlton.
1993 cover design by Chris Tyrrell, RBCM.
1993 edition edited and designed by Tara Steigenberger, RBCM.

Published co-operatively by

OOLICHAN BOOKS and the ROYAL BRITISH COLUMBIA MUSEUM
P.O. Box 10 675 Belleville Street
Lantzville, British Columbia, Victoria, British Columbia
Canada V0R 2H0 Canada V8V 1X4

Printed in Canada by
Hignell Printing Limited
Winnipeg, Manitoba

Dedicated to Dorothy

Without whose patience and support this story would not have been told.

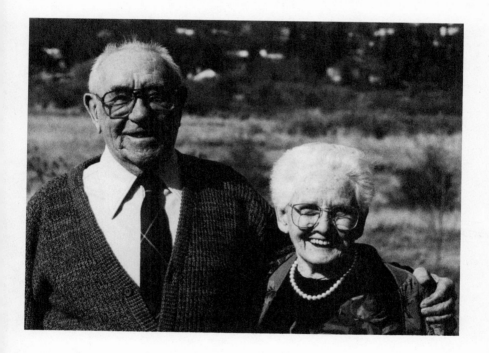

FOREWORD

Coal mining has been an important industry in British Columbia since the 1850s. It has influenced the course of our history in many ways, affecting immigration, settlement, industrialization, transportation and the nature of the landscape.

And, of course, the industry has changed dramatically over the years. In the first operations, coal was extracted in the most primitive fashion: surface deposits and out-croppings were mined with little investment in equipment. Later, when the extent of the deposits was appreciated and markets developed, large-scale mines with extensive pithead structures, railroads, coking facilities and heavy capital investments, were brought into production.

However, these advances did little to change the life of the miner — a life characterized by long hours of manual labour, performed hundreds of feet underground, in conditions that can be described as hazardous, uncomfortable, dirty and dark. Working in the mines was, for many men, a way of life and it shaped family life as well. Nearly all activity in the mining towns centred on the mines. The mine-owning companies provided the houses and often most other services or facilities in the towns. The owners also determined the payroll for the miners and controlled the economic prosperity of the community. Anxious for improvements, the miners organized and their unions battled, in a very real sense, with management for better conditions and wages for the men.

Immigrants from the coal fields of England, Scotland and other parts of Europe came to British Columbia to work in the mines, as did others from Japan and China, and many stayed in company-owned mining towns such as Ladysmith, Cumberland and Natal, for a lifetime. For those from the British Isles in particular, the work was much the same as they had left behind in the "old country," and so was the daily routine of shift work, trying to keep clean after hours of handling coal and raising families. In a sense, a miner might leave his pick at the end of the day in England and begin again at a new coal face in a Vancouver Island mine, without an appreciable change in his way of life. Even the equipment was much the same. It required skill and practical training to be a miner — to know how to extract the coal and to stay alive — but little money and little opportunity for education or change was the way of life in the mines.

The coal mining industry prospered in British Columbia in the early 1900s and reached a peak output, producing over three million tons, in 1910. This figure was not to be exceeded for 60 years. Mines were operating on Vancouver Island, in the Nicola-Similkameen valleys and the Crowsnest Pass, with several thousand men directly employed in the mines. By the 1930s, the coal industry was in decline as the great depression worsened and as oil took an increasing share of the market for fuel. Additionally, many of the best deposits had been extensively mined and the remaining coal was becoming increasingly costly to work. By the early 1950s, despite greater mechanization and other efforts to make the mines more competitive, nearly all of the underground mines in the province were closed; only a few survived, providing for the limited remaining market for coal. The closure of the mines brought the days of the hand miner to an end. The declining industry had not attracted young labour due to the unpleasant and hazardous nature of the work and the great range of other opportunities available in postwar British Columbia. Additionally, workers' seniority in the mines favoured the retention of the older miners on the payroll as the industry declined. Most often, it was an older generation of miners who worked the last underground deposits by hand.

A resurgence of coal mining began in the Kootenays in the 1960s with the development of coal exports to Japan and the increased costs of petroleum products. For reasons of economics, efficiency and the nature of the coal deposits, open-pit mining was employed extensively. These new operations are, technologically, generations apart from the old ones, and it is largely a new generation of miners, familiar with the new technologies, that now forms the new labour force. The older mines and the skills of the hand miners were passing into history, with little to record their passing or to tell the stories of the miners themselves.

Bill Johnstone began his career as a hand miner in England when he was thirteen and, with the brief interruption of a few years farming on the prairies, spent his working life in the industry. Gifted and ambitious, he studied and he eventually became District Superintendent of the mines at Cumberland operated by Canadian Collieries (Dunsmuir) Ltd, on Vancouver Island. During the intervening years, he worked at nearly every phase of coal mining, from working on the picking tables to shooting explosive charges. He also studied mining engineering and mine rescue.

Bill Johnstone's story is unusual for a number of reasons. The range of his experiences provides a broad insight into the life and work of many phases of mining. In addition, it is told by someone with first-hand experience. It is unusual for a miner to have been able to complete the range of training that Bill did through his own dedication and work. Moreover, this is more than just the autobiography of one individual; many British Columbians could take a chapter from it and call it their own story. Immigration, the depression years, or most significantly the life in the mines, were experienced by many residents of this province.

This autobiography provides real insight into the life of the miner and how men worked in the mines. It is a story that only a person who has spent his life in the mines could relate and it is a valuable record.

Robert D. Turner – 1980

FOREWORD TO THE SECOND EDITION

The publication of a new edition of Bill Johnstone's *Coal Dust in My Blood* will make many people happy. The original printing sold out quickly and in the years since 1980 there has been a continuing interest in the history of coal mining in British Columbia. Bill's story remains revealing, informative and timely.

The Northeast coal fields near Tumbler Ridge have become a major producer of coal and the mines in the East Kootenays continue to play an important role in the economy of the province. However, for many people, the story of early coal mining in British Columbia is little known. Personal recollections from earlier periods in our history are a precious resource. We are fortunate that Bill Johnstone has shared his many experiences with us to help preserve an important part of our history.

Robert D. Turner
Chief, Historical Collections
Royal British Columbia Museum
March 1993

PREFACE

When I first began this story of my life it was intended to be a legacy for my children. However, many people interested in knowing the customs, life and times of coal miners in the early part of this century urged me to submit my story for publication. I have endeavoured to respond in my own style with the answer to their request.

The following pages comprise nearly three-quarters of a century of my life spent in and around the coal mines of two continents. Some of the incidents in these chapters may appear trivial, but these have been introduced to supply the reader with information that otherwise might never be known.

Should this narrative fall into the hands of the learned, I hope they will bear in mind that the writer is better versed in the art of wielding a pick than a pen. There may be some who disagree with the opinions I express, but I called the shots as I saw them.

Most of the story is from personal experiences and observations. Where I referred to historical or statistical matter, I researched the most reliable and authentic sources available.

I hope this narrative will be received for what it is intended to be — the story of a breed of men, the pick miners, who are no more, and of one who had the urge to "tell it like it was."

W.W. Johnstone

Acknowledgements

The road from pen to print is often a most arduous one and, in this respect, my autobiography was no exception. To those many friends who, by their interest and encouragement, gave me the necessary motivation to begin the work and carry it through to completion, I give my sincere thanks.

I also wish to acknowledge the staff of the Royal B.C. Museum for their advice. I am particularly indebted to Robert D. Turner, who edited the original manuscript, making many suggestions for additions to the story, and by his interest and efforts, made the publication of this work a reality.

Contents

THE FIRST YEARS

The county of Northumberland was my family home. It was there that my father, as his father before him, worked and raised his family. And it was there that I too learned my life's work as a miner, following the family tradition. The verdant countryside that typified most of the county, with its miles of stone-walled fields, medieval castles, manorial estates and heather-covered moors, was not the Northumberland I knew as a boy. I was born in 1908 in the colliery village of Hartford, about ten miles from the city of Newcastle. Hartford was a duplicate of many other mining villages, built with an eye to economics rather than aesthetics. It conformed to the practice of the times, for when a coal company opened a mine, a few rows of houses were built to shelter the workers and their families. These houses were usually of the meanest kind, and my birthplace was no exception.

Hartford was of mid-nineteenth-century vintage and consisted of a few rows of soot-stained yellow brick houses. There were twenty houses to a row; all were the same size and each one the same as its neighbour. There were two bedrooms, a kitchen, sitting room and scullery. The latter had a cement floor. The scullery played an important part in the day-to-day life of the miner, and more so in the life of the woman of the house. There, hot water was heated for the miner's baths as well as for all the laundry and scrubbing that had to be done in the home. The scullery was equipped with a large iron pot built into a brickwork frame with a fire-grate underneath. A fire was lit under the pot every day for the hot water supply.

The fronts of the houses had no gardens; one stepped out of the front door onto the street. The back door was different. At the back was a small yard enclosed by a brick wall about five feet high. At the end was a coal shed and next to it a midden, the place where the ashes and household refuse were dumped. Next to this was the dry toilet.

There was no water in the houses. Each street had one cold-water tap located at the centre of each row. This provided a meeting place for the women to chat with their neighbours while waiting for their water pails to fill.

Drainage consisted of a white tile trough that ran the length of the road and emptied into a catch-basin. All bath, laundry and dish-washing water went into this open trough, to wend its way slowly to the catch-basin. It was a fine place to sail little wooden boats and to race the chunks of soapy froth that floated to the end of the row.

The ash middens were cleaned once a week as were the dry toilets, but with a difference; the middens were cleaned in the day-time, the toilets at night. The toilet cleaning crew were known as the honey-wagon men. Apparently they worked only at night on the theory that what you couldn't see wouldn't hurt you.

It was a formidable task for the miners' wives to keep their homes and families clean. All the water had to be carried in pails to the house, and waste water carried out the same way. If there was more than one worker in the house, many buckets of water were needed every day for the baths.

The north-country housewife had a traditional way of doing her laundry. The clothes were put into a wooden barrel, three feet in diameter and about three feet high, half filled with hot water. With a poss stick, a kind of dolly that weighed about ten pounds, the dirt was beaten out of the clothes. This was heavy work for a woman. Then the clothes were scrubbed with a stiff-bristled brush, the white ones boiled and blued in clean, cold water. Wash day was wash day; nothing else was done that day. All the clothes were folded and put through a mangle, a contrivance of spring-loaded wooden rollers, to be pressed before being put away in drawers.

These nineteenth-century English colliery villages were all much the same. Rows of identical houses dominated by the tall chimney stack and headframe of the pit. The quiet of the village was broken every minute of the working day by the chug-chug of the exhausts of the steam-driven winding engines bringing the tubs of coal to the surface. Living close to the pithead one would hear many other sounds that were

peculiar to a coal-mining village: the noise of coal hitting steel plates, the shunting of railroad coal cars, the hum of the ventilating fan and the steam whistle signalling the beginning and end of each shift. It was a never-ending cacophony of sound when the mines were working.

No description of these old mining villages would be complete without mentioning the ever-growing waste heaps. These were the symbol of coal mining and can be found all over the world where coal is mined. The heaps played an important part in a lad's life. On them he played, tracked Indians, was a cowboy, or was the Indian and was shot dead, all of which certainly added to his mother's burden on wash day.

I spent the first four years of my life in Hartford. At one time the hart probably had roamed the woods and meadows of this part of the country, but they were now long gone. The ford by which they crossed the river was also gone, replaced by a sulphur-laden lifeless stream of water pumped from the mine workings.

In these mining villages the caste system of Britain prevailed. The houses of the junior officials were a little different from those of the miners. Sometimes they were a bit larger, or had a different kind of fence or doorway; nothing very pretentious, just enough to make them distinctive. The colliery manager's house was something else. It was situated on the outskirts of the village in secluded grounds and surrounded by a high, stone wall to ensure privacy.

The social gap between the manager of a colliery and the miner in those days was so wide that it could not be bridged. In seven years in the mines of England I saw the manager once. He walked past me in company with another official without a hint of recognition. As for the coal owners, they lived on their vast estates, in their manor houses and castles, as far removed from their workmen as the stars in the sky.

My father was one of twelve children of Scottish and north-country stock. His father was a coal miner and at one time his mother (my grandmother) worked as a picking-table girl at a colliery in the county of Cumberland. With this background my father followed his father into the mines at twelve years of age. It is not surprising that I have a little coal dust in my blood.

Father was a rugged individualist and a hard worker, always contracting for jobs such as rock tunnelling that paid a premium for special skill. In recounting his boyhood to me, he once said that when he first started in the mines some days he was so tired that his father carried him home on his back. This was the lot of the coal miner in the late

3

nineteenth century. It is no wonder he became a rebel and a leading voice in labour reform in Britain.

One often hears today how capitalistic Britain exploited the people of India, the West Indies and Africa, but in my experience no one was more exploited than the British mill workers and the coal miners. Many of these disgruntled workers eventually immigrated to Canada and worked in the mines in British Columbia as I did.

My mother was of Scottish ancestry; she was one of the clan Brodie. She was a quiet, devout woman, strong in body and spirit. Her life was dedicated to her husband and her family. She bore ten children of which I was the first. The lot of a coal miner's wife was not easy, but despite the never-ending battle against coal dust, all the cooking, the mending and raising of her family, mother still found time to attend choir practice each week and play the organ in church on Sunday.

It was she who taught us pre-schoolers table manners and ABCs. She was a kind and gentle woman, but was not beyond using the belt on our bottoms if we didn't behave.

One of my early recollections of living in Hartford concerned my grandmother Brodie. One morning I was coming home from Sunday School along the sulphur-laden creek with a group of four-year-old boys, and we dared each other to jump over the creek. I was wearing a blue velvet suit with a white collar of which I was very proud. The suit and collar were soon forgotten in the challenge of the jump. I made my leap, missed the opposite bank and landed face down in yellow muck. One look at my clothes and I knew I would be in trouble at home, so off I went to see grandmother. My appearance left no doubt as to why I had paid her a visit. I was put into a tub for a bath while she cleaned my clothes. She must have done a good job on both, for I didn't get a licking when I arrived home. The incident was never mentioned until I was in my teens, but I never forgot grandmother's kind deed.

Such were my beginnings; they were not different from thousands of others in my stratum of society. It was our way of life; we knew no other. In those days travel was limited and communication was meagre, so one had little opportunity to find out how the other half lived.

The mine at Hartford was an old one, and the miners, being on contract found it difficult to make decent wages. My father, who always kept in touch with the mining fraternity, heard of a new pit that was opening about twelve miles away. Shortly before my fifth birthday he got a job at the new Ellington colliery, where he had a chance to earn higher wages, and we moved.

SCHOOL AND WAR

Our new home was in Ashington, a much larger coal-mining centre with a population of some 26,000. Like other industrial towns of England, the long rows of soot-stained brick houses, topped by myriads of chimney pots, were Ashington's most conspicuous feature.

In the north of England, it was the custom of the mining companies to provide their married employees with a free house and coal, but this was part of the wage structure, so the term free was misleading. On the surface, it appeared to be a boon but I have often thought that such "gifts" were of doubtful benefit. The miner would have been better off if he had been given a bigger wage, and paid rent for his home and his coal as other workmen did. I feel that this practice was a psychological tie that bound the workmen to an unpleasant job. In the event of disputes or strikes, the threat of eviction and lack of heat could be a powerful club in the hands of the coal companies.

There were so many houses to be supplied with coal that to deliver a load to every miner by horse and cart would have been too costly. In Ashington a network of narrow gauge railways was laid along the back street of the rows of company houses. Each house had its coal shed and ash pit in the back yard. The coal was picked up from a central depot where a train of four side-dump bogies, each holding fifteen hundredweight, was assembled. This train was hauled by Clydesdale horses along the streets where a load was dumped at the coal shed door of each miner's home.

A miner was allowed one load every two weeks and, there being thousands of miners, the coal delivery was a continuous operation. The bogies were also used to haul the ashes and refuse from the middens and toilets, but instead of being open they had heavy lids that covered the sometimes odious load.

The part of the town where we lived was comparatively new. The water was supplied by cold-water taps placed at intervals along the row. Ashington differed from Hartford in having a catch-basin in each yard for the disposal of dirty water. The only aesthetic features of the streets were their names. Some were named after trees such as Hawthorn, Maple, Sycamore and Chestnut. Where I lived, the streets were named after Shakespeare's heroines: Ariel, Juliet, Katherine, Rosalind and Portia. Our house was 105 Portia Street.

The streets were unpaved but were made of hard-packed cinders so that when it rained they could be muddy. This was where we played our boyhood games, such as rounders, kick the can and marbles. They were the avenues of commerce; the marketplace of the pedlar. On any day one could hear the cry of the oil-man selling his oil for the lamps of the house, and whale oil for the miners' lamps. The fisher lasses with creels—a basket for carrying fish—on their backs offering haddock, cod or herring to the housewife. Then there was the scissor grinder who would sharpen knives and tools for a few pence. An interesting pedlar was the gypsy tinker, who would park his caravan on the outskirts of town and walk down the streets offering to mend pots and pans. It used to be said that when the gypsies came to town, the women would bring in their washing from the clothes-lines because the gypsies would steal anything they could get their hands on. In addition to these colourful pedlars, there were the regulars, such as the butcher, baker, grocer and the ice-cream man. One unique pedlar who made his weekly rounds was the rag-and-bone man. He collected rags for paper-making and bones for the fertilizer industry. He paid for these items with balloons for the children or scrubby stone—a soft, colourful sandstone—for the housewives.

The women in these mining villages used this stone to draw fancy designs on the cement thresholds of their houses. There was a certain status to the woman who had a clean, artistically-designed entrance. The more whorls and curlicues she drew, the more she added to her status. The miner's wife had little prestige in English class society, but the reputation of being a clean housekeeper was a badge of honour in the community, so most of them kept their houses spotless.

One man who used to make periodic visits to our street was the crake—the town crier—but instead of using a bell he used a ratchet-type noise maker. By whirling this instrument he produced a harsh penetrating sound, and when enough heads had popped out of doorways he would announce his message. They were usually notices that the mine would be idle, or that a meeting was being held. In those days the crake was a necessary means of communication. We lived four miles from the mine where my father worked. If the wind was not in the right direction we couldn't hear the buzzer blow, signalling an idle day. The company would send the crake around to make the announcement. This unique name for a town-crier was coined from the raucous cry of the bird that lived in the grain fields—the corncrake.

Walking down any row of houses, one would see certain numbers chalked on the doors, usually 1, 1:30, 2, 3 and 4. They were for the information of the knocker up, or caller as he was sometimes called. Some of the workers had to be at work at odd hours, so the company employed a man to waken them and the numbers on the door indicated the time they had to be wakened.

A common practice among many mining families was that the working sons did not pay for their board; instead, all the earnings of the household went into a kitty which was administered by the woman of the house. At one time my grandmother Johnstone had six sets of wages coming into the house each week. Every Saturday morning—payday—Grandmother put on a clean white apron and seated herself in a rocking chair in the kitchen where each son dropped his golden sovereigns and silver into her lap. She could neither read nor write, but she could account for every penny in the household spending. All her purchases were made at the Cooperative Store, where dividends were paid quarterly on the amount of purchases made. These dividends were used to buy clothing for the boys at Thitsuntide and at Easter. When the sons left home to be married, they were outfitted from head to toe and given a few pounds as a sort of dowry to start them off. This was one custom that allowed large families to live with dignity in spite of poor wages and sub-standard housing.

It was from the Portia Street address that mother took me by the hand and enrolled me in the Hirst East Infant School. This was where the children of our district started their education at the age of five. The infant class was a mixed one of fifty or fifty-five boys and girls.

My first recollection of the school was of seeing the strap prominently displayed. It was hanging on the side of the teacher's desk and

was the first thing to catch my eye as we marched into the classroom. The deterrent to any nonsense was made plain from the start, but I can't recall if the strap was ever used while I was in this class. The first year of Infant School passed without any problems, and I remember at the end of the year being presented with a child's reader for proficiency in reading, thanks to my mother's pre-school preparation.

The next step was the awesome one of entering the Big School, and going into Standard One. The Big School was divided into two sections, the boys' school and the girls' school. The playground area was split by a steel fence that could have contained lions. It was made of one-inch square iron bars, six feet long, set in concrete at four-inch spaces, with each bar pointed at the top so that it would be a hazard to climb over. How clearly the difference of the sexes was thrust upon us young boys, but at six years of age, who cared!

The curriculum of the council schools was very basic: English grammar and composition, mathematics to elementary algebra, history, geography, penmanship and an introduction to music. Physical exercises were performed in the school yard for fifteen minutes each morning before the bell rang at nine o'clock to start classes. Each school had its own soccer team, whose activities were carried on after school hours. Interested teachers took part in supervising and training the school team.

I was never aware of any discontent among the teachers who had this extra job of coaching and managing the school team. Inter-school rivalry was so strong, that to have the top team in the county was a coveted honour. In fact, most of the professional soccer players in Britain were a product of the schoolboy football leagues. It seemed unnecessary to have high-cost gymnasiums to keep us fit in those days.

By now I had a sister and a brother, and had learned that there was work to be done around the house and that I had to do my share. In the days before the advent of the deep freezer and refrigerator, shopping for perishable goods was done daily. Every day after school I had to go to the store for groceries. I suppose these chores were magnified in my eyes because my closest pal was an only son and he had more time to play than I. This, of course, made my chores seem doubly bothersome.

After school on Friday, my job was to clean the brass fender and all the fire-irons that were part of the decor of our house. The fender was a conglomeration of brass spools and rods, polished steel, filigree and a base of black cast iron. The brass was polished with Brasso, the

steel with steel polish and the cast iron with black lead until it shone. In addition, there was an assortment of pokers, tongs, brass ornaments and a cast iron retriever dog about a foot high that had to be black leaded. It all seemed designed to make work. I also had to help take care of the younger ones in the family, and so had little chance to play. I realise now that this enabled mother to spend more time on her endless war against soot and coal dust.

During my second year in Big School, an event took place which was to change the lives of thousands of people. Kaiser Wilhelm of Germany marched his troops into Belgium and World War I was underway. At the beginning, the populace behaved as if the whole episode was a game. Bands played in the streets, soldiers in colourful dress uniforms marched to the stirring music. There were posters of Lord Kitchener pointing his finger with the caption "Your King and Country need you." The war provided an opportunity for many young pitlads to get out of the coal mines by enlisting in the services. There was an aura of excitement about the war at that stage; it had almost the air of a carnival. This was soon to change.

The men of the town enlisted and left for various training depots, and then were shipped to different theatres of war. My father enlisted as did most of my uncles, and to me they were all heroes. Soon, however, food rationing came into effect, and casualty lists began to appear in the newspapers. The gala air was dispelled, and people began to realize that war was a serious business.

Its first impact upon me was the change in the school day. I attended the East School, and when the army took over the neighbouring South School for soldiers' billets, these pupils had to be accommodated at our school. It was arranged that the East pupils attended in the morning and the South pupils in the afternoon. This arrangement continued throughout the war, so that for four years I attended school for half-days only. In spite of this, my time for play was still limited.

Very early in the war all essential goods were rationed. Food shortages were the main concern of the women because, in most cases, their men were away. Rumours would circulate that a certain store had received a shipment of a particular food item. When I came in from school mother would hurriedly send me off to stand in the queue, hoping I would be in time to obtain some of it. One instance I remember was being sent to a store that had received a shipment of tea, which was being limited to two ounces per customer. After standing in the

queue for more than two hours, I was about to enter the shop when a man appeared and said, "Sorry folks, we are sold out." I returned home tired, disappointed and empty handed. We took such episodes in our stride, not because we had any special qualities, but because our neighbours were in the same boat. It was part of wartime living.

My father was serving with the Royal Naval Division and I had eight uncles who were in the services. One was killed at the Dardanelles; another was gassed in France and died shortly afterwards. Some of my uncles received shrapnel wounds, and when they came home on convalescent leave we children were taken to see them. These wounded soldiers were, in our young minds, the heroes of the day. The young lads would boast to one another about how many of their relatives had been wounded and bask in this second-hand glory. One morning my chum, Fred, came to our house and said to me, "Billy, the Germans have killed my dad." That was all he said. How does one eight-year-old comfort another? This incident brought home to me the fact that war wasn't just brass bands and waving of flags.

One night Fred and I were playing on a nearby pitheap, when suddenly the silence was broken by the sound of mine-whistles. This was the signal for an air-raid and the town was plunged into total darkness. Suddenly the sky was pierced by searchlight beams. We stopped playing and cocked our ears, listening for the sound of Zeppelin motors. Finally we heard them in the distance. What a thrill! We had a grandstand seat in the war. As we sat entranced, watching the searchlights probe the sky, one suddenly focused on the Zeppelin and every beam in the district was at once pin-pointed on the raider. To complete the show, fighter planes were sent up to chase the enemy out to sea where it was shot down in a blaze of fire.

When I returned home bursting to tell mother of the wonderful sight I'd seen, I was in for a surprise. Instead of being thrilled by my seeing such a thing, she was all set to give me a licking for worrying her by my absence during an air-raid. My aunts had been out looking for me and, not finding me in the immediate neighbourhood, assumed that I would be safe in a friend's home. I didn't get the licking because mother was too glad to see me safe, but I was warned never to do a thing like that again.

One break occurred in the wartime routine of the family that made a complete change of pace for us. Father was stationed for a time on the South Downs in the county of Dorset and, while there, he sent for the family to spend a holiday with him before he was sent

overseas. It was summer, and the climate was much balmier than that of the northeast coast, so it was an enjoyable interlude. We spent nine weeks there and had lodgings on a farm. To a boy who had spent his life in colliery villages, life in this rural setting was an experience to be remembered.

One day I was walking through a field and found myself surrounded by a pack of foxhounds. I was scared out of my wits. All I could see were lolling tongues and rows of teeth. I must have been howling like a banshee because eventually a horseman in a red coat rode onto the scene and at a command from him the dogs backed off. He calmed my fears, patted me on the head and sent me on my way. This was the nearest I ever came to participating in an English upperclass sport.

We had not long returned from our holiday when mother gave birth to another son. This one was named Alfred, but he only lived three months. He had taken a bout of diarrhoea which seemingly couldn't be stopped. A number of the neighbours suggested that eggs would help, but there were no eggs to be had. Finally one friend came running to our house and said, "Hannah, I've got an egg for you." Mother thanked her for her kindness, then told her sadly that it was too late; Alfred was gone. I remember the little white casket being carried in grandmother's arms as the adults of the family left the house on their way to church.

Father had made application for compassionate leave, which was refused. He felt bitter about this and had little use for faceless bureaucracy ever after. I have thought of this incident often and wondered what rules prevailed that allowed one segment of the people to spend time fox-hunting, while another couldn't have time off to bury their children.

As the war continued the coal supplies of Britain were being depleted because so many miners were in the services. The mines had been operating shorthanded since the war began, but the time had arrived when miners had to be released from service to go back into the mines. Father was one of thousands who were discharged in the latter part of 1917.

On November 11, 1918, the war came to an end. There was rejoicing throughout the country. In addition to national celebrations, every street in every village organized its own party to welcome the soldiers home. Tables were set up in the streets and laden with all the goodies that could be scrounged. Before sitting down to the meal, a

fancy-dress parade was held round the adjacent streets for all those who were able to find or improvise costumes. Mother had arranged that I would take part, but I was so afraid of appearing ridiculous in the eyes of neighbours and friends, that I just had to find a way of avoiding the parade. My solution to the problem was quite simple. When the time came to be dressed I was nowhere in sight. That morning I took a walk in the country, returning home when the parade was over.

We sat down to a sumptuous feast such as we had not seen in four years. Speeches were made welcoming the men who had returned, and prayers said for those who had given their lives. Prizes were awarded for the best fancy dress which, of course, didn't affect me. Mother was disappointed that I wasn't in the parade but my shyness at this time was really very painful. I think I was the only boy in my age group not in fancy dress. There were pirates, gypsies, cannibals, nurses and many other strange characters. It was certainly a day to remember. Each child was presented with a commemorative mug, suitably inscribed. My daughter, Edith, still has mine today. The wants of the mining fraternity were simple; a feast and a parade were a highlight not soon to be forgotten.

Now that the war was over, our school schedule was put back on its former basis. The South School boys went back to their own school, and we attended ours for the full day. This put an end to the war we had waged with the 'Southies' while they attended our school. They had to pass an old mine-waste heap on their way home from school and we dug trenches in the heap and waited for them to pass. As they neared our positions we would leap out of the trenches, shouting charge! and throw stones. The Southies would retreat and regroup. Then they would throw a barrage of stones at us and sometimes capture our trenches. Of course, each battle ended at supper time. This continued throughout the war years. It now surprises me that there were not more split heads, considering that at times over a hundred lads would be throwing stones. In fact, I cannot recall that blood was shed more than half-a-dozen times.

I could never participate in these skirmishes as often as I would have liked because most of my playtime was taken up with looking after one of my younger brothers or sisters and I dared not take them into the fray.

After the war, life settled back into the routine pattern. I was now enjoying school, particularly reading. Cheap editions of the classics,

costing only sixpence, introduced me to Dumas, Hugo, Hawthorne and Shakespeare by way of Lamb's Tales. I was an average student and gave my teachers problems as others did. Discipline was strict and we were kept in bounds by the strap, staying after school or writing five hundred lines, knowing that if they were not turned in the next day the strap was waiting. I remember one teacher, a Mr Jackson, who had an uncanny aim with a piece of chalk. He would notice one of the boys looking out of the window or otherwise not paying attention, and in a flash he would throw the chalk. More often than not, the chalk would find its mark; the boy's ear.

These were the days of the penny matinee on Saturday afternoon, which we looked forward to very much. In fact, the worst form of punishment that our parents could give us was to deprive us of this treat. The highlight of the show was the sixteen-episode serial. We could hardly wait for Saturday to come so that we could find out how our hero had extricated himself from the predicament we had left him in the week before. The popular shows at the time were *The Perils of Pauline,* starring Pearl White; *Tarzan of the Apes,* with Elmo Lincoln and a swashbuckling picture that seemed to run on for years called *The Purple Domino.* Our favourite actors were Eddie Polo, Chester Conklin, Fatty Arbuckle and the inimitable Charlie Chaplin. We never had vacation in the summer; there was no such thing as a paid holiday in those days. These Saturday shows were all we youngsters had to look forward to. It took very little for us to enjoy ourselves. The pictures were our only look at another world. Today children are sated with shows on television making them much more blasé about such things than we were.

But my school days were soon to end. I was thirteen and had reached standard seven X, the highest grade in the council school system. There was no doubt what my future would be. It was staring me in the face; coal mining was my destiny.

INTO THE PITS

In February 1921, father took me to the mine office where I signed on as a surface worker. Being only thirteen, I was not allowed by law to work underground. My job was on the picking tables at tenpence per day. This was not enough to keep me, but by now there were six children in our family: Ethel, Tommy, Fred, Jane, Dorothy and me. The little I earned helped to augment the family income.

The job on the picking table was the most mind-stifling occupation that could be imagined. Our job was to pick out the pieces of shale from the coal as it passed on a conveyor. The boredom of watching a slow-moving conveyor passing one's eyes for eight hours a day, six days a week, was enough to drive one crazy.

In spite of this, there were some men who had done no other job in their lives. No wonder their conversation was football, sex and pubs, in that order. These were the only things they knew that gave a bit of spice to a monotonous occupation. These were the beaten people, often the poor students at school, with nowhere to go, and no hope of improving their lot. But they were human and deserved a better slice of the economic pie. We cannot all be Einsteins or university graduates.

After one year of this uninspiring work, I was of age to go underground, and I looked forward to this. Anything would be better than the picking tables. Starting underground was a red-letter day in the life of a pitlad. This was the day he joined the ranks of the men.

By custom, when a boy starts underground he must have new clothes of the traditional style. To deviate from this would brand one as an oddball. The shirts were of navy blue flannel and the pants, of fustian cloth, were short and worn above the knee. Sturdy black hobnailed boots, an old suit jacket and a cloth cap completed the outfit.

There were other essentials. One was the cloth bait-bag to carry my lunch. These bags had a tape draw-string at the neck, so that when pulled the bag was closed and a loop was left to put over the arm for carrying. Mother made six of these bags because one never went to work with a dirty bait-bag. She would have been the talk of the town if her son had been seen going down the street with a dirty bait-bag. Next, was a tin water bottle. (In those days, there were no such things as thermos flasks.) These bottles had a pair of lugs on the sides to which a strap was fastened, allowing them to be carried over the shoulder.

Another piece of apparel worn by the young miner was the "arse-flapper," a piece of leather about sixteen inches long and eight inches wide, which was slotted to allow a belt to be threaded through. It was worn over the buttocks. The pit tubs, used to carry the coal, were made of rivetted steel plate. On some grades they had to be moved by bracing one's feet against a tie and pushing with one's behind; the arse-flapper saved wear and tear on both skin and clothing.

As most young boys starting in the mine worked in non-gaseous areas, that is, in places where a safety lamp was not required, each boy had to buy his own "midgy" or oil lamp. I don't know where the word came from, but a dirtier form of illumination would be difficult to imagine. The body of the lamp was a concave piece of tin, eight inches long with a hook soldered on the back of it so that it could be worn on the belt thereby leaving the hands free to work. At the base of the lamp body was a pocket which had the oil vessel, and out of this extended a tube where a half-inch diameter wick protruded which provided a yellow, smoky flame. One can imagine how dirty our clothes became from using this sooty contraption. The companies did not provide these lamps nor the oil for the lamp; they had to be purchased by the miner. In those days one paid for the privilege of working underground. It was from such small things that the seeds of discontent were sown that made the miner a rebel.

Suitably clad and equipped, I set off for my first day underground with some apprehension. I was not afraid of working in the pit, but the thought of being the butt of the older boys' pranks, or of being scared

15

when the cage went down, did worry me. These were the thoughts uppermost in my mind as the train chugged to the pit four miles away. I started on the fore-shift which was from 2:00 a.m. to 10:00 a.m. The shifts of the Northumberland mines seemed to have been devised to break the worker's time into neither day nor night. The back shift worked from 10:00 a.m. to 6:00 p.m., and the night shift from 6:00 p.m. to 2:00 a.m. The fore shift and back shift were the production shifts. During the night shift equipment was moved and repair work done on the main haulage roads.

The men were lowered into the mine in double-deck cages with a holding capacity of twenty-two men. As I stood waiting for my turn to enter the cage, I had to put up with the good natured ribbing of the other miners; their comments being mostly on my new clean clothes. I stepped on the cage, the signal was given to lower away, and it began to move. Then suddenly we plummeted! I thought the bottom had dropped out of the cage. We arrived at the shaft bottom, six hundred feet down, in a few seconds. I felt sure my stomach was still up the shaft somewhere. I found out later that the hoistman is given the word when a boy is going down for the first time, and an extra fast ride is part of the initiation of the young miner.

I was given a guide to take me to where I was to work; I judged it to be about a mile and a half from the shaft bottom. Then I was handed over to the deputy overman who was in charge of a small section of the mine. My job was to open and close a trap-door to allow a set of tubs pulled by a pony to pass through. These doors were used to control the ventilation of the mine. If the door was left open, the air current would be short-circuited and the workings beyond the door would receive no air.

The importance of this menial job was impressed upon me from the start. Negligence on my part could result in injury or death to others in the mine. With this kind of knowledge stamped on the young miner's mind right at the start, it is no wonder that coal miners become a breed of their own. They often disagreed among themselves, but no outsider could interfere in their affairs.

It was only after two weeks' work that my first week's wages were due. The company always retained one week's pay. I suppose this was to facilitate bookkeeping as payrolls couldn't be kept up to date with over a thousand men employed. I had six days' wages to draw, at one shilling and fourpence a day, a gross of eight shillings, which at that time was worth two Canadian dollars. This was the most I had ever

earned and it was a proud moment when I handed mother this grand sum. I was given sixpence a week pocket money to spend as I wished, and I thought I was the richest lad in town. Most things are relative. Sixpence was nothing to the rich; but it was a windfall to the pauper.

The eight shillings a week was a welcome addition to the family coffers, though of course it was not enough to feed and clothe me. I was a growing boy and could eat a horse between two mattresses. I am sure I must have eaten more than eight shillings worth of food each week, to say nothing of the clothes I wore out. A pair of pitboots cost ten shillings and, due to water and kicking track switches, I could wear a pair out in two months. Here I was going to work every day, doing an essential piece of work, and I didn't earn enough to feed myself.

The system of cheap child labour meant that my father and others like him were subsidizing the coal companies and owners. We had been taught in school that the Earl of Shaftsbury introduced the first Factory Act in 1833, limiting the hours of work and age of children working in the mills, factories and mines. Now, after ninety years, instead of going into the pits at eight years of age, we went below at fourteen. It had taken nearly a hundred years to add six to the working age. That was the rate of progress.

One of the largest coal owners was the Duke of Northumberland who, it was said, received sixpence a ton for all the coal produced on his lands, and thousands of tons were shipped every day.

A story is told of the Geordie pitman who was doing a bit of illegal fishing on the river on the duke's estate when along came a fellow who said to him, "What are you doing here?"

The fisherman replied, "Oh, I'm trying to catch a fish for supper."

The stranger said, "Don't you know you are fishing on private waters belonging to the Duke of Northumberland?"

"Yes" said the pitman. "The duke has lots of fish and he won't miss any that I get."

"Do you know who I am?" asked the fellow.

"No I don't," said the Geordie.

"Well, I am the duke, and you are trespassing."

The Geordie scratched his head for a moment, gave the duke a blank look, and said, "Duke, how is it that you own all this land and river, and I don't own any?"

Without hesitation the duke said, "My forefathers fought for it."

The Geordie gave him a cold stare and said, "Okay, duke, take your coat off and I'll fight you for it." There could be logic in the miner's humour.

After three months as a trapper, the next step was working on the endless-rope haulage system. This was used on all the principal haulage roads in the mine. Endless-rope haulage differed from direct-rope haulage in that it was slower, and moved at about two miles per hour. Instead of the rope being attached to a set of tubs, the set was attached to the rope by a patented clip. The endless-rope never stopped, except in emergencies, the clips were placed on the rope while it was in motion. The haulage hand's job was to unhook and attach the clips at the various junctions and marshalling points along the route to the shaft bottom. My wages were increased to one shilling and eightpence a day when I became a haulage hand.

The aim of haulage workers was to grow old enough to become a putter. A putter had to be eighteen years old and have a healthy strong body. His job was to drive the ponies that hauled the tubs of coal from the miner to the landings, where they were assembled and attached to the haulage ropes. In the eyes of the young pitlad this work carried prestige.

Putters were on contract and could make ten to twelve shillings a day, which seemed a lot of money to us. At lunch time we haulage boys ate our lunch with the putters who recounted for our benefit tales of the dances they had attended, and the girls they had met and taken home. These stories were told with a lot of embellishment, and the lurid details of their romances often reached the point of absurdity.

I toiled through the ranks of haulage jobs over the next three years, eventually landing a job at the shaft bottom. This was a job for strong capable boys, because the output of the whole mine was handled by two haulage hands. As the endless-rope haulage system delivered a steady stream of tubs to the shaft, my job was to remove the clips from the front and back of each set of four tubs, and uncouple the tubs ready to be put on the cage. This was a busy job and we two lads never stopped all day, except when relieved for our lunch-break.

I was then earning four shillings a day and my pocket money had increased to half-a-crown a week. One couldn't get into too much trouble with that amount to squander. I didn't drink—I was too young for that—but I spent my meagre allowance on an occasional show and on books. A pitlad's life in these small mining villages was one of drudgery, work and sleep, with little to look forward to. I began thinking there had to be more to life than what I could see facing me now, but I had no answer to the question of how to get out of this hum-drum existence; that was to come later.

IMPROVEMENTS

After World War I, and a thirteen-week strike in 1921, the cry of the miners for a better deal had to be heard. The class structure was still firmly entrenched. It was well-nigh impossible for a boy to break away from the traditional work of his father, especially when the only industry in the district was coal mining. But an air of discontent was filtering through the coal fields of Britain and, in 1924, the traditional political parties of the government were defeated by a Labour majority for the first time in history.

The country was in an economic slump. The first to feel the squeeze were the miners, who, because they shouted the loudest, were branded as the bad guys—not for the first time either. As recently as 1974, Prime Minister Heath went to the polls calling the miners of Britain the villains responsible for the economic plight of the country. He lost the election and it wasn't solely because of the miner's vote. True, there were ten million union workers in the country, but there were also twenty-five million who did not belong to a union.

In 1974, English newspapers were carrying stories of pensioners eating tinned cat food. At the same time the Duke of Buccleuch was advertising for a head gamekeeper "to supervise ten beat keepers." The Duke of Wellington's need was an "under river keeper" for his exclusive stock of fish. If these were the conditions in 1974, one can picture the position of the miners fifty years earlier. I know we can't all be

dukes or lords, but the gap between the upper and lower classes was far too wide. However, some improvements were in store.

The company I worked for, the Ashington Coal Company, was a leader in the field of trying to improve the miners' lot. The Company started a program of recreation. It acquired land for football fields, cricket pitches, bowling greens and tennis courts, and constructed buildings within the complex for indoor recreation such as gymnastics, boxing and general physical fitness courses. The miners paid twopence a week, and one half-penny a ton was levied on the cost of coal to finance what was called the Miners' Welfare Programme. This was a boon to the younger employees; there were now things to do other than sit in pubs.

Instructors and coaches were hired to encourage and train young athletes, and it was from these men that we learned some of the finer points of cricket and tennis. Prior to this, these two sports were available only in grammar and private schools, so in a way this too was a revolution of sorts.

While the recreation program was fine for the young sports-minded miner, it did nothing to change the working or living conditions of the older workers. They still trudged home each day bringing mine dirt with them. However, even here a change was in the offing. Our company decided to construct a pithead bath-house. This was a tremendous improvement, especially for the pitmen's wives, who no longer had to lug pails of water to be heated from the bathtub on the floor. Above all, the mine dirt was at last being left at the mine.

The baths were a far cry from the zinc bathtub. There were white-tiled shower cubicles which were maintained in spotless sanitary condition. The wet and sweaty pit-clothes were hung on hooks and pulled up to the high ceiling by ropes and pulleys to dry in time for the next shift. Adjoining the pithead bath building was a canteen where a miner could buy, at cost, a cup of tea, biscuits, sandwiches or the ever-popular packet of Woodbines, a cheap cigarette.

The introduction of new ideas is not always greeted with enthusiasm, and at first some of the old-timers refused to use the baths. The thought of stripping in front of their work-mates was too much for them. But, after a while, most of them threw their modesty to the winds and bathed at the mine. I suspect there was some prodding from their wives.

All these changes were steps in the right direction; by their introduction some of the wretchedness of mining was eliminated. However,

in the area of miners' housing, there was still much to be desired. The provision of canteens, playing fields and gymnasiums didn't alter the environment where the miner ate, slept and raised his children. Fortunately, a move to provide better housing was in the wind.

About this time, Lord Leverhulme, the soap manufacturer, and Rowntree, the chocolate maker, began building garden villages for their employees. It was not long before my own employer announced that they were going to build a modern mining village.

The site chosen for this village was out in the country, on the banks of the River Lyne, a mile from its mouth; it was to be named Lynemouth. Before a brick was laid all the roads and curbs for side-walks were constructed. These houses were built in rows but were much shorter than the rows in the older villages. Each house had a fenced garden at the front which was separated from the adjoining garden by privet or laurel hedges. The backyard was paved with cement, enclosed by a high brick wall. Forming part of the back wall was the coal shed and a flush toilet.

These new houses had the usual scullery where the laundry was done, but the biggest boon was the bathroom, where the women could scrub the children without having to fill a tub in front of the hearth. There was plumbing throughout the houses and a hot-water tank was built into the walls behind the fireplace to maintain an adequate supply of hot water as long as the fire was lit. The oven was built in, next to the open fire, and by manipulating a series of dampers the flames were deflected around this circular chamber. By today's standards, these would be considered monstrosities, but to my mother they were a blessing. She could get all the hot water she needed at the turn of a tap and there was a sink indoors to dispose of waste water. For us, this was living in style.

The first few streets of the new company village were completed in 1925. Father had made application for one of the new houses, and, when it was ready, we moved to the village. It was the first time in our lives we had lived in a house with a bathroom and a flush toilet, even though the latter was in the backyard. The village was surrounded by fields and nearby were pleasant walks through woods skirting the mean-dering river. It was certainly a new lifestyle; we thought we were in heaven.

But the joy of these new surroundings was to be short-lived. We had barely settled in the house before tragedy struck. When the family moved in, the plastered walls in some of the bedrooms were not quite

dry. To overcome this, mother had lit a small fire in each of the bedroom grates. One evening around eight o'clock, my nine-year-old sister Jane got out of bed to place the blazer—a steel plate used to allow the draft to flow under the grate—in the fireplace, and as she did so her flannelette nightgown caught fire. In spite of being given immediate medical and hospital care, the burns were so severe that she died the following morning.

This was a sad beginning to our life in the lovely village. A cemetery had been laid out and dedicated before the first houses were occupied. My sister was the first to be buried there. The family was deeply stricken by this turn of events. We had been plunged from elation to bereavement within a few days. The accident was a terrible shock.

Mother said a few prayers and talked to her family. With her guidance and inspiration we looked to the future with hope. There were six children in the family; mother had presented us with another sister, Ruby, the year before, and taking care of them and the home, left little time to mourn.

I continued to work as a haulage worker but hoped to become a putter in 1926, when I became eighteen. As I neared that birthday I began to pester the officials to get me a cavil. Cavil is a north country term and is the name of the system of distributing the good and bad working places of a mine by lot. Cavilling day was every quarter and if a man was unlucky and drew a poor working place his earnings would suffer that quarter. Consequently, it was an important day in the life of a pitman.

In January 1926, I was told that I would get a cavil and become a putter. When the list of cavils was put on the notice board, my name was on it. It showed the section of mine where I would work for the next three months, and the name of the pony allotted to that section. The ponies didn't move from section to section each quarter as the men did, but worked in one place only. The reason for this was that ponies were of different heights, varying from nine hands (three feet) to fourteen hands (four feet, eight inches). It would have been useless to have a pony four feet tall allotted to a section that had a height of less than that. So the ponies stayed where they were best suited.

These ponies were of differing temperaments too. Some kicked, some would not back up, which was an essential part of the work, and some were stronger than others. A good pony could mean money to the putter who drove it. Ashington Coal Company bred and raised their own ponies on their farms. There were three breeds, Shetland, Welsh and

Galloway, as well as crosses of these breeds. The mares were kept on the farms. Only stallions and geldings were allowed to work underground.

The ponies were well cared for. In fact, they were taken care of much better than many animals on the surface. Each had his own stall in a warm, electrically lit stable. They were washed down at the end of each shift, fed chopped hay, carrots and grain, and bedded down in clean peat moss. Many people think that pit ponies were blind when brought to the surface; this is a fallacy. The ponies relied on the light of lamps, and their stables were lit at all times. As a result, their eyes were accustomed to light and darkness as any other underground worker.

A putter never referred to his animal as a pony. In Northumberland it was called a Galloway by the pitlad, regardless of breed. They were short, stocky animals, mostly of a gentle disposition, affectionate and responsive to kindness, and a credit to the company that developed the strain.

Putting was work for strong, agile, young lads. It was brutal work; an endless routine of push, pull and lift all day in close cramped quarters. In some parts of the mine the putters would be wading through water a foot deep; in others water ran from the roof, and the putter was soaking wet all day. The putter was responsible for supplying the hewers with empty tubs and hauling the loaded ones away. He would take an empty tub to a point as close to the face as possible, put it in a siding, then take the pony to the face where it was attached to the load. The full tub was hauled past the siding and the empty tub pushed by hand to the miner. The loaded tubs were then hauled to the landing where they were assembled for further transport.

On an average day, a putter could take care of five or six hewers. His wages were based on the number of tubs he handled, not by the tonnage. Many factors contributed to the make-up of a putter's pay packet. First was the distance to haul. As it increased, the rate per score increased proportionately, and extra was paid if one had to push the empty tub over a specified distance, that is to say, from siding to the face. Consideration was also given if the working places were wet, and additional money was paid if water dripped in from the roof. If the grades were such that the pony could only pull one tub, a few pennies were added to the score price. The putter was also paid sixpence for unloading the timer trams. A ticket was stapled to one of the pieces on the bottom layer of props or planks in a load. When the tram was emptied, the ticket was recovered and turned over to the deputy. He recorded it and the putter was paid for his total each week. In a good

cavil, a putter could earn fifteen shillings a day, but in a poor one he would be paid the minimum of six shillings and fourpence.

In the advance longwall system of mining, which was the method used at Ellington colliery, the haulage roads that the putter used were maintained through the gob, which was the area from which the coal had been extracted. As a result, he worked in the newly mined-out places where subsidence was not complete. Consequently, the roof and floor were continually on the move. It was not uncommon to take an empty tub to the miner, and when fetching it out fifteen minutes later find that the roof had settled a few inches, making it impossible to get the tub through until a timber had been chopped out or a bit of roof taken down, to make the needed height.

The track used at the coal face was lightweight, and in four-foot lengths, which meant a joint every four feet. Each joint was a potential place for derailment, and these were many. In fact, a putter could wear out his arse-flapper in six months. I have often been amazed at how well our legs stood up over the years, considering the bent, cramped positions they were subjected to in our putting years.

One day, two putters had come off shift and were stripping to go under the showers at the pithead baths, when one said to the other, "I've knocked that bloody scab off my back a half-a-dozen times today." The other one looked at it for a second and replied, "Hell, what are you crying about? Look at mine. Yours is only two inches around; mine is three!" I have often thought of this conversation and wondered how stupid people can be. What a wretched existence, when all a man had to boast about was the size of the scabs on his back. And this wasn't the middle ages, but the mid 1920s.

Coal miners were at the bottom of the class structure of Britain in the 1920s, yet as a group they were good solid citizens. They had the same hopes and fears as other working people, and were not ignorant as sometimes depicted. They had to be fairly intelligent because they were living with ever-changing situations in their work. They had to make quick decisions in hazardous conditions. Most miners were good family men, and wanted a better way of life for their children. One might ask why the miner did not get another job, but there were many reasons. By tradition he was a coal miner. His thinking was conditioned to coal mining and that was the only skill he thought he had. A free house and coal gave him a sense of security, however questionable this might have been, and living in a one-industry environment, working six days

a week, he had little opportunity to find out how the other half lived, or to seek other work.

Newspapers and magazines invariably pictured the miner either drinking in a pub or reeling home drunk. This image was not at all realistic, and was not typical of the pitman. His companionship was found at his favourite pub, but he also had his garden, racing pigeons and many other hobbies and pastimes. When people of the so-called upper class over-indulged at their club, they could be put to bed on the premises or driven home by their chauffeur; they need not be seen reeling home.

I recall one young haulage boy who left the mines to work as a pantry-boy for one of the titled gentry. When he paid a visit to his home after a year in service, it was difficult to tell by his affected airs whether or not he was the lord of the manor. Some of the local people, particularly the women and even miners' wives, thought he was a little bit better than a miner. It was not only non-mining people who thought that the miner was at the bottom of the pecking order. I failed to see how this line of thinking prevailed when a man who cleaned pots, pans and boots for a living was considered to be of better class than one who was producing the energy for an industrial nation. To me, a gentleman was always a gentleman, regardless of his station in life.

In spite of the menial aspect of his work, and its lack of prestige, the miner would abhor the thought that anyone pitied him in his job. He was his own man with pride in his craftsmanship, and through it, in his calling. However, he did not like innovations. The traditions and customs by which he lived, the slow but steady change in methods of work and the fear of unemployment all combined to lead him to regard the introduction of mining machinery with misgivings. He preferred to preserve his traditional methods of work and the customs with which he had grown up.

I started in the mine when there were a few disc-type coal-cutting machines on the longwall faces, and the pom-pom, or punching machine, was used in some of the headings. However, a considerable part of the output still came from hand mining by coal hewers, as the miners were called.

A unique piece of equipment used by a hewer was his cracket. This was made of wood and looked like a stool, but built low with a sloping top. He used his cracket when he had to lie on his side to under-cut the seam. By placing it under his arm and shoulder, he could keep his lower shoulder clear of the floor and swing the pick freely.

As more and more machinery was introduced into the mine, the days of the skilled hewers were numbered. They had worked hard and had played an important part in helping to build a great industry. Perhaps their skill and craftsmanship were neither sufficiently remunerated nor recognised. The grievances of the past are still in the mind of many, and there is the tendency to hand on the memory of these grievances when their reality has largely disappeared.

THE WALLS COME TUMBLING DOWN

With the introduction of coal-face machinery, recreation facilities and improved housing, it appeared that the coal companies had at last recognised that the miners' life-style had to change. However, one field that received very little attention at this time was that of training and education. At the time when most of the production came from hand mining, young miners, after working on the haulage, acquired the art of mining by working at the face with their fathers or other older miners. This kind of training was sufficient for the lad whose only work would be mining, but as the mines began to use more machinery, some kind of special training was obviously needed. Up to this time the few machine men had been trained by representatives of the machine manufacturers, and the men trained in this way passed on their knowledge to their helpers.

Mechanization of the mines also meant a change in mining systems and technology. To meet these anticipated needs, the Ashington Coal Company pioneered in upgrading the education of the employees. Most young pitlads entered the mines having at best a standard seven education. The Company offered to send those boys to school who could pass a test. By doing this, the Company hoped to create a pool of young men who could later become senior officials in the mines.

The Company began the Continuation School, as it was called, engaging two teachers and equipping a building with the necessary

materials. Any boy eighteen or under and employed by the Company could attend this school; but only forty of each year's applications could qualify. The curriculum was designed to meet the standards of Durham University matriculation. The program was academic with emphasis on the sciences. The Company hoped that eventually some of the students would continue to university and obtain degrees in mining engineering.

The Company supplied all books, writing materials and tuition, and those students accepted were also paid wages for the two days a week they attended school. The complete course took three years, but only the top twenty of the forty first-year students were eligible to continue to the second and third years. After acceptance, the only conditions were that each student would provide himself with a set of drafting instruments, be neatly dressed, wear a collar and tie while at school and complete all home assignments.

Human nature being what it is, there were some lads in the mine who thought this was a chance to have two easy shifts every week and get paid for them. They were soon disillusioned. The ordinary high school term was five years, five days a week, to matriculation, and the company school was attempting to do this work in three years at two days a week. The two days at school were fine, but the homework was tremendous, especially as the students had to work the other four days in the mine. My own application was accepted and, while I was never more than an average student, the education I received had an important effect on my future.

I was contract putting now, and the amount of homework assigned didn't leave much time for recreation. However, I had no complaints. New horizons opened that I never knew existed. A chemical laboratory in which to practice experiments was an eye-opener to me, and practical demonstrations of the principles of mechanics made the study of this subject much easier. The introduction to good reading was a source of pleasure that stayed with me all my life. During those years the required reading was: *The White Company* by Conan Doyle; Shakespeare's *A Midsummer Night's Dream, Julius Caesar* and *The Merchant of Venice; She Stoops to Conquer* by Oliver Goldsmith and Palgrave's *Golden Treasury*. I have always been grateful for the opportunity of attending the company school, because there were many things in life I would have missed without this experience.

It was now 1926, the year of the General Strike, and our walls came tumbling down. There was a combination of factors that caused the General Strike. The post-war boom was over, European mines were

coming into production and British mines were in the hands of companies whose scope was limited by the coal landlords, who in the past had control over the size of the leases. These and other factors placed the industry in a poor competitive position with its European counterparts. The first and only solution was, as usual, to cut the miner's wage and increase his hours of work. To a group who had fought over the years for the eight-hour day and a living wage, this was blasphemy. The result was inevitable; the miners went on strike.

There were many ways of keeping occupied during the strike. Some miners worked in their gardens, while some went fishing. One chore that all of them took part in at one time or another was gathering coal from the waste heaps. My own objective was to pick a minimum of a hundred pounds a day because it required that amount to keep our house going. I put the coal into a jute sack and carried it on my back to where my bicycle was parked, placed it across the frame, then wheeled it a mile home. Once, while carrying the load on my back, I stepped into a rabbit hole, and to this day I can hear the crack in my ankle as I went down. My ligaments were badly torn; having an extra hundred pounds on my back aggravated the injury. So my coal-picking days came to an end for a few weeks, and this job was passed on to father. In addition to picking coal I used to go crabbing along the rocky sea coast. I spent some time each day at this, sharing my catch with other families in the village.

As the strike dragged on, signs of hardship began to appear. Street committees were formed and arrangements made to feed the children at least one good meal a day. This was done on a cooperative system. Some people had vegetable gardens; others had fish. I had crabs. Some had a little nest-egg that they sacrificed to help the cause. I know that prior to the strike father had a few pounds saved, but this was used up long before the strike was over. I heard afterwards that he had handed out money to parents who had hungry children to feed.

The end was inevitable. The miners were starved back into the pits. In these days of inflation, it seems strange that the 1926 strike was not for a raise in wages, but a protest against a cut in wages and longer working hours. However, after thirty-one weeks the miners gave in, returning to work for less wages with twenty minutes added to the working day. Management and government had brought the miner to his knees by importing coal from Europe to keep British industry going. Today labour wouldn't tolerate the use of scab coal.

It may seem strange that in the 1970s the effect of the 1926 strike is still being felt in Britain, but it is. It is pin-pointed by the difficulty of recruiting young men for underground labour. In my father's time it was accepted that the sons would go into the mines, but the generation of fathers who were young men during the strike were determined that their children should never work in the pits, and the bitterness remains to this day. Many a defeated miner vowed that, in the end, he would win by seeing his progeny escape from coal mining. After the strike we settled into the dull routine of pit work, with the added load of disillusionment and hopelessness.

We had not long returned to work when an epidemic of smallpox hit the north of England. It seemed to be more prevalent in the mining villages, probably due to malnutrition during the days of the strike, and there were a few deaths. Four in my family came down with the disease and I was one of them. The symptoms were similar to those of influenza—fever, aching bones and a headache. After about ten days I felt fit to walk, but that was when I was ordered to the hospital for quarantine. The spots were beginning to appear and that is the contagious phase.

When a patient entered the hospital, the first treatment was to have all the spots daubed with permanganate of potash, a nauseating puce-coloured concoction. We were kept in isolation for several days until the spots disappeared. My one recreation while in the hospital was to take the rabbits caught in the snares set along the fences of the estates adjacent to the hospital. The rabbits were a delicacy and a great improvement to our meagre diet. It gave me great satisfaction to encounter an arrogant gamekeeper on one of these jaunts, and watch him turn pale and run away at the sight of me when he realized I had smallpox. I really felt I had put the fellow in his place and got the best of this symbol of the upper class.

I was released from the hospital, cured and ready to start work where I had left off. I was putting, working hard and beginning to think there had to be something more to life than I could see in front of me at this time.

One day, when working in a wet area, the pony and I had to travel through a place in the roadway that had water lying a foot deep. This meant I was soaking wet after the first pass through the water, and as a result, for the rest of the shift. On one of the trips, as I passed the deputy overman's station when he was there writing his report, I said, "Say Jack, I think I deserve extra money for being soaked all day."

Quick as a flash, he replied, "Bill, thou's paid for putting—not for thinking." How can you beat that kind of reasoning?

I had ended my studies at the Continuation School and hoped for some recognition by the management. This was not to be. The boy who got the position of apprentice official was one who had never worked underground before, but whose relative was a senior official of the Company. I was disappointed but began to understand that it didn't matter what one knew, but whom. In the light of this experience I felt that my future didn't lie in coal mining in England. It was at this time that thoughts of getting away from the mines, and of emigrating if necessary, occurred to me. I was not happy in my work and I wasn't going to spend my life in this unpleasant environment.

My life was becoming the stereotypical life of the coal miner. I was too young to go to pubs, and in any case I had no taste for beer, preferring to find companionship on the sports field or tennis court. My pals and I had also enrolled at the local ballroom for dancing lessons. There we learned the popular dances of the day. My chums and I occasionally attended the local dances when we could afford them and were on a shift that allowed us the time to go. We were at the boy-looks-at-girl stage, and the dances were one place where we could meet girls. I am afraid our prowess on the dance floor didn't help in our conquests. We must have seemed like bumps on a log to the more worldly set. All we knew was pit work, and a coal mine isn't the best place to acquire the social graces. How could a girl be interested in the number of tubs a putter handled in a day, or in the tales of the behaviour of his pony?

As the company recreation facilities were free, or, more accurately, their costs were deducted from our pay, we used them quite a lot. In the summer we played cricket and tennis and, in the winter, soccer. A weekly visit to the cinema was usually on the agenda of the pitlads. Although we didn't have much to spend, we did enjoy what free time we had.

The wage of contract putters varied from day to day. Some days he could earn fifteen shillings but, on others, if things didn't go right he might only make seven shillings. I used to feel I had done well if I could hand my mother £2 10s. for my week's work. Another son, Kenneth, had been added to the family in 1926. He was the last to be born into the family. There were now nine in our family, and it took every penny we earned to keep the household going. Some of my pals

were getting a pound a week pocket money and had more to spend than I did. But no matter how I envied them, I couldn't hope to receive that much from mother.

I was reaching a stage where I seemed to be caught in a trap. Here I was going to work every day, doing a job that appeared to have no future and gave minimal returns. I suppose I could have left home and searched for work in other parts of the country, but mining was the only thing I knew. This, and my fear of the unknown, held me back. I was also held by bonds of family loyalty. The extra few pounds that I contributed to the household were sorely needed.

In the spring of 1928, a series of events happened that were instrumental in changing my whole life. The putters wage was based on the number of tubs he handled, whereas the miner was paid by the ton. For example, if the rate was three shillings a score, and he hauled sixty tubs, a putter's earnings would be nine shillings. The tubs at the mine held eight hundredweight, which was suitable for the size of the haulage roads and enough for one man to lift in the event of a derailment. In one of their efforts to cut costs, the Company introduced, on a gradual scale, a larger capacity tub having ball-bearing wheels and an inset bottom. This tub held twelve hundredweight, and being heavier and slung low on the axles, was much more awkward to handle in a derailment.

While it could be understood that ways had to be sought to cut costs, it was soon found out that the putter was to be paid no more for handling these larger tubs. The hewers and fillers couldn't load as many in a shift and, due to their size, we couldn't haul as many in a day. It boiled down to a reduction in a putter's pay by thirty percent. We younger fellows didn't concern ourselves with union matters or agreements. These things were left to the older miners and, much like many union members today, we hadn't a clue as to what went on between management and men. We should have had more interest in our affairs but, being young, we were content to let someone else do our thinking for us. I am afraid the younger members of the rank and file were apathetic when it came to such boring things as union meetings. Representation was made to management for a higher score price for the larger tubs, but to no avail. There was nothing in the agreement that specified the size of the tubs.

To beat this large tub racket, the putters decided to side-track, switch and roll-off any of the new tubs that came into their section. What we were going to do was literally hide these tubs as they were

fed into the haulage system. To the non-miner this may seem impossible, but there were miles of unused roadways and old workings where it was not difficult to hide a few hundred tubs.

We continued the disappearing act for about two weeks before management noticed that none of the new tubs were coming to the surface. Then they knew what was being done, so at the weekend, a crew of junior officials were put to work gathering all the hidden tubs and returning them to the regular haulage system. When we came to work on the Monday fore-shift, we were faced with an ultimatum that all the new tubs must be used. Refusal would bring instant dismissal. We had little choice in the matter. It was less than two years since we had been starved back to work, and we were not in a position to buck the tide. After much grumbling, the putter decided to give the new tubs a try, hoping that something would come out of it.

We continued to work that week, but it was soon apparent that we could not make wages handling the new tubs, even though the conversion was only partial. On the Friday fore-shift at 2:00 a.m., we were in the bath-house changing clothes to start the shift, when one of the putters, without a word, turned his water bottle upside down emptying it. The significance of this act to a miner was obvious; no water no work. As the water trickled out of the narrow neck of the bottle, not a word was said by anyone. There was a quiet tension in the air; we all knew this was serious business. Finally when the bottle was empty the putter said, "I'm damned if I'll put their bloody tubs for less money than I was getting after the strike." This was the signal for all the putters to empty their bottles, and when that was done we changed our clothes and went home to bed. There were eighty-four putters involved in this episode.

We didn't show up for work the following Monday, but on Tuesday a policeman called at each of our homes to deliver a summons to appear in the County Court at Morpeth on the charge of breach of contract. The union had a lawyer to represent us. My recollection of the event was that we didn't have anything to say. It seemed all the talking was done by the company lawyers. After what seemed like a very short time in the court-room, the judge announced his decision. Each defendant was fined £1 7s. 6d. This was my first and only look at British justice in action and I must say that, in our case, the wheels moved with speed.

The only thing I remember was the union lawyer asking the court if our fines could be paid on the instalment plan. After deliberating for

a few minutes, the judge showed his great magnanimity by allowing the fines to be paid by pay-roll deduction at the rate of 2s. 6d. per week.

One bit of humour came out of this miserable affair. When the judge announced his verdict, one of the putters, the clown of the group, stood up and shouted, "Your highness, that's not right. I wasn't at work that morning because my pit boots were at the cobblers getting mended." He managed to get all this said before a couple of policemen got to him and shut him up. But this outburst did him some good; he was the only one whose fine was cancelled. The injustice sticks in my craw to this day, and was a reflection on the treatment that working men could expect in the courts at that time.

After this event, I knew that mining in England was not for me. This was the last straw. I was now more determined than ever to get out of the pits. I had two choices: join the services or emigrate. I wasn't going to be beaten down by the system forever.

When I told my parents of my feelings, father said, "Forget the services; you had better join a brick wall." I respected his opinion, so this left emigration. I had my whole life in front of me and I decided I would go to Canada because it was the cheapest place to get to in the Commonwealth. In addition, the Canadian National Railways had a plan of assisted passages for immigrants who would work on the farms. Once the decision was made, my parents did all they could to help me get the money together I would need for the trip. The qualifications for acceptance of assisted fares were that one had to have good health, be under twenty-five, male and of good character. My pal, Bob Snowball, decided he would like to go too, so we made application together. This was a boost to my morale; it meant I would have companionship in the new venture.

After a medical examination and submission of the necessary documents, I had only to wait in anticipation. Finally after three weeks on tenterhooks, I received word that I had been accepted and should be prepared to leave near the end of May. I was quite happy at this news but my elation was somewhat subdued when Bob informed me that his application had been turned down for health reasons. If I were going to Canada, I would have to go alone. My first thoughts were to abandon the plan. It appeared a formidable journey to do alone. In my stratum of society we never travelled far from home, which made us rather naive. The idea of leaving everything I knew to go to a strange country alone was a bit frightening.

Gradually, however, the glamour and anticipation of seeing another country, plus my distaste for the pits, overcame my fears. Under the plan, the fare from Liverpool to Winnipeg was £10. In addition I had to deposit £10, which I would pick up when I reached Winnipeg. This was to cover rail fare and meals for the journey further west. With the help of my parents the money was deposited, and I was notified of a booking on the Furnace Withy ship *S.S. Newfoundland*, sailing from the Hornby dock on May 22, 1928.

The day finally arrived when I had to leave the mine; I remember the last pay I drew had a deduction of one half-crown—the last instalment on the fine that had to be paid. I had paid my debt to the country, and I would leave it owing no man.

I promised my brothers and sisters I would write to them, and send them something from Canada. My brothers wanted bows and arrows, tomahawks and feathered headdresses. My sisters urged me not to fight Indians and not get scalped! Hollywood had done a good job of brainwashing.

It was now time to say good-bye to my mother; father was coming to Newcastle with me and we would say our farewells there. It must have been a painful parting for my mother. I was the first to leave home and she didn't know if she would ever see me again. I had the stimulus of new adventures to help allay some of the anguish, but mother had only the same drab life to look forward to. I kissed her at the front door, then strode hurriedly away. I looked back once and she was waving goodbye with tears in her eyes.

Father had little to say on the journey to Newcastle. Neither of us wore our hearts on our sleeves. As the train was about to leave I said, "Farewell dad; I'll write to you all." I shook father's hand and stepped on the train. My family ties were now broken. As the train travelled along, the thought crossed my mind that this was the first time I had ever shaken hands with my father. I had many regrets at leaving my family, but none at leaving the mines, England or the system I had lived under for twenty years.

The New Land

When I arrived in Liverpool my first objective was to find the overhead railway that traversed the miles of docks. I knew the route to take and had instructions to get off at the Hornby dock station near where the *S.S. Newfoundland* was berthed.

I kept a sharp eye out for the Hornby dock and an ear cocked to hear the conductor announce it as the train chugged its way along the docks, stopping at frequent intervals. But imagine my consternation when he shouted, "End of the line." In desperation I overcame my shyness and asked where the Hornby dock was. The result of not asking directions was that I had a two-mile walk lugging my suitcase to find the ship.

I finally found the *Newfoundland* and was admitted aboard, shown my cabin and told that we would sail on the outgoing tide. Being worn out with the events of the day: leaving home, new sights and a long walk, I rolled into my bunk and was soon sound asleep.

This ship was not like the large Cunard, or White Star passenger liners that brought so many settlers to Canada and the United States of America. It was a combination passenger ship and cargo carrier, having accommodation for only a hundred passengers. The rest of the ship was taken up with cargo holds. With the *S.S. Nova Scotia*, the *Newfoundland* plied the triangle run of Liverpool, St John's, Halifax, Boston and then back to Liverpool.

I awoke the following morning to the call of the steward, fully rested and ready to take on the world. In a short time I had showered, shaved, taken a brisk walk around the deck and eaten a hearty breakfast. I also had the opportunity to meet some of my travelling companions, which helped dispel the feeling of loneliness that had haunted me since leaving home. After breakfast some of the other chaps and I took a walk on deck to see if we could find out where we were. The sea seemed to be unusually rough, considering that we could not be too far out so early in the journey. We discovered that we were off the north coast of Ireland, an area noted for rough water. The ship was rolling a lot, but I was determined to find my sea legs and not let this tossing about spoil my journey.

After about an hour on deck I began to feel a little queasy but, being determined to enjoy the sea voyage in spite of my stomach, I kept on walking. I thought that if the ship would only stop for a few minutes I would feel much better, but that ship just kept rolling along. Finally, like many others, I was unable to stave off the inevitable and ended the walk with my head over the rail. The delicious breakfast I had eaten a short time before soon became a feast for the gulls that were following in our wake. As soon as I was able, I made my way down to the cabin where I spent the greater part of the crossing. Seasickness has to be one of the most miserable of the minor afflictions that beset mankind. I felt so ill at times I wouldn't have cared if the ship had sunk, just as long as it stopped moving.

Having spent the greater part of the trip in my cabin, I had seen little of the Atlantic Ocean, but when we were about a day out of St John's, Newfoundland, I began to feel better, and this gave me a chance to explore my surroundings. We had reached the iceberg zone and a few tips could be seen from the ship's rails. I was curious about these masses of ice, and wondered how they could be avoided at night. I had heard of the *Titanic* disaster. I asked one of the ship's officers about this and he explained that all the large icebergs in the shipping lanes were accounted for. The maritime nations had a system of tracking and recording the position of all icebergs as they drifted south.

The ship finally docked in the land-locked harbour of St John's, and we were told that we would be there for two days, and that we were free to go ashore to do some sightseeing in this Crown Colony of Britain.

A group of passengers got together for some sightseeing and, as this was my first look at another country, I became an enthusiastic

tourist. We visited Cabot Tower which stands on the bluffs overlooking the Atlantic Ocean and the harbour.

The two-day respite was soon over, and my stomach had enjoyed the motionless interlude. The next part of the sea journey was the short trip down the coast past the Cabot Strait and Cape Breton Island and into the harbour of Halifax. I must have been the world's worst sailor, for no sooner had the ship nosed out of St John's harbour and into the open sea than I became seasick again. When we eventually disembarked I was sure glad to see the last of that ship.

More than 166,000 immigrants arrived in Canada in 1928, mostly from Britain and Europe. The Canadian west was in urgent need of farm labour. Canadian No. 1 Northern Hard wheat was considered to be one of the finest milling grains in the world, and the cry was, "Break more land, raise more wheat."

To meet the demand, several agencies were authorized to recruit labour. Among them were the Canadian Pacific Railway Company and Canadian National Railways. The Soldiers' Settlement Board also brought many families to the west. Dr Bernardo's Homes for orphan boys also sent many of their boys out to Canada to make a new life. It wasn't difficult to get settlers for this new land because Europe was still feeling the effect of the war. The slavic countries were afraid of the Russians, and England had not fully recovered from the 1926 work stoppage. In general, the labour forces of the Old Countries were unsettled and unsure of their future, and those who could get away, did so.

It was a motley crowd of large and small families, some dressed well and others shabbily, that gathered in the immigration sheds at Halifax. We were soon sorted out and directed to the railway station to await the train that would take us west. As I walked along the platform, I was amazed at the size of the Canadian locomotives and coaches. Compared to the ones I had seen in England these were giants. Another thing that impressed me was the length of the train. Our train had two baggage cars and twelve coaches. We were notified which coach we would occupy. There was one coach for British settlers and eleven for central Europeans who spoke no English.

These coaches are worthy of description because I doubt if any like them have been used in a generation. They were called colonist cars and were home to the cross-country traveller for four, five and six days, depending how far west one was going. Each coach was equipped with a stove for simple cooking. Next to it was a bin containing a supply

of coal. Passengers stoked the stove under the watchful eye of the train-man and the conductor. Fresh water was stored in built-in tanks and replenished at each railway divisional point. Hand basins and toilets completed the sanitary arrangements. The seats folded out to make a bed for two people, but the most interesting feature was the top bunk. The ceilings in the coaches were made of curved panels which were part of the decor. At night they were pulled down to form an upper berth adequate to sleep two people. One can imagine the condition of the coach after fifty people had lived in it for a week. But no matter how uncomfortable the journey, the travellers were sustained by the hope that the future held promise.

When the train pulled into the depots where there were food out-lets, the occupants of our coach would get out, stretch their legs and purchase some food or, if there was time, have a meal at the station restaurant. I learned later that we were overcharged at some of these railroad stores and cafés where a few unscrupulous clerks were not above taking advantage of the settlers' difficulty with Canadian currency. At one stop a fair-minded conductor took me to the clerk who had sold me a loaf of bread and a pound of butter, and I was refunded fifty cents.

One thing that puzzled me for a while was that the passengers in our coach were free to come and go as we pleased at the stopping places along the line, but the occupants of the other eleven coaches were not allowed to get out. When we stopped for food, only two or three persons from each coach were allowed on the platform and these did the purchasing for their respective groups.

I was at first surprised at this seeming discrimination. It must have been difficult for the passengers, especially families travelling with small children, to be cooped up in the coaches for days on end. Having been an underdog myself, I felt for the plight of these people. I was pre-pared to voice my opinion at the injustice of this treatment. However, on thinking the situation through, I realized that this was the way it had to be done. I could imagine the chaos that would result at the depot stores and restaurants if six or seven hundred people, who couldn't speak English, were turned loose. I suppose the rules had evolved through experience in catering to earlier colonist trains, and were in the interest of all concerned.

I was interested in the sights and scenery of the country as we travelled through it, and was somewhat disappointed that I didn't see any Indians on horseback riding along the side of the train doing their

whooping and hollering. Hollywood had done a good job of brain-washing me too.

One of the first places I remember was Springhill Junction in Nova Scotia, where one of my travelling companions was to meet his brother. The chap had found out I was a coal miner and he begged me to get off the train with him because he felt sure his brother could get me a job in the mines at Springhill. The offer was tempting, but I knew it was not ethical. I had availed myself of the assisted passage for farm workers and I felt that was what I must do. Also, apart from doing the right thing, I had left England to get out of the mines; besides, there was £10 waiting for me in Winnipeg. I thought of this episode many years later when reading of the mine disasters of Springhill colliery and wondered if fate had guided my decision.

I had left England with little money and as the journey continued I was becoming concerned about whether my money would hold out until I arrived in Winnipeg. The unexpected two-day stay in Newfoundland has used some of the money I had allotted for the train journey, and having also been rooked in some of my purchases I was left rather short. However, by practising frugality during the last two days I managed to eat adequately until I reached Winnipeg.

My first concern on arriving in Winnipeg was to see the agent responsible for placing the new immigrants, and to collect my £10. I still had three half-crown pieces, which was less than two dollars in Canadian funds. But I was told the amount was too small to exchange, and advised to take the half-crowns to a silversmith and sell them for silver. I did so and received a little over a dollar. The sharpies were surely waiting for the greenhorns coming to town.

It was morning when we arrived in Winnipeg. I picked up my £10, and the placement officer told me to see him after lunch when he would tell me where I would be sent. After spending the morning looking at store windows along Portage Avenue and treating myself to a nice Canadian lunch I returned to the office. There were a few other fellows on the same errand as I, and we hoped that some of us would be sent to the same place so that we would not be quite alone.

Those in our group who had immigrated under the Canadian National Railways' plan all went to different places. The placement officer spread ten of us from Brandon, Manitoba, to Berwyn, in the Peace River country of Alberta. I was to go to Holden, Alberta, and my train was scheduled to leave that evening.

The farm labour program worked this way: The farmer who required labour placed his order with the station agents in the towns serviced by the railroad. The applications were sent to Winnipeg, then to agencies in England and Europe, and it was expected that jobs would be available for the newcomers upon arrival at their destination.

In the spring of 1928, Winnipeg was a bustling city, the gateway to the west and the distribution point for prairie commerce. It was from there that the immigrants were dispatched to the three prairie provinces. Any friendships made on board ship or on the train were usually broken at Winnipeg.

The train I caught that evening was a duplicate of the one that had brought me to Winnipeg. One coach was reserved for British settlers and eleven coaches were for Europeans. I assumed that the single men were going to farm jobs too, and that the families were going to farms under settlement schemes inaugurated by the large land-owning companies such as Hudson's Bay, Canadian Pacific Railway, and by the federal and provincial governments.

All my preparations for the journey west were now made, and I wrote a postcard to my family telling them of my destination. After paying the fare to Holden and meals in Winnipeg I figured that with care I would have enough money to last me until I got a job. I had been assured by the agent in Winnipeg that farm workers were needed in Holden and a job would be waiting for me when I arrived.

As the train puffed its way across the prairies, it stopped and passed through many small farming towns and villages, taking much longer than the two days for regular trains. Some towns had only one or two stores and a couple of grain elevators. I couldn't visualize Holden being anything like these places. It had to be a large town, perhaps not as big as Winnipeg, but nearly so. The farther I travelled the more tiny hamlets I saw, and the hopes of Holden being a metropolis began to fade. I wondered, if Holden was like these places, what could I do in the evenings after work, or on my days off.

It may seem strange to the sophisticated youth of today, but at twenty I had never met a person of another nationality. With eleven coach-loads of immigrants from other parts of Europe, I was curious to see and possibly speak to these strange foreigners. Although our coach was full, we did manage to keep it clean and relatively neat. Most of the food we bought was of the precooked kind, or at best requiring a minimum of preparation. Our biggest effort was boiling an

egg or boiling water for tea; on the other hand, the Europeans did all their cooking in their coaches.

Upon taking a walk through the other coaches, my first impression was one of utter bedlam. There were clothes draped over the backs of seats, hanging from upper berths and dangling from hooks by the windows—a perfect picture of disorder. The aisle was littered with scraps of paper and food scraps from some fifty people who were cooking, eating, sleeping and living in the cramped quarters of a railway coach.

While I do not pretend to be over-fastidious—you got used to eating lunch with dirty hands when working in a coal mine—mother did teach us to be clean. Her cooking always had the pleasant smell of good food. The predominant odour in these coaches was that of garlic—second hand—overlaid by the stench of stale sweat and unwashed bodies. I soon felt an urgent need for fresh air and returned to my own quarters.

With this glimpse of how the other half lived, I became interested enough to ask the trainmen and conductors about these settlers, and learned that they were mostly from Poland, Galicia, the Ukraine and the Balkan countries. They were a hardy, frugal people whose roots were close to the soil, and who, today, with their descendants, are the backbone of farming in western Canada. They were looking for something better for their children, and were prepared to tolerate any hardship to reach their goal—a piece of land of their own.

Meanwhile I still had my own problems. My money was running low and the train was about twelve hours behind schedule. I would be a breakfast and a lunch short before reaching Holden. However, the fact that there would be a job waiting for me when I stepped off the train allayed any fears I might have had.

The train arrived in Holden around noon and I said good-bye to the few remaining travelling companions whose destinations were further west. My journey of more than six thousand miles was at an end. I stood on the platform watching the train fade away in the distance then turned to see the village of Holden. I was dismayed to see that it was like many other farming villages we had passed. There were a few grain elevators, one main street with a dozen stores and a few dwellings; that was Holden. It was certainly not Winnipeg!

The first thing I had to do was to see the station agent at the depot and get to my job. When I handed him the letter of introduction from the Winnipeg placement officer, he said, "Good God, I sent that order

for men six weeks ago." The farmers had their summer help and there were no jobs on his list. One look at my crestfallen face told him I was desperate. He told me to take a walk up the street and have some lunch and he would take a run into the country to see if he could find a farmer who needed a man. What he didn't know was that my eating money was all gone. I hadn't a penny; my last meal had been supper the night before, and it never occurred to me to tell of it. It was one of the things that are just not done.

I sat on the edge of the wooden sidewalk of the main street waiting patiently for the return of the agent. During the next hour I was asked twice by complete strangers to come and have a beer. It happened that I was sitting unknowingly in front of the hotel beer parlour, probably looking rather forlorn. As I refused their hospitality, little did they know I would rather have had a cup of tea. I know these people were trying to be kind; if I had so much as hinted that I was hungry, I'm sure I would have been given a meal by these hospitable westerners.

At about three in the afternoon the agent arrived accompanied by Mr Louis Ritland, a farmer who was looking for a hired man. We were introduced and the responsibility of the Canadian National Railways was ended. The farmer asked about my knowledge of farming. Of course, I told him I knew nothing of farming and that I was a miner but not afraid of hard work. He said he couldn't pay me the going wage, but I could start at $20.00 a month plus board, with a hint of more if I worked well. Of course I agreed. By this time if he had offered me a meal I would have jumped at it. I gathered my suitcases and got into his brand new Essex, which he proudly explained he had just purchased. He also told me that he lived four miles from town, which was only a few minutes drive. To me it seemed the end of the world. My life in Canada was about to begin.

THE HIRED HAND

As we rode to the farm the uppermost thought in my mind, other than being hungry, was being so far from civilization. I didn't realize that four miles out of town was considered by the locals to be close in. My prairie farming education was beginning.

When we arrived, we pulled up at an empty granary situated next to the barn. I was told to put my suitcases in it and change into my work clothes. When the agent asked my new employer to come to town to look me over, he had been hauling poplar poles from his wood lot. Rather than unhitch the team of horses, he tied them to a fence post until he returned. The trip to town was a mere interlude in the routine of the day's work. I changed into my overalls and was ready for work. By then, I had reached a stage of hunger where the novelty of new surroundings wouldn't allay the gnawing pangs of an empty stomach. But I couldn't tell Mr Ritland; that would be begging.

We went out to the poplar bluffs where the poles had been felled the previous winter. They now had to be hauled to the farmyard, and stacked in piles ready to be sawn into stove-wood lengths for the following winter's fuel. We brought one load in and unloaded it without incident. But on the second, as I was lifting the butt end of a pole over my head to reach the top of the pile, I felt so weak that I couldn't raise it high enough. My feet were in such a position that I lost my balance and I had to let the pole go. It came crashing down the side of the pile with a clatter, causing Mr Ritland, who was on the other end, to jump

for safety. He was a bit put out at having to run to avoid the tumbling log, and wondered if I had worked in the mines and was as strong as I said I was, why I couldn't lift one end of a poplar pole above my head. This bit of irony was enough to make me swallow my pride, and told him that I hadn't eaten since the day before, and that it was weakness from hunger that caused me to let go of the log.

He stepped back from me with a strange look on his face, then in a quiet voice, with a hint of an apology in it, said, "Why you damned silly Englishman, why in hell didn't you open your mouth? That's it for the day. Come on, we'll unhitch the horses." As he passed the house on the way to the barn he let out a roar to his wife, "NINA! Get something to eat on the table right away! This fellow hasn't eaten since yesterday." After stabling the team we went to the house. I was introduced to Mrs Ritland and admonished by her for not speaking up and told to sit down. This was the first time I had been in a house since leaving home nearly three weeks before. Who would have thought walking into a house would be such a memorable occasion?

After my meal, I was given a brief tour of the farmyard and shown the barn, pig pens, chicken house and granaries. As we came to the one where my suitcases were, Mr Ritland said this was where I would be sleeping. His wife had made a bed for me and there were clean sheets and plenty of blankets. He wished me a good sleep and said he would call me in the morning. I bid him good night and went into my quarters.

My first reaction to my new sleeping quarters was that people didn't sleep in places like this; shelter of this kind was for animals. There were no windows in the building; its main purpose was to store grain. Still, it was shelter. I had never slept outside a house in my life and I was now alone with my own thoughts. I was feeling sorry for myself; I felt I was the loneliest man in the world.

After a restless night, I was called by Mr Ritland to start my first full day of work. My conception of the Canadian farm was that there would be miles and miles of flat fields of yellow grain, waving gently in the summer breeze. I didn't expect to see trees growing on the prairie. I had plenty to learn about Canadian geography.

The Holden area is in the Park Belt of Alberta north of the treeless prairie. It is rolling land broken by willow-lined sloughs and groves of poplar trees. Clearing these wooded areas was part of farm work in the Park Belt. One could not start farming here just by putting a plough into the ground as could be done on the bald prairie.

In the next few days, in addition to clearing land, I was to learn how to harness a team and to milk two cows that provided for the household milk, cream and butter. Many of these chores took practice to learn well and I often made embarrassing mistakes. Other barnyard chores that fell to me were feeding a couple of dozen pigs, cleaning the barn and learning the quantities of hay and grain fed to each animal. Milking was one of the most difficult of the chores to learn. Even after acquiring the rolling motion of the fingers, practice was needed before one became a proficient milker.

However, it was not long before I became a good milker, and milking became my job twice a day during the summer. I also had to learn how to separate the milk, take the cream to the cooler and feed the skim milk to the pigs and calves. While I had many things to learn about farm work I also had to adapt to a different lifestyle. On the first two days when I finished work I hurried to the granary, changed out of my overalls into a clean shirt and pants, washed in cold water and went to the house for supper. This was the way I had done it at home and naturally I thought everybody did this. But after supper there were many other chores to do: cows to milk, stock to feed and bed down for the night, wagons to grease, machinery to fix and the many other never-ending small jobs that are of a farm. With this kind of work routine, I could see that I had to stop changing clothes in the evening. Mr Ritland came to the supper table in his work clothes, so on the third day dressing for supper ceased. The time between coming in from the field and supper was short and it would have been rude to be late at the table.

One other habit I had to break was that of eating breakfast as soon as I got out of bed. When I was called in the morning at five, I had two cows to milk, animals to feed, the barn to clean and be ready for breakfast by 6:30. I can always remember how I enjoyed those breakfasts. I was ready for them. Another thing I missed very much was a cup of tea and a snack in the evening before going to bed. This had been a regular meal in England, and it took some time before I got used to going to bed without the evening snack.

I was determined to become a Canadian and worked hard to learn all I could. It was not long before all the milking and other barnyard chores became my responsibility. They were the most tedious of all farm jobs, but I was alone with nowhere else to go so the work didn't bother me. My worries about the proximity and size of Holden were

46

of little consequence; when the chores were done, I was ready for bed and not thinking about going to town, even if I could have got there.

The Ritlands took a kindly interest in me, but they never quite forgave me for not telling of my hunger that first day. When I explained that one didn't do such a thing, Mr Ritland said, "Young fellow, you are in Canada now and you have to shout up!"

After spending a couple of weeks learning my way around, Mr Ritland began to leave me more and more on my own. At the end of the first month I had a surprise—he gave me $30.00 instead of the agreed $20.00, saying I had earned the extra pay. At the same time, I was given a room in the house. This did more for me than any amount of money could have done. It made me feel as if I were a member of the human race again. I suppose the farmers hiring transient labour had to be discriminating about who was to use their homes. The granary period was a time of probation.

As the days passed, the Ritlands' confidence in me grew and they would occasionally leave for a day, giving me full responsibility for the chores. Finally, they would go for a weekend, leaving the farm and the children in my care. I took these responsibilities seriously and looked after the children and farm with the utmost care. I had told the Ritlands that I had looked after my brothers and sisters since I was eight or nine. They were so pleased with my efforts in taking care of their children that I was soon treated as a member of the family.

Being a newcomer to the west, I was inevitably the subject of some pranks, and Mrs Ritland's brothers couldn't resist setting me up. They each tried riding a steer around the corral but when my turn came, they talked me into riding the cow. The steer, they insisted, was too tired and it wouldn't be a fair contest. That was the way they set the trap. I got on the cow's back and she tried desperately to buck me off but I was hanging on like a leech. Desperate, she put her head down and ran right through the corral fence. I ended up with the top rail in my face and was knocked clear off her back. The boys were delighted with the results! Bruised and battered, it took me a few days to appreciate the humour in the situation.

I was becoming familiar with handling horses and we were into the haying season. But here, once again, inexperience led to problems. I did not understand Mr Ritland's directions about how to assemble the windrows and ended up with dabs of hay all over the fields—dabs which I had to gather up into manageable windrows.

Although I had been busy all summer, it hadn't been all work. I had been introduced to baseball, and although I didn't know the rules, I enjoyed the hustle and bustle of the game. I was also asked to go to a stampede by Mrs Ritland's brother but I didn't know what he meant, as I thought a stampede was when cattle ran amuck. He explained to me the events that took place at these rodeos and naturally I told him I would love to go. Mrs Ritland packed a large lunch and the whole family and I drove to the nearby town of Bruce for the big day. The skill and dexterity of the cowboys in riding and roping was a sight to see. For a lad who had been raised in an English industrial town to be thrust into the front row of the wild west was an unforgettable experience.

One other treat was in store before the start of harvesting. All the Ritland family and I were invited to a prairie corn feed. The only corn I had seen was the grain we called maize, and it was fed to pigeons in England. When I was handed a plate of three cobs of corn on it I was at a loss. I didn't know how to tackle them; did one use a knife and fork, or pick them up in one's fingers? I watched the other guests carefully and followed their technique. Soon I was able to work on a corn cob like a virtuoso on a harmonica.

The fields of wheat were now yellow and ripening. Soon I would experience my first Canadian harvest. At the start Mr Ritland ran the binder using a four-horse team. My job was to stook the bundles as they were kicked out of the binder. Stooking was fairly hard work, and at that time of the year the weather was generally hot and dry. The bending, lifting and walking all day made it a hot and dusty job. I had enjoyed a summer of good food, fresh air and work, so I was lean and hard and the work was no hardship to me. In fact, I revelled in how much I could stook in a day.

My wages were changed from a monthly rate to a daily rate of $3.00 when I began stooking, which more than doubled my pay. One day, Mr Ritland told me that he and his brother-in-law were buying a power binder. He offered me a contract to stook for both of them. I accepted.

It was a lonely job, but in the end I made an average of $7.00 a day—good wages in 1928. When the stooking was finished, the next task was threshing. I looked forward to this because I would be working with other men. All summer I had worked alone and I felt the need for companionship. The wages for threshing were $6.00 a day: $4.00 for the man and $2.00 for the owner of the team of horses. I drove one of Mr Ritland's teams.

That fall I threshed twenty-eight days and, though the work was hard, it was enjoyable with the feeling of camaraderie that existed among a threshing gang. I had accumulated a nice little nest egg with my summer's work. I had spent very little. A few work clothes, tobacco and one tooth extraction by a doctor in the back room of the town drug store were my only expenses.

Upon completion of threshing, I returned to the farm I called home where there were a few jobs to be done. The winter's wood had to be cut into stove lengths. This required two days of continuous sawing which left a mountainous pile of firewood. As the weather became colder, a steer and a hog were butchered—the family meat supply for the long prairie winter. I had not yet experienced a Canadian winter, but from reading Samuel Hearne's accounts, I expected it to be one continuous blizzard.

The day finally arrived when Mr Ritland had no more work for me but offered me free room and board for the winter. I had become very fond of the family but five months without earnings was something I had not thought about. So I told him I would stay with him as long as I could but if I got a job that paid wages I would have to leave. There was no farm work at this time, so my only hope was the coal mines.

I wrote letters to various mines in the Edmonton area, and to other lignite mines in central Alberta, finally receiving word from a mine at Dinant, a hamlet near Camrose. I had a job if I could be at the mine within two days. This step indicated how a miner thought; here I had been on a farm for six months, and the only other job I could think of was coal mining. I didn't think there was any other way to make a living.

I packed my few belongings and said my good-byes to the Ritland family. Their home had been my home for six months and they had been kind to me. I left with some regrets and turned my back on the farm and was on my way to the work I knew best.

A Prairie Coal Mine

When I stepped from the train at the tiny settlement of Dinant I wondered if I had made a mistake and had landed at the wrong station. I was looking for all the well-known features of a colliery. There was nothing that remotely looked like a mine anywhere in sight. There was no mistaking a British colliery; its towering head-frame and tall brick chimney stacks were visible for miles. All I saw here was a general store, two grain elevators and a few houses near the railroad depot. My bewilderment was soon dispelled when, upon making enquiries, I was directed to the mine about a mile away.

As I walked toward it my thoughts were of a bustling industrial establishment. But as I came over the brow of a low hill, I saw the mine practically at my feet. At first glance it appeared to be a conglomeration of dilapidated buildings. All were built of wood with corrugated tin roofs. The hoist room and boiler house formed one building, identified by the metal chimney protruding from its roof. A lean-to added to this building served as a blacksmith shop and next to that was a small building which served as the miner's bathhouse. A spur track ran through the property connecting to the main line, on which box cars of coal were shipped to market. I was to learn that this design was typical of the many small prairie mines that were scattered throughout the lignite coal deposits of Alberta.

In addition, there was a cookhouse and three bunkhouses one of which was to be my home for the next few months. These were for single men. The cookhouse was operated by a man and his wife and consisted of a kitchen, dining room and living quarters. On the edge of the mine property were about ten houses occupied by the married men with their families. Such was the settlement of Dinant.

At the office I was signed on as a miner, working under a temporary permit. The Coal Mines Act stated that all coal miners at the coal face must be the holder of a Certificate of Competency. This was granted after an oral examination by the District Inspector of Mines. I was issued a permit pending the next visit of the inspector. The questions were so designed that the examiner could tell if the candidate had worked in a coal mine—questions such as, how would you frame a set of timber, and how would one test for gas using a safety lamp? These were basic questions for anyone with coal mining experience. Within a couple of weeks the inspector visited the mine and I obtained my certificate allowing me to work in any mine in Alberta.

After signing on I was directed to the bull cook. He was the man in charge of the bunkhouses, and one of his jobs was to keep them clean and supplied with coal. He also cleaned the dining room, peeled potatoes and hauled garbage and ashes from the innumerable stoves that were scattered about the property.

I was shown to a bed in one of the bunkhouses. It was one of twelve and was covered with a straw mattress. In the centre of the room stood a huge potbellied stove, a rough homemade table and a couple of benches. These completed the furnishings of the frame buildings. Occupants were expected to provide their own bedding, so I had to walk back to the general store to purchase a pillow and blankets before I could settle in for the night.

I could see by the head frame that this was a shaft mine, but I got a surprise when I found that we didn't go down the mine by a cage, but by a series of stairs. This was a new experience to me. The shaft was only forty feet deep, so climbing up and down was not difficult. Like many other small mines in the lignite field, there was no coalface machinery used to assist the miner and there was no drilling and blasting. Every pound of coal produced was dug by hand, or as they say in the trade: it all came from the point of a pick.

The seam was six feet thick with a two-inch clay band parting in the middle. The basic method of mining was to dig out the clay band,

which was like rubber at times, to a depth that could be reached with safety. When the clay band had been hewn out, the top and bottom benches were released from pressure so that they could be picked out in chunks. Each miner was responsible for timbering his own working place. As the cars were loaded, they were pushed by hand to the entry, picked up by a driver and hauled by horse to the shaft bottom.

Miners were paid by the ton, but only the coal that passed over a three-inch screen was weighed. Any coal less than three inches in diameter did not count on payday. This was a non-union mine and was a prime example of labour being exploited. The plus-three-inch coal was sold at a premium, while the minus-three-inch was used in the mine boilers for power. Any surplus was sold to neighbouring farmers at a cut rate.

With this practice I could see why explosives were not used. If they had been, there would have been very little production over three inches. We were always careful when loading the cars, handling the lumps of coal as though they were eggs, always bearing in mind that three-inch screen. In spite of this handicap, I managed to earn between four and five dollars a day, which was more than I made in England.

This mine had unusual working hours. The eight-hour shift was split in two parts of four hours with an hour off at noon for dinner. The men who lived in the bunkhouses went to the cookhouse and sat down to a full three-course meal. The first few days I thought it was fine getting a break in the middle of the day and having a good meal. But I soon changed my mind, as I found that after such a meal I was unable to swing a pick or stoop and shovel without discomfort. Thereafter, I settled for a snack which I had been used to in the Old Country.

Bunkhouse living was a new experience for me, different from anything I had ever seen before. There, twelve men of different countries, cultures and environments were thrown together in intimate surroundings. There were no amenities to make living comfortable. The bunkhouse was bedroom, sitting room and recreation room. With men living in such close quarters for months, there was fertile field for debate and argument, which sometimes reached the fist-swinging stage. To maintain a degree of harmony, rules were agreed upon and most problems were resolved by the process of majority rule and compromise.

It was here I spent my first Halloween. In England, we celebrated Guy Fawkes Day instead. The bull cook had a Model T Ford touring car that was his pride and joy. That evening a bunch of the miners got together and literally manhandled the car onto the roof of a boxcar using planks and muscles. In the moonlight it was a sight to behold.

The following morning the bull cook was doing his chores without seeing anything amiss. Then, as the sun rose in the sky he saw his dearest possession perched on high. The poor chap was frantic. He ran from one bunkhouse to the next accusing the occupants of being dirty sons-of-bitches for doing such a thing. He reported to the manager who did not have much sympathy, but we managed to cool him down and suggested some of the nearby farm boys had done this terrible thing. We told him not to worry. We big-hearted miners would save his car. So by using planks and brawn we got his car down safely and thereby became the good guys.

There was little to do with leisure time in the camp. We had no radios, and I did not gamble, which was a common pastime. I felt I could ill-afford to lose my hard-earned wages. I had other plans for my money.

Back in England my father had been in hospital, so I wanted to make the coming Christmas one my family would remember. I obtained a catalogue from Eatons and spent many hours poring over its pages. I had never seen anything like it. Here was a huge department store at my fingertips. I had presents to buy for three brothers and three sisters, as well as for my parents. When the order arrived, I wrapped the gifts in fancy Christmas wrapping and proudly sent them home, together with a money order for £20. Knowing that this would make my family's holiday season a little brighter gave me happiness and a lot of satisfaction.

Early in the new year I received word from my parents that they had applied to come to Canada under a settlement scheme. Although I was elated at the thought of seeing my family again, I was also apprehensive about how my father would be able to make a living in this country. He was forty-five and had no farming experience. I had discovered that this was a young man's country, and unless one had either money to become established, or a skilled trade, supporting a family could be a difficult undertaking. I was also apprehensive about the state of my father's health.

I wrote to them telling them that, without means, Canada could be a harsh country. I pointed out that my circumstances were different than those father would face, that I was young, healthy, single and could move to where there was work. But this was no deterrent—the inherent desire to get the sons out of the pits was the deciding factor.

The mine worked regularly that winter and I saved as much as possible in anticipation of my family's arrival in Canada. In fact, my first Christmas in Canada was spent in the bunkhouse with three

other fellows who had nowhere else to go. Although it was a dull festive scene, I didn't really mind as long as I could work and save for the future.

In spite of differences of opinion and arguments amongst the men in the bunkhouse, there was a latent concern for one another. An indication of this was shown when I came down with a severe cold. All I wanted to do was stay in bed and try to keep warm. After a couple of days of misery, one chap, a middle-aged German, looked me over and said in his broken English, "Beel, you plenty zick; no worry, I feex you good." He moved my cot close to the big heater, borrowed extra blankets and wrapped me in them until I looked like a mummy. He boiled a tobacco tin of water, then added some Rawleigh's liniment to it. Rawleigh's liniment was marked *For External Use Only* but I was given this concoction to drink. By light-out I was soaking with sweat. The potion and treatment must have been right, for the following morning I was feeling much better and soon recovered.

At the end of February the single men were notified that they would be laid off on March 15. This was common practice in the domestic coal mines of Alberta. In a seasonal industry of this kind, the operators relied heavily on transient labour to man the mines in the winter. The transient miner had a different attitude towards his job than the British miner. The British miner usually had been associated with the industry for generations and customarily lived in one district all his life. The western Canadian miner had no such traditions. Firstly, because the industry was relatively young, and secondly because of the seasonal nature of operations, he didn't put down roots in the community.

So, in the middle of March 1929, my first Canadian coal-mining experience ended. It was not one I had enjoyed, but it was different. Not being paid for the minus-three-inch coal that I had loaded still rankled me somewhat, but that was part of the system and I couldn't do much about it. In the meantime, I received word that my family had been accepted as immigrants and that they would arrive at Vermilion, Alberta, on April 20, 1929.

Rather than sit around doing nothing waiting for my parents I decided to look for a job on a farm. The ground was still frozen, making it a poor time to look for farm work, but I got a job cutting brush for a month. I knew I would need every cent I could accumulate to help my family. A few days before their arrival, I said farewell to my Dinant friends and set out for Vermilion with mixed feelings of joy and apprehension.

HOMESTEADERS:
HUDSON'S BAY COMPANY STYLE

I waited with anticipation at the Vermilion depot for the arrival of the train. I had little information regarding their plans except that they were coming under the auspices of the Hudson's Bay Company Land Settlement Scheme. As to where they would be settled, I hadn't the faintest idea.

When the train arrived, about twenty families got off. At a glance one could see they were full of hope and ambition. Their enthusiasm for the chance to start anew in the young country was mirrored in their faces. I soon spotted my family. They had seen me standing on the platform as soon as the train pulled in. It was a happy reunion. The only thing that marred the joy of seeing them all was my father's appearance.

When I had left England a year earlier he was a strong healthy man; when he stepped off the train I barely knew him. He had aged twenty years and had the face of an old man. I hid my thoughts from the family. I did not want to show my concern to mother because I wanted this reunion to be a happy time for all.

My family availed themselves of this assisted immigration plan with the object of having a better future for the children. As father expressed it, "I hope we have done the right thing and this is good-bye to the pits."

Under the scheme, a hundred British families were to be settled, each on a quarter-section of land. Their quarters were scattered over an area of some three hundred square miles, of which the town of

Vermilion was the geographical centre. To prepare for the arrival of the settlers, the Hudson's Bay Company had appointed an agent with an office in Vermilion.

A plain clapboard house and a small barn were built on each quarter section. Each house had a kitchen and two small bedrooms downstairs and a wide open attic that could be partitioned off for other sleeping space. I use the term "upstairs" rather loosely; the stairs were merely slats nailed to the exposed studding of one of the bedrooms, and one entered the attic through a trap door in the ceiling. The only protection from the elements was the three-quarter inch siding and half-inch Donnaconna Board on the inside. There was no such thing as insulation. This was to be home for nine people. The barn was built of the simplest construction, shiplap on two-by-four studding, with a wide dutch door and four bare walls. There was room for eight animals with an alleyway between. Later we built poplar-pole stalls to separate the animals.

Each quarter had a well dug on it. On father's, the well was seventy-five feet deep, and lined with two-foot diameter cribbing. Later, we made a windlass for the well, eliminating the need to haul a bucket of water hand over hand. During father's tenure he was never able to afford a pump.

Each settler was provided with four horses and a harness, one cow in calf, one pregnant sow and ten chickens. The equipment issued was one farm wagon with five two-by-twelve inch planks, twelve feet long. These, with two end boards, served as a wagon box of sorts. Actually, it served as a platform for bulk material; such a contrivance certainly couldn't hold loose grain. The machinery to farm the land was a fourteen-inch wooden beam, breaking plough and a six-foot disc harrow. The smaller articles allotted were: ten rolls of barbed wire, a crowbar, logging chain, axe, pointed shovel, a kitchen range, a rough table, two benches in lieu of chairs, an airtight heater and one bedstead with mattress. These were the total assets the settlers were given with which to try and wrest a living from the new land.

A schedule was drawn up to allow for the payment for the land and chattels. Even under the best of conditions, it would have been an impossible task. Had the land assigned to the settlers been of good quality, it would have been purchased and farmed by the established farmers long before. I suspect that the settlement scheme was one way the Company could dispose of second-rate land and rid itself of a tax liability.

The quarter section allotted to father had, at one time, been used to graze sheep. The soil was poor with many rocks. The whole quarter was low-lying, which made it subject to early frosts, thereby reducing the chances of raising a good crop of grain. Also, many sloughs dotted the farm which reduced the arable acreage. This farm should never have been touched by a plough. It was grazing land. There were natural groves of poplar which provided shelter for livestock, and the grassy areas were a good source of buffalo grass, which was a nutritious natural food.

After the reunion with my family at the station, the first thing I did was take them to a restaurant for a Canadian dinner, which was a treat they all enjoyed. Father had to make arrangements to get the family to the farm and to find out about the livestock. He was assigned one team of horses and a wagon this first day to enable him to take his luggage and any supplies out to the farm. While he saw to the other equipment and livestock, I took mother shopping to get the things I knew she would need. I had saved a few hundred dollars for this and it was a joy to see the expression on her face as we purchased the necessary articles and provisions.

I ordered two hundred pounds of flour, a hundred pounds of sugar, a twenty-pound pail of Roger's Golden Syrup and much more—buying all in bulk. This kind of shopping was completely foreign to mother who was used to buying in small quantities. I think she figured there was enough to last a year.

I explained to her that she couldn't run to the store for items and therefore must stock up on things that would keep. One item that was new to her was Royal yeast cakes. She had always used fresh yeast bought on the day that she baked bread. Now she would need yeast that kept indefinitely. There were many things to learn in this new land and everyone in the family was prepared to pitch in to make a go of it. Other things we purchased were a copper boiler, zinc tub, washboard, pails and pans. We had a real shopping spree. It was the last one that mother was ever to have.

Mother and the younger children were taken to the farm by the agent in his car, while father, my brother, Tommy, and I followed with the team and wagon and with the supplies we had purchased. We were given directions and set off for our new place, which was twenty-two miles from Vermilion. Not being too sure of the way, and hauling a loaded wagon, it took us six hours to cover the distance.

A mile from our farm the dirt road came to an end; when I saw this I was sure we were lost. It was late in the day and I began to worry. I didn't want to be wandering around the country in the dark. I was also concerned about mother and the rest of the family. There was a farmhouse nearby, so I drove the team into the yard and knocked on the door. Out came a short stocky fellow, and before I could open my mouth, he said with a broad cockney accent, "You must be the Hudson's Bay settlers." I said we were and asked the way to section seventeen. "I can tell you the way," he said, "but let me give you some advice; take that team, turn it around and get the hell out of here while you have a chance, because you'll never make it." These were the first words of greeting by a neighbour and I never forgot them, perhaps because they were so prophetic.

I asked him why he would say such things to dishearten new-comers. He replied, "Matey, the land is no good. If it had been it would have been sold long before you people came." It was low, he explained and the crops would freeze. It was fit only for pasture, and we would never take a crop off it. I appreciated his advice, but we were a family of nine people with very little money to make any choices, so this had to be our home. He said his name was Benny Dew, and if we needed any help or advice we could call on him and he would help if he could. I thanked him, then he directed me to the trail that led to our place.

Next morning we had a lot of organizing to do. There were no cupboards or shelves in the house and some quick improvising had to be done to store the supplies we had bought. Father and Tommy went to a farm three miles away to choose the cow, pig and chickens allotted to us. I stayed at home and made temporary pens and partitions in the barn.

The house was built in the middle of nowhere. Our nearest neighbour was over half a mile away, and at night there wasn't a light to be seen in any direction. It must have been difficult for mother. She had lived in communities, places where there were people all about. She had left a comfortable home, carpeted floors, upholstered furniture, piano and her many treasures collected over the years. Here she had nothing; we used apple boxes as seats. Until I could get to town, all the children slept on sacks filled with hay. But there were no complaints; they all had stars in their eyes looking to the future.

When father returned with the animals, all that remained to complete his quota of chattels were two more horses, a plough and a disc. We had a journey of forty-four miles to make to collect these in Vermilion

and I judged it would take about fourteen hours to do it, allowing time for business.

It was early morning when we left and we arrived at our destination without mishap. We were directed to a corral at the edge of town where forty to fifty horses were milling about. Other Hudson's Bay settlers were on hand, all on the same errand. After looking over the horses and commenting on the pros and cons of each animal, they made their choices. If one of these men got a good team it was purely by chance as these people were from the mines and factories of Britain. None of them knew very much about horses, especially these western range horses.

Father got his team and harness and we tied the new horses to the back of the wagon, which was loaded with the plough, disc and barbed wire. Then we set off for the journey home. We had not gone far when one of the horses tied to the wagon pulled back on the halter rope, snapping it, and we had a strange horse on the loose. We tied the team to a fence post and went after the runaway. After much running and coaxing with a can of oats, I finally caught it and fastened it to the back of the wagon again. This happened twice more and I was just about at my wits end. Here we were miles away from home with the possibility of this horse breaking away every few miles. We finally met an old-timer on the road and I told him of the trouble we were having. He tied the halter rope to the ring in the back-pad of the horses pulling the wagon, one on each side. We now had all four horses in front of us. When the spare ones pulled back, the pull was on the flexible harness of the team. Once this hook-up was made, our travelling troubles were over.

As we neared home I noticed a red glow in the sky and said to dad that I thought it looked like a prairie fire. Dad thought it was the glow from the setting sun. I didn't say much, but I had misgivings about mother and the children being home alone. When we topped the rise overlooking the farm, my worst fears were realized. The fire looked like it was on our place. We travelled the last mile as fast as the tired horses would allow, and when we reached the farm the sight we saw was enough to make a man cry.

There wasn't a blade of grass to be seen; the haystack that we had just got was burnt to ashes and mother was sitting in a little patch of unburned ground with her few belongings and the children. It seems that a fire had got out of control about a mile west of us, and as there were no ploughed fields to make a fire-guard, the fire swept across our

land, continuing east across virgin prairie for two miles until its progress was halted by a dirt road. Here was a fine beginning to a new life!

The next morning the country had the appearance of a dead planet. Every step raised a puff of sooty dust, and the absence of bird sounds made a silence that could be heard.

Father gazed at the devastating landscape and in a voice filled with anguish said to mother, "My God, lass! What have we come to?" They had only been on the farm three days. In the light of subsequent events, I wonder if this wasn't an omen; it was certainly grim initiation into farming. This was no time to cry or brood as efforts had to be made to feed the animals. I managed to buy a load of hay from a neighbour. Fortunately, within a few days the healing process began, and in ten days the prairie was covered with a fresh green carpet.

This misfortune brought to the fore the traditional western regard the farmer had for his neighbour. Our two closest neighbours, Benny Dew and John Wadsworth, knew that father and I had left for Vermilion that day and that mother was alone with the children. As soon as they saw the smoke they knew that a prairie fire was on its way. Regardless of what they were doing, they hitched their horses to ploughs and set off for our place. The first thing they did was to plough a ring fifty feet in diameter and told mother to get her family into the centre of it and stay there. The next priority was to plough a fire guard around the house and barn. Through their efforts, both were saved. Only those who have lived on the sparsely settled prairie can realize the true worth of a good neighbour. When others, further away, heard of the fire that had burned over the lands of three new settlers, they were quick to send some home-cooked food for us. Their kindness was never forgotten.

We needed the help of these neighbours many times in the next few years and they never failed a call for assistance or advice. As time passed, we too were able to act on the good-neighbour policy. Our neighbours, Johnny and Ben, were lone farmers. They could not afford hired men but relied on their children for extra hands. Our only way to be a good neighbour was to lend our hands when needed. So began our life on the prairies; we had had our baptism of fire.

The brochures distributed in Britain showed fields of ripe grain, and fat cattle eating their way across a lush pasture. They also told of the friendliness of the people of the western farms. I am afraid only the latter part held true.

THE HARD YEARS

Once we had the animals and equipment, a plan had to be made to enable us to support ourselves. For financial help, I could have left home and worked for others, leaving the family to work the farm. But it was agreed that because they didn't know the first thing about farming, I would stay at home and put my limited experience to use.

I still had some savings left, but I knew we would have to nurse them as there were so many things needed and so little money. Only the bare necessities could be bought.

The top priority was to try and break at least five acres, and seed it to oats for winter feed. Next, a garden had to be ploughed and planted, and a windlass made for the well. The farm had to be fenced to protect the tiny seeded area from roving cattle as our municipality had an open herd law. Stalls were built in the barn from poplar poles which made the day-to-day care of the stock much more convenient.

Most of the jobs took us longer than they would have done if we had been properly equipped. For example, in fencing we didn't have any wire tighteners, so we braced the wagon, wrapped a couple of coils around the hub of the large back wheel and, using a pry between the spokes, turned the wheel. This method gave the leverage to get the wire taut. We accomplished most of our work by improvising and by using brute strength.

Another priority was clearing and breaking new ground for seeding the following year. With only four horses, it was a slow tedious job. In the park belt, with such deep willow and poplar roots, four horses proved to be far short of that required to break this virgin land.

When ploughing, I would hang onto the plough handles as it turned the sod, then when I saw a stump or root in the path of the ploughshares, I would let our a roar at the horses to try and get the extra spurt that was needed to get through the root. Sometimes this worked but, more often, I was stuck with the plough embedded in the heart of the root. The only way to get out of the predicament was to chop the root out. This phase of farming was called breaking. It was well named; we broke harnesses, whipple-trees, axe handles, chains and hearts; in fact, it seemed we broke everything but the land.

When the blackened earth had returned to its natural green, the stock was turned out on the open range to graze. This allowed our own pasture to grow to a height that would support our animals without being overgrazed. There were two disadvantages to grazing stock on the open range—getting the horses each morning and looking for the cow twice a day. This was a time-consuming chore that the prairie fire had forced upon us.

We had managed to get five acres sown to oats and hoped this would yield enough to feed our stock. We continued to spend as much time as possible in breaking new ground for next year, but this came to an end when haying season came. I used some of my dwindling resources to buy a secondhand mower and purchased lumber to build a hay-rack. These were essential implements if we were to have feed for our stock. As summer wore on I could see tough times ahead and my funds were just about gone. The garden would not produce until later in the summer. Having no stock to butcher we were forced to purchase everything we needed, and nine people took a lot of feeding.

The summer of 1929 was dry. It became evident that the crops in the district would be a failure. I had hoped to get a winter grub-stake by hiring myself out during harvest time, but it looked as though none of the nearby farmers would need extra help. I heard through a neighbour's son that there were good crops in central Saskatchewan, so he and I set out for that part of the country. We landed jobs at once, stooking for $4.00 a day and threshing for $5.00 a day. That fall I made $220.00, which I knew would be needed to see the family through the winter.

It proved to be a difficult winter. The school children had to have warm clothing and footwear, which took a large portion of my cash.

We butchered a pig and managed to get our winter supply of potatoes. With these, four hundred pounds of flour, a hundred pounds of sugar, a supply of rolled oats, lard, salt and the ever present twenty-pound pail of syrup, we figured we could manage through the winter. Due to the poor crops my chances of getting winter work were slim. The one cow we had was in calf but still giving milk. By careful management mother was able to make a little butter to augment the fat requirement of our diet. Our dozen chickens stopped laying when the weather became colder; however, mother had preserved a few dozen eggs in water-glass.

I could tell by our consumption that before winter was over we would be without meat. In this cold climate, working outdoors made meat an essential part of the diet. Can you imagine what nine people can do to one pig? It looked as though it was a lot of meat when we butchered it, but by Christmas it was just about all gone and there were still four months of winter facing us.

Father, Tommy and I worked that winter clearing land, preparing it for the breaking plough in the spring. From the clearing we cut the next winter's firewood, and made fence posts with the larger red-willow wood. One chore that had to be done every few days was chopping ice out of the well. As the pail was pulled up some water would spill over and this spillage froze, gradually closing off the top of the well. Father was not able to do much about this so it was up to us boys. I would tie a rope around my waist and be lowered into the well and clear the ice away. It was a risky job, but it had to be done.

This first Christmas in Canada was a heartbreaker for my parents. There was no money for gifts for the young children. The older ones understood, but how were we to explain why there was no visit from Santa Claus to little ones? Even in hard times in England, mother always managed to have a present for each of us, but this one seemed hopeless. However, we older ones and mother decided something had to be done for the little ones. Mother made stuffed dolls from old stockings, I built a log doll's house, and Tommy built a wooden locomotive. These few things took the edge from a barren Christmas.

By the middle of January we were in dire straits. We had reached the stage where there were more meal times than meals. We had been able to snare a rabbit or two, but it was a precarious source of meat. It was impossible to hide our plight from the neighbours. Kids will swap lunches at school, and dry bread and rabbit sandwiches would be a topic of conversation.

One morning Benny Dew paid us a visit and handed me an old .22 rifle saying it would make getting a rabbit a bit easier. In the meantime I had got a few days' work cutting wood at a dollar a day, and I took a day's wages of this badly needed money and bought two boxes of shells. I bought the .22 shorts as one got more of these for the money. This worked fine for a while; I was able to keep meat on the table even if it was only rabbit. Our border collie was now able to get a good meal too. She was a working dog, essential on the farm, and a working member of the family entitled to her share of food.

One morning late in March, Tommy and Fred and I went hunting for rabbits. We were following a rabbit through a willow thicket, but as we squirmed through the branches Tommy crossed in front of me. Suddenly the gun went off and the bullet struck him in the head. He was dead before he hit the ground. The only thing I could think of that could have caused this awful thing was that a willow twig had caught the trigger, firing the gun. The old gun didn't have a safety catch. I was horror stricken and numbed by this calamity. I sent Fred on the run to the house a mile away for help, then picked Tommy up, laid him across my shoulders and set off for the house. My mind refused to admit that Tommy was dead, believing that he was only unconscious and would be all right if I could get him to a doctor. My father came running to meet me and we finally reached the house. Word was sent to a neighbour who had a phone and the doctor and the police were sent for. Tommy was pronounced dead by the doctor, and the resulting enquiry found that death was by accident. I was in a state of shock for some time. It was a traumatic experience for me, and although time has healed the wound, I will carry the scar to my grave.

There was no money for a funeral; however, I believe the Hudson's Bay Company agent arranged for a plain coffin and our neighbours dug the grave at the little cemetery of Stellaville. On the day of the funeral Johnny Wadsworth came with a well-groomed black team pulling a freshly polished democrat. The coffin was placed in the back of the vehicle; there were no flowers. Where does one get flowers on the Canadian prairie in March? A sorrowful family and a few neighbours trekked the two miles across the prairie to the little cemetery where we laid my brother to rest. This was the end of a young man's life. He had not been in the country a year. He had come to it full of expectations and hope. I still ask myself: Why?

After the funeral we shed our silent tears, some together and some alone. I had a strong feeling of guilt about this awful thing that had

happened to my family. In spite of their problems my parents tried to make things easier for me, but there was so little that could be done. Time would have to be the healer.

In the spring I got a job on a nearby farm at thirty-five dollars a month and my sister Ethel left home and found work in Edmonton. As soon as I received any wages I sent them to my folks and went home on Sundays to help father. That year he managed to put in about ten acres of oats and nearly twenty acres of Garnet wheat. This strain of wheat brought a lower price than the better-milling Marquis wheat, but we selected it because it matured six to ten days earlier than Marquis.

That summer of 1930, the family's prospects began to look brighter. The summer rains had assured us of a decent crop, the cow had produced a healthy heifer calf—a future milk cow—and the two sows we had acquired produced twenty-two pigs. Dad had managed to put up a few tons of wild hay; all in all it looked as though next winter would be better than the last one. It is no wonder they call the prairie farming country, a 'next year' country. The farmer I worked for could only pay me part of the cash he owed me as he was caught up in the money shortage too. The demands on my earnings were many. There was food, nails, axe handles, plough-share sharpening, rivets for harness repairs and many small things. It looked as though I would be able to earn a good sum in the threshing season, and Fred, who was fourteen, was able to earn a few dollars working on weekends and during the summer holidays.

Harvest time came and most farmers were jubilant because their crops were good. In fact, on the farm where I worked there was a ten-acre field of oats so heavy that a wind storm laid the whole field flat. The binder was fitted with extended teeth to facilitate picking up the downed grain, and the crop could only be cut in one direction.

I was stooking this field and carrying the bundles some distance to leave a clear passageway to allow the binder to travel empty one way. Due to the tangled way the grain was lying, the farmer had to fight for every swath he made; the canvases would plug solid, and the knotter would jam. It was a frustrating, hot, dusty job. After a series of these foul-ups the farmer was at his wits end and at one point he jumped off the binder, got down on his knees in the dust, extended his arms to the heavens, and shouted, "Oh Lord God in Heaven, if You want this bloody crop more than me, please come down and cut the son of a bitch."

That fall I took my father's team and hired-out on a threshing crew for thirty-six days at six dollars a day. Father didn't have much

grain to sell. Some of his crop, which had been a good one, had to be kept for seed, and sixty bushels had to be kept for the family grist. We needed all the oats for our stock and to "finish" the pigs for market. To allow dad to keep all his grain, I paid his threshing bill out of my wages. It seemed that we would be set for winter. We had twenty pigs to go to market, two pigs to butcher and 250 bushels of wheat to sell. The cash from the pigs and wheat, produce from a good garden and all the flour and cream of wheat we would need, made our future prospects look much better.

Our hopes were soon dashed when it came time to market our produce. First, the twenty pigs, each weighing about 200 pounds, brought only two and one-half cents a pound; five dollars for a 200 pound pig. Two tons of meat on the hoof for a hundred dollars; yet bacon was thirty-five cents a pound in the store—somebody was making money. When father took his wheat in to sell, the grain buyer had so many excuses why he couldn't pay much that one would think he was doing us a favour by taking the wheat at any price. All father could get for his crop was sixteen cents a bushel—forty dollars for his crop. Our whole family had worked hard for a whole year and all the cash we realized at the end of it was $140.

We didn't know it, but we were in the midst of a depression. What did the price of shares on the stock market have to do with sixteen-cent wheat and two-and-one-half-cent pork? In our small way we had produced enough food to feed several families, yet we didn't earn enough to feed ourselves. I have heard those years between 1929 and 1939 called many things: the lost years, the wasted years and the great depression. To me these were the years that destroyed men's souls; there was no dignity left in a man; his confidence was destroyed. I know that people who experienced the great depression will never forget it, and those who did not, will never understand it.

I stayed around home the early part of that winter getting the family prepared, butchering the hogs, digging a root cellar for potatoes, turnips and carrots and cutting enough wood to see the family through the winter. We all worked at clearing more land for the plough next spring. Early in the new year, I decided I could do more for the family by getting a job in the mines around Edmonton.

I gave mother all the money I had and kept ten dollars to see me through my job hunting. I hitched a ride to Edmonton and arrived at one in the morning. I slept in a street-car waiting room until daylight,

then mingled with the hundreds of other unemployed who were gathered in the city. In 1931 Edmonton was a city of quiet desperation, a cross-roads of the thousands of transient unemployed. Here they would alight from the freight trains, stay for a few days, then be on their way via another freight train to another city hunting for that elusive job. I was in an element that was foreign to my nature; I didn't have the experience of being "on the bum," and I am afraid I was a poor scrounger.

My first objective was to buy a five-dollar meal ticket at a cheap café. I could eat for a week with this ticket. The headquarters of the wandering fraternity was the employment office, or "slave market." Here we would meet others on the hunt for work and listen to the rumours of jobs to be had in Winnipeg, Regina, Vancouver or almost anywhere in Canada. Some of them were tradesmen, while others had a much higher education than I had. When talking to them I began to think that if men with these qualifications couldn't find a job, what chance was there for me?

One morning I went to the employment office to find that coal miners were wanted. I immediately pushed my way to a counter, got the clerk's attention and showed him my miner's certificate. He gave me a slip of paper to give to the employer, then told me the mine was at Hinton, which is nearly 200 miles west of Edmonton. I told the clerk that I didn't have money to pay the fare, so it seemed I would be unable to go. I was asked if I could borrow the money, or if I had any friends who could help me. Of course I didn't, so it looked as though I would have to jump a freight train if I wanted to get to Hinton. As I was talking, a bystander heard our conversation and as I left the counter he told me he knew where I could get my fare.

This fellow knew the ropes of job hunting in and around a city. He took me to an office in the Alberta legislative building, where he told my story to a man in charge. Within a few minutes I was given a railway ticket to Hinton. The fellow who had taken me to the office wondered whether he could get a job if he went with me to Hinton. I told him I wouldn't know as he wasn't a miner. He decided to take a chance anyway and said he would be on the tender when the train pulled out that night.

That night I rode the cushions to Hinton and my new-found friend damned near froze to death riding the tender of the same train. I felt rather guilty about this; after all, it was through his efforts that I was inside the train and not riding the rods. It was early in the morning

when we arrived in Hinton. There wasn't a soul in sight or a light anywhere. All that could be seen in the darkness were trees. At dawn a light appeared in a building situated among the trees. Upon investigating, we hit the jackpot; we found the cookhouse for the miners. I paid fifty cents for two good breakfasts, and we ate while we waited for the mine manager. My friend was chilled to the bone, but after eating a good meal and sitting around the heater in the cookhouse he soon felt better. The manager appeared and when I showed him my work slip I was hired on the spot. I spoke to him about my travelling companion and explained how we got here. He figured that anybody who wanted a job as badly as my pal deserved one. He gave him a job as clean-up man around the plant. In those times, having a job gave one status. It meant a dollar in the pocket, and a dollar went a long way.

The mine at Hinton was a new operation and the facilities were incomplete. In fact, the cookhouse was the only building and the miners, in groups of four, slept in tents provided by the mining company. There was no machinery for coal production in the mine. The coal was very hard and had to be blasted to get it loose. The first thing I had to do was buy a set of drilling tools, an axe and a saw; the pick and shovel were supplied by the company. I also had to buy a supply of powder, detonators and fuse. A miner had quite an outlay before he got started.

The seam was thin, only three feet thick, so I worked on my knees in a crouched position all day. Getting the coal was a rudimentary procedure: drilling, blasting, loading and timbering. The trick was to place the shot-holes to get the maximum amount of coal from each shot, while using the least amount of powder. It would do no good to fire a shot and have the coal blown all down the gallery so that it could not be loaded. It was the miner's powder that would be wasted. I was quite satisfied with my earnings, which averaged five dollars a day, six days a week. On Sundays I earned another five dollars cutting mine props; I was grateful to be working every day earning a decent wage.

One day toward the end of June I drilled a round shot of holes intending to blast after the lunch break. After firing the first shot I returned to the face to charge another hole and, peering through the smoke, I saw that the blast had knocked out a post supporting a dangerous piece of roof rock. I immediately began to reset the timber and had just got the post and cap-pieces in position, ready to drive in a wedge to tighten it, when the roof caved in. I was buried. I learned later that about two tons of rock had fallen on and around me.

A nearby miner heard the noise of the falling rock, called for help and began freeing me from the rock that had me pinned to the floor. This took only a short while, and I was soon put on a stretcher and on my way to the surface. The manager was notified and wanted to ship me to a hospital right away, but I told him I would be all right once I got a hot bath and a rest. I stood on one leg and bathed myself, then the pitboss drove me to my tent about a mile away from the mine. I lay on my cot until my tent-mates came from work at four. While lying there, the numbness began to wear off and I began to feel my aches and pains. I didn't feel like going to the cookhouse for supper, so I asked one of the boys to bring me back a flask of tea and a couple of sandwiches when he returned. I thought that with a few days rest I would recover and soon be back to work. As it turned out, after lying in the tent for two days and nights I began to feel worse and asked my mates to tell the manager to come and see me. I told him that the pain was getting worse rather than better, and that perhaps I should see a doctor or go to a hospital.

The hospital was at Edson, about sixty miles away. As there was no ambulance available, it was arranged that the CNR Continental Flyer would be flagged down at three o'clock the next morning, and I would be put on board. When it was due, I was carried on a stretcher to the depot to wait, and I lay there for about half an hour shivering like an aspen leaf. Even in June the high country can be quite cold, especially when one is weakened by injury. Imagine my feelings when the train pulled in, the baggage car doors opened, and I was loaded on the floor like so much freight. One episode of this journey that I shall never forget was the conductor bending over me and asking for my fare. My wallet was in my pocket and I asked him to take it out and get the money. By that time I was too sick to worry about tickets or money. He did so, stuffed the wallet in my pocket and pinned the ticket to the blanket covering me—I was now a paid-up piece of freight on the CNR. I wonder if the railway employees saw so much misery that they became callous and didn't see the plight of a fellow human being.

The ambulance was waiting in Edson and I was whisked to the hospital in a matter of minutes. I must have shown signs of distress, because the first thing I remember was a nurse asking if I would like a cup of tea. That tea really hit the spot, and even today I remember it with gratitude. I was given a sedative and when I next awoke it was mid-day and I was in a warm bed. I was given an examination by the

doctor, who told me that I had no broken bones, only torn ligaments and muscles. The healing process would be slow and I could expect to spend time in the hospital.

The hospital in Edson was run by the Sisters of Service, an order of the Roman Catholic Church. The care I received was the best. I suspect that the staff gave me some extra attention because I did not have any visitors. Their kindness was some compensation for the behaviour of the train conductor, which had stuck in my craw.

Once the pain had been alleviated, my stay in the hospital was not unpleasant. In fact, compared to the jungle of the world outside, it was heaven. I was receiving compensation of forty dollars a month and, as my wants were meagre, I was able to send a good share of this to my parents. Then fate struck again. Eight weeks after going to Edson, I was downtown in the barber's shop having a haircut and suddenly became violently ill. I was still using crutches and got back to the hospital as quickly as possible. I lay on my bed, vomiting most of the afternoon. The nurses tried to get the doctor, but he was on his rounds of the Coal Branch, an area of coal mining camps on a spur line southwest of Edson.

He finally came about midnight, examined me, then announced that I had acute appendicitis. I had my appendix out the next morning, and after ten days the stitches were removed. I knew I wasn't fit to go back to mining and planned to go home until I was strong enough to do hard work again.

After retrieving my baggage from the mine at Hinton, through the kindness of the doctor who gave me a ride while he was on his rounds, I finally said good-bye to the staff, expressing very sincere gratitude and left on the night train for my home.

FAREWELL TO FARMING

I arrived at Mannville at seven o'clock in the evening and took a walk around the village to see if there was anyone from my district on the street. As our farm was nine miles from town, I hoped to get a lift. One chap was able to take me within three miles of home. It was eleven o'clock when I reached our farm gate, tired from the trip and from lugging my suitcase for three miles. I crawled through the barbed wire gate, and suddenly an ugly-tempered collie had me at bay. This was a new dog father had acquired. I was a stranger to him and wasn't making another step in face of his menacing attitude. The house was three hundred feet from the gate, so I just stood and shouted for all I was worth. Then suddenly a lamp flickered in the window and I was home.

When I had been hurt I had written to my parents saying I had sprained my ankle and, there being no facilities at Hinton, I was going to hospital for treatment. But after eleven weeks this excuse began to wear a bit thin. When all the welcome-homes had been said and we were having a cup of tea, dad commented dryly about my "sprained ankle"; I hadn't fooled him.

The money I had sent had been put to good use—there were two more heifers for future milking stock, a flock of turkeys was nearing marketing stage and Dad had bought a second-hand hay rake and wagon box. He had put up a good supply of hay, broken more land for seeding next year and cleared ten acres ready for the plough. The

whole family had worked hard since I left them early in the year. Father didn't look too well, and mother was very thin and looked as though she hadn't been getting enough to eat. But the children, while being thin, were healthy and as tough as willow wands.

However, the crop was not too good. The wheat had been touched by early frost which would mean a lower price. Even the top price of grain on the market was far below the cost of growing it. This was a bleak appraisal and I had no answers. We would need every dollar to get through the winter.

I got a job stooking, although I shouldn't have been doing such work; I had to convalesce the hard way. I continued until the threshing was completed and again poured most of my earnings into the "blind gobbler" of a farm. Even then, the returns from our place didn't cover the cost of production. Father got twelve cents a bushel for his wheat, but it cost nine cents to thresh it and a cent a bushel for twine, to say nothing of seed, feeding horses and machinery repairs and upkeep. It was a hopeless situation.

Father still had the turkeys to sell and hoped they would bring cash into the kitty. We killed fifty birds and stayed up all night dressing them; we even pulled out all the pin feathers with pliers to make a first-class marketable product. We packed them in cardboard boxes, wrapped them in blankets to prevent them from freezing and set off for town. The buyer, from the Pat Burns Company, looked over our turkeys and said the top price was eight cents a pound. For those with a crooked breast bone or over twelve pounds, he would give us six cents a pound. I was so mad at his attitude that I told him he wasn't getting any of my birds at six cents. He just turned his back and said take it or leave it. The result was that I threw fifteen turkeys back into the wagon and sold the other thirty-five for less than a dollar a bird. To fight this situation was as effective as punching a pillow.

This was our experience in everything. When we were successful in raising a marketable crop, whether it be grain, animals or fowl, the price was so low that we lost money. My wages were going into a bottomless pit and showing no results. During the following winter, conditions became so desperate that father had to apply for relief, as did most of the Hudson's Bay settlers.

Father had to clear the brush from the rights-of-way of municipal roads for a food voucher. A twenty-dollar voucher was based on cutting, piling and burning the brush on a right-of-way half a mile long

by sixty feet wide. Even though he worked for it, father was made to feel as if this were charity. They didn't think that the municipality was getting roads at bargain prices. We all worked on the road jobs as they had to be completed before the food voucher was issued. Such was the charity of the depression years.

One day two men on horseback called at the house and asked to water their horses before travelling on. In true western style, it being near noon, mother asked them to stay and have lunch. She had bread and butter on hand, but only one egg. Being resourceful, she boiled the egg, added a bit of onion and made sandwiches for the visitors. The family sat at the table and had only a cup of tea saying we had just had lunch. We were too proud to let it be known that our guests were eating the only egg we had. After they left, we had a meal of potatoes and bread.

I remember one day when the thermometer was registering fifty below, father scraped a layer of ice from the inside of the window; and, putting one eye to the peephole he had made, said to mother, "It's a lousy country we have come to hinney; wooden houses, tin chimneys, paper money, nay insurance men and woodpeckers for callers." This was his humorous way of comparing the life style of Canada against the one he was used to in England. In spite of the hardships they faced, I never once heard one word of regret at having left England.

I set off on my usual winter job hunt at the coal mines in the Edmonton area. As usual, I had little money. The first few nights I slept on the floor of the Immigration Building with fifty other men. If I could find a place to sleep, I could manage on less than five dollars a week. One Chinese café near the CNR station had a three-course meal advertised for a quarter. I availed myself of this once a day. The meal included soup, ground beef, potatoes, carrots, pie, coffee and all the bread one could eat.

Every day I tramped out to the various mines in the area. All were working, but all were fully manned.

My excursion that winter proved fruitless, so I returned to the farm hoping I would find some winter work where I was known. I did manage to land a job with a farmer for the grand sum of five dollars a month and board. This barely kept me in mitts and socks, but it was one mouth less to feed at home. I worked ten hours a day doing all the barnyard chores, plus caring for fifty head of cattle that were wintering in straw stacks. These had to be fed and watered twice a day.

As I was not too far from home, I would spend most of my free time on Sunday with the family helping where I could and doing jobs that father was unable to do. As spring approached the supply of meat began to run low. They had been catching a few rabbits in traps and snares. Guns were no longer kept on the place. The rabbits helped, but a steady diet of rabbit left a lot to be desired. One Sunday my brother, Fred, and I were out walking on the quarter adjacent to ours, when we heard a rumbling sound like muffled thunder. As we came closer to the sound, we crawled on our bellies in the snow as we didn't want to startle whatever was making the noise. On a slightly higher piece of ground were nearly a hundred prairie chickens doing their mating dance. So intent were they on the business of the moment that our presence had no effect. They danced in a regular circular path with a diameter of about seventy-five feet. It was a carnival scene. They stamped their feet, puffed out their chests and made a drumming sound by beating their wings rapidly.

Seeing the regular pattern of their walk, I judged that they could be caught in traps. Fred and I returned home to get some traps. We set them on the well-beaten path the birds had made then waited until morning. As I had to work, the job was left to Fred. The family had fresh prairie chicken as long as the mating season lasted. Conservationists of today would shudder at this practice, but they aren't hungry.

I worked that summer for the going wage, which was thirty-five dollars a month and board, did the threshing in the fall and tried the mines again without getting a job. However, that winter a fellow came into the district with a well-boring machine and I got a job with him at three dollars a day and board. This was a bonanza! My principle job was to go down the two-foot diameter hole when the auger encountered a rock, and clean it out. Not too many men relish going down a two-foot diameter, one hundred feet deep, hole with no cribbing; but this was fine for me as it made a more comfortable winter and gave me a good start in the spring.

As the depression continued, farmers cut back on hiring summer help and work was becoming more difficult to find. Hired hands were staying on farms for their board in the winter months to be available for spring work at going wages. In the spring I hired out to a farmer who had no money, to work for him for five months for one-tenth of the crop. I had to take the same risks as the farmer as to both yield and market price. We worked well together. When it rained, I rejoiced; when

it was dry, I worried with the farmer. He milked half-a-dozen cows to provid a weekly cream cheque which kept the house in groceries. I was able to get an advance of a couple of dollars from this source once in a while for small items I needed. Cash was certainly a scarce commodity.

I finished my term with the farmer and went threshing for twenty-eight days at four dollars a day. At the end of the threshing season, I called on the farmer to find out how much money was due me for my five month's work. I was shown the threshing bill—this verified the quantity—and the elevator slips on grain sold to date—this verified the price. When it was tallied, my share came to $168.00 or $33.60 a month. I had received an advance of $14.00 during the summer, indicating I hadn't painted the town red that year. My total earnings from April 1 to November 20 were $280. One thing I didn't have to worry about was income tax.

I didn't know it then, but for me this was to be farewell to the farm and farming. I had spent five years there, and had nothing to show for them but heartache. There had to be a better life somewhere in this bountiful land. With these thoughts in my mind I set off on the road in quest of work.

I was not to see the farm again for forty years, and then only on holiday when I took my wife to see where I had tried so hard to start a new life with my family. She, who had been born and brought up on a farm, looked and could see clearly why we finally gave up. She knew no one could have made a living on that place, and nobody would have taken it as a gift. She wondered why we had tried so long and hard before leaving.

I also discovered that someone had tried to farm our quarter after our family left, but had given it up. When I visited the farm in 1976, nature was beginning to reclaim the land. New poplar groves were growing where none had been before, scrub willow was flourishing around the sloughs which were plentiful as the water table was much higher than when father farmed it. The house and barn were still there, but in ruins. These relics, and a carragana hedge, are the only reminders that a family lived, hoped and dreamed there.

MINING ON A SHOESTRING

In that winter of 1933, Edmonton hadn't changed. Thousands of men were jobless, and hundreds were on the move; all hoped to find work at any price.

I hoped that with so many mines in the area I might eventually get a job. The steam coal mines of the Coal Branch worked winter and summer, and therefore had a permanent work force, so there was little chance of work there. My best prospect was in the seasonally operated mines of the lignite field.

After two weeks of job-seeking I met two chaps who were working in a small mine and they thought I would be able to get a job there. Andy, the older of the pair, 120 pounds and short and wiry, did the talking for both of them. He was married with one daughter. Fred, the exact opposite to Andy, was six feet tall, weighed about 170 pounds and was all muscle. He was taciturn, single and had made his home with Andy for years.

Fred had a car and we drove to the mine about twelve miles north of the city. I met the manager and was hired on the spot. This was unusual and I wondered what could be wrong. It seemed I had got the job too easily. When I saw the mine, I realized why; it was the most decrepit coal mine tipple I had ever seen. I looked at Fred and Andy, then at the structure, and all I could say was: "Does it work?"

The mine was in the once-flourishing mining camp of Cardiff, now almost a ghost town and only a shell of its former self. A few scattered houses were all that remained of a bustling community. Some were empty; others falling down. A few were occupied by old-timers living with memories of "the good old days."

The operator had spent his savings on acquiring the lease and repairing the tipple, in the hope of earning enough to live through these troubled times. Although he was the owner, he was as hard up as his crew of five. This was a hand-mining operation, the owner being hard-put to supply shovels let alone machinery. It was truly "gopher hole mining."

Andy's family was in a rented house in Edmonton. We couldn't afford to commute every day, so we had to find a place in Cardiff. As Andy had to pay his rent and support his wife and daughter, and Fred had his car to maintain, we agreed to pool our wages and rent a shack in Cardiff for five dollars a month. We stayed in Cardiff during the week and went to Edmonton at the weekend for supplies.

We equipped our shack with mattresses, a couple of benches, and a rough home-made table and obtained some dishes and pots and pans from Andy's house. All we needed was a stove, and we would be ready to "bach." We bought one for five dollars from two old ladies living in Cardiff. These two women were well on in their sixties, having spent most of their lives in Cardiff. They offered us all a glass of whisky, and seemingly wanted to talk, directing most of their conversation at Andy and Fred. I guess I was just a youngster in their eyes. They talked of Cardiff in its heyday when it was a bustling mining camp. In the course of the conversation one old girl quite casually remarked, "In the boom times I used to have six girls working for me." I nearly blurted out, "Why did you need that many to take care of a house this size?" I held my tongue as it dawned upon me that she had been a madam and had run a bawdy house. I was certainly the country bumpkin. The conversation continued as if nothing untoward had been said. She had mentioned the incident as casually as talking about the weather.

The work at the mine was of a hit-and-miss kind. The storage capacity was small and there were only five mine cars. We were paid by the ton, but could only work when there was room to dump coal into the storage bin. Our working place in the mine was kept full of loose coal ready to be loaded as soon as our mine car was emptied. The five-man crew went to work every day and waited patiently for

someone to come and buy a ton of coal. We would sit in the mine shed and listen for the squeak of sleigh runners indicating a possible customer. One day the boss told us he had finally got a contract to supply the Moose Hall in Edmonton with fifty tons spread over a two-week period. This contract, plus the local sales, enabled the three of us to get through the winter.

Our wages varied due to the intermittent type of work, but we averaged about fifteen dollars a week. Andy's wife, by careful shopping, would buy enough meat to bake pies for us to take to the shack, making a little money go a long way. One thing we had to make sure of was that we put aside one dollar for gas for the car. By pooling our resources, four adults and one child managed to live fairly well.

The winter was nearing its end and soon this shoestring operation would close for lack of orders. I had made enough to live on that winter, but was unable to send my parents any money; their circumstances always concerned me. I intended to go back to Mannville to do farm work where I would be able to keep an eye on my family. I had written several letters to acquaintances asking them to let me know if they heard of any openings in the mines they worked in. Just before the mine was to close, I received a letter from Tommy Levison, a Hudson's Bay Settler who had quit the farm the first winter and gone to the coal mines. His letter informed me that there was a job for me at the mine at Wabamun if I could get there in three days.

I lost no time in packing my few belongings. I regretted leaving Andy and Fred. We had lived in each other's pockets for four months, and it was only through our combined efforts that we had managed to get through the winter without too much hardship. As I left them I told them I would keep in touch and let them know if there were any jobs available at Wabamun. This was one way the mining fraternity were able to help each other. Again I was saying good-bye and, being the nomad, I wondered if I would ever find a place that I could call mine. I yearned for roots, and hoped to find them over the next hill.

AT LAST I PUT DOWN ROOTS

In the spring of 1934 Wabamun was a sleepy little village. Situated forty-five miles west of Edmonton, its only claim to fame was its proximity to the beautiful lake from which it took its name. It was a simple place to live. There were no sewage or water systems, wells and out-houses took care of these matters and coal-oil lamps provided the lighting. At least we didn't have to worry about month-end utility bills. There were two general stores, a garage, a pool room and a hotel; the rest of the town was made of scattered private dwellings of all shapes and sizes. The name Wabamun was adapted from the Indian word meaning mirror, and aptly described the lake on a calm day when the reflected shoreline could be seen clearly in the waters.

The town owed its existence to the nearby coal mine which employed fifty men, and to the seasonal fishing industry which produced half a million pounds of whitefish a year. In addition, for a short time each winter, the Arctic Ice Company used the lake to harvest tons of ice of the finest purity. That ice was so clear that one could read a watch through an eighteen-inch block.

There were farms in the area, but few were self-supporting. Many of the farmers augmented their income by working in the mine, fishing or cutting mine props. My hopes were to find a place where I could earn a living throughout the year. Any dreams I had of making a life on a farm had long been squelched by past experience.

Upon arriving in Wabamun, Tom Levison and I walked the two miles to the mine to see the manager. He asked about my mining experience, at the same time sizing me up as if I were a horse on sale. At least he didn't feel my muscles or ask to see my teeth. He should have done that to complete the interview. After a bit of humming and hawing he said he'd give me a job, but only on the condition that I stay single. I was astounded at this effrontery; but I was also desperate. This indicates how grim were the times when such a condition could be laid down before getting a job in a coal mine. The reason for this qualification was that the company kept a bunkhouse for single men and a cookhouse, run by a Chinese cook, with the agreement that there would always be a minimum of ten men eating in the cookhouse. Apparently the number using the cookhouse had dropped to nine and this was the reason I was hired. I was given a room in the bunkhouse, which contained a single bed and a clothes closet—a much better arrangement than the bunkhouse at Dinant.

Although this was a lignite mine, it differed from any of the prairie mines in that the company had some industrial contracts which enabled the mine to work fairly steadily in the summer months. The majority of the work force was married, some having their homes in Wabamun, and others had houses of sorts near the mine. Although it was a small operation, it had an air of permanence about it. Here families had their homes, and their children attended the village school. It looked like a place where one could plant roots.

The mine was entered by a level tunnel in the side of a hill. A steam plant provided power to operate the winch which hauled trips of coal out of the tunnel. A screening plant and a bathhouse, where the miners showered and changed clothes, completed the surface installations. A spur-track, connected to the main line, provided the means to ship coal in car-load lots to the market.

The seam had a unique geological formation. It was nine feet thick and level, there being no dips or inclines of any consequence. Instead of being overlaid by shales and sandstones as most coal seams, the stratum next to the seam was composed of gravel beds forty to eighty feet thick. To maintain a stable roof, only seven feet of the seam was mined. Shortly before I had arrived at the mine a workman had been killed by a cave-in, and eyewitnesses said there wasn't a bruise on him; he had been smothered to death by fine gravel and sand. It was most important to keep the two feet of coal at the roof well timbered; if this shell were broken, the sand and gravel above would run like water.

The system of mining was the room-and-pillar method or pillar-and-stall method; again the coal was produced by hand. This was the fourth mine I had worked in Canada and none had any face machinery to aid in coal production. With hand labour being so cheap, and able to satisfy the market, mine owners had no need to spend capital to mechanize their mines. The rate of pay was fifty cents per ton. Nothing was paid for timbering or laying track; this work was included in the tonnage rate. By working hard, a miner could average five dollars a day, and working four and five days a week provided a comfortable living. My total overhead was only a dollar a day board, and a dollar a week for the bunkhouse. The most important point was that the mine worked in the summer and that meant I could stay in one place. I was tired of the hit-and-miss kind of life I had been living and yearned to belong somewhere.

Joe Wong, our cook, was quite a character and had a keen eye for women. His two favourite pastimes were getting drunk in Edmonton on weekends, and talking with the bunkhouse boys about women. He particularly liked looking at pictures of movie stars. Often, when preparing a cake for the next day, he would take a mixing bowl in his arm, spread out movie magazines on his work bench and parade back and forth beside the bench, beating the batter as he examined the pictures. My job was to turn the pages for Joe as he paced and stirred. A typical conversation went like this:

"How about Jean Harlow, Joe?" He took his time looking at her picture as I pointed to it, and then with a gleam in his eye judged, "Oh boy, nummer one." To Betty Davis he responded, "Nummer flee," and to Marie Dressler, dressed as Tugboat Annie, "Jees Klisee! She nummer fitty." Joe was a good friend and typical of the light-hearted men from all over you would find in such bunkhouses.

Toward the end of the summer the mine went on slack time, and we began to work only two days a week. This was barely enough to meet expenses, but I hated to give it up for something that might be worse. So I stuck it out in the hopes that the winter would bring more work. But this slack time compelled some of the men in the bunkhouse to leave, thereby reducing the men eating in the cookhouse to less than ten, the viable number. After a few days of this it was announced that the cookhouse would close. This also meant that the bunkhouse would no longer be used, and the men would have to find lodgings elsewhere. In spite of the conditions laid down by the mine manager on my being hired, circumstances took away some of the power that allowed him to dictate how a man had to live his private life.

I found lodgings with Mr and Mrs Jack Andison, an elderly couple who lived in the village. They were very kind to me, treating me as a member of the family. It was they who encouraged me to build a house of my own. I bought two lots in the heart of the village for twenty dollars each. The next question was how to get a house built. Jack Andison was handy with tools and he offered his help and advice, if I provided the materials. I explained to him that all I needed was guidance. I would do the work if he told me what to do. Fortunately, the owners of the mine also owned a lumber company in Edmonton. They were willing to give me credit. My only credit rating was that I worked at the mine; my payments would be made by payroll deduction. I made a list of material required to build a two-room house, twelve feet by twenty-four feet.

That building was my first real possession. It was small; but it was mine. Because there were no services in the village, I got water from a neighbour's well, and a hole in the ground with a "one-holer" served the little dwelling adequately. I managed to get a bed, a dresser, a stove, a couple of chairs, a table and, with a bit of scrounging, enough dishes and pots to let me go it alone. My early attempts at cooking were a disaster; when Andy and Fred and I batched at Cardiff it was Andy who was chief cook. My contribution was doing the dishes and taking out the garbage. But now I was on my own and I had to eat my mistakes. My salvation was bacon and eggs. I was fortunate that I liked them because they were my mainstay.

As a property owner I was part of the community, and I found it a most rewarding experience after so many blank years. I was able to meet people with many interests, including music. My parents had given me lessons on the piano for nearly three years when I was ten years old, but since coming to Canada I had no opportunity to play. A group of four fellows got together and formed a dance orchestra. Our drummer, Fraser Kerr, had a piano at his home and this is where we did our practising. This four-piece band comprised of Ted Lee on saxophone, Ira McKeever, violinist and Fraser Kerr on drums; I played piano. We were known as The Revellers and were quite popular in the district. In fact, we were booked for Friday and Saturday nights for months ahead. I could earn two dollars a night with the orchestra. Many times this money bought my groceries when the deduction from my pay for lumber left me with nothing to draw—which happened frequently before I got the house paid for. I always said that my piano playing helped to pay for my first home.

Being a resident of the village, I became involved in reviving the defunct tennis club. The company donated cinders from the boiler plant and a group of volunteers spread, raked and rolled them, which provided another activity in the village. A soccer team was formed in which I took part, so I was leading a full life for the first time since coming to the country.

That winter my friend Andy got a job at the mine. He didn't want to move his family from Edmonton because his daughter was enjoying the school she attended, so he came to live in my house. Andy was a good cook and that was a load taken off my shoulders. At this time I was working the afternoon shift and Andy was on day shift. I used to get home at about 1:30 a.m. and Andy would get up and have tea with me at that time. If the mine was going to be idle that day, we would stay up and do our laundry, hang it out and then go to bed getting up when we felt like it. This raised a few eyebrows among our women neighbours. It was unthinkable that two bachelors should be the first to have their washing out on the line on wash morning. They put a lot of stock on this small thing. But no matter how early they got up to beat "those bachelors," they never made it. When they looked out, our laundry was always waving in the breeze. It finally dawned upon them what was happening, and that put an end to the prestige of early morning laundry.

The mine worked steadily that winter. I paid for my house and the few furnishings I had and still managed to send a little money to my folks. In the spring we got news that gave us a lift. The manager told us that if the men would agree to accept a reduction of five cents a ton, the company would have a very good chance of obtaining the Saskatoon Power contract. Anyone who came with a request like that today would be thought crazy, but, in those days, the importance of that contract to the miners could not be ignored. If we got the order, the mine would work five and six days a week all summer. If not, the outlook was for one and two days a week.

We had a meeting of all the men. This wasn't a union mine—we controlled our own affairs. After hearing all the pros and cons, we voted to accept the reduction and hoped that it would allow the management to put in a successful bid. The men at the mine were mostly married men with families, and it was not difficult to see them opting for a little less per day in the hopes of a larger weekly pay. We waited patiently for the opening of the bids at the end of March, but the results were disappointing. We lost the bid to a cooperative mine in Drumheller. I

heard the bid was ninety-eight cents a ton FOB the mine. With this news, we resigned ourselves to a slack summer of work. I had a stake in this community; and, rather than hit the road again, I was determined to stick it out in this little village. I felt that if the married men could survive then I certainly could, being single and having no debts.

A WEDDING WITHOUT BELLS

Wabamun was a nice place to live. I had made many friends and I had no desire to work on farms again. Circumstances had put me back to mining; so I thought if mining was to be my life, I would try and go to the top—I would study for a first-class certificate. This was an ambitious goal; most mine managers were products of universities or mining school, but I knew that if I didn't try I would be forever unhappy at my job. I think it was the stimulation of study and the hope of someday improving my position that made the work tolerable. It was in this frame of mind that I enrolled in the Bennett College in Sheffield, England, on a complete correspondence course in mining engineering.

I got down to business in earnest when five large textbooks and six lessons arrived. I could mail them as they were completed, but the new lessons were in batches of six. The lessons I sent were marked and graded by percentage, corrected and returned to me. It was a thorough course and a good arrangement. A student could study at his own pace. After a few lessons I decided to try the Alberta third-class examination. I submitted the application and was notified to appear before a board of examiners. After a wait of three weeks I was notified that I had passed the examination, but a certificate could not be issued to me until I had completed the course in mine rescue. There were no facilities in

Wabamun to take this training and I could not afford to travel to Edmonton every week to avail myself of the training station there. But I did have the satisfaction of knowing that I had at least passed the first hurdle in the study of mining. As time permitted I continued my studies even though I was held up on the third-class certificate.

The year 1936 began the same as the previous years; the economic blight still plagued the land. To make matters worse, God seemed to have forsaken the farmer, for in these depression years the rains across the prairies had been far less than normal. It was at this time that many families in the dust bowl area of the plains simply abandoned their farms and trekked to greener pastures. These were the conditions that influenced a man's thinking, and tempered his character in this furnace of adversity.

One fellow in Wabamun had lost his wife some months before, leaving him with two small children. His only way to handle the situation was to obtain a full-time housekeeper. He told us he was expecting a housekeeper to arrive on the train and like most small villages, meeting the train was a common pastime for those who had nothing better to do. The evening the new housekeeper was due, some of us younger ones were overcome by curiosity and were at the depot when the train pulled in. Of course, not wanting to appear too obvious, we stood at the side of the building and peeked around the corner to see the woman alight. We had expected an older woman but did we ever get a surprise when the woman who stepped off the train turned out to be young and nice looking.

I was invited to a bridge party one evening and when I entered the house the first person I saw was the new housekeeper, Dorothy Riddoch. We were introduced and before the evening was over I made arrangements to see her again. She was a tiny person, less than five feet tall, and weighed less than a hundred pounds. But what she lacked in size, she more than made up for in spirit and grit. She came from sturdy Scottish and Irish pioneers, her grandfather having homesteaded in the Lacombe district of Alberta in 1898. Her mother was a pioneer school teacher from Nova Scotia who had come west to teach in the little red schoolhouse of the prairie. Her great-grandfather on her mother's side was the builder of the largest wooden ship ever built in Canada, the *W.D. Lawrence*, built at Maitland, Nova Scotia. She had been born to her parents' homestead, and was no stranger to hard work and frugality.

We continued to date for a time. Our dates consisted mostly of talk, about ourselves, our lives, our families and our future. By this time, the mine had gone onto two days a week and there wasn't much money about, but we talked of marriage. I had been thoroughly brainwashed by the plight of my parents and had a feeling bordering on a phobia over poverty. The more we talked about marriage, the more desirable it became and, as many others had done, we believed two could live as cheaply as one. Then one day we decided to take the big step. We carefully worked out our finances, and agreed that if we had a quiet wedding we could be married in June.

We decided to have a civil wedding and asked Andy and his wife and another couple to be our witnesses. I obtained the license and set the date for June 8. On that day we were married in the legislative building in Edmonton by Mr Mackie. I was twenty-eight and Dorothy was nineteen; old enough to understand the step we had taken. Mr Mackie said to us as we were leaving words I have never forgotten, "Although you have not been married in God's house, you have been married in His sight, and I wish you both a happy life together." When people ask me where we were married, I tell them that we were married in the largest church in Edmonton. After the wedding we had a small dinner party at a restaurant. This was the highlight of the day, because a fairly expensive meal in these times was a luxury few could afford. The rest of the day we spent shopping for some items a woman would need in a home, such as curtains, table cloths and cutlery.

The day following our marriage was a day the mine worked, but this was one shift I stayed at home. Dorothy and I have called this day our honeymoon. It was spent hanging curtains, gluing together kitchen chairs we had bought unassembled and making other alterations that are the delight of the homemaker. We had been married quietly and not too many of our neighbours knew about it. But soon word got around. I was told that I was the last person the neighbours thought would ever get married, especially to a comparative stranger in the village. We were soon assimilated into the life of the village and made friends with other couples. We spent many pleasant evenings in each other's homes, playing cards or just visiting. Being married completed that feeling of belonging that was such a part of my being. We were a part of the village.

Over the next few months I discovered what a dynamo I had married. She was a regular whirlwind at housework. Our little home was

kept clean and comfortable and she could make the tastiest meals without having hundreds of ingredients. She often said, "Anyone can cook if they have everything to cook with, but a good cook is one who can make a meal with a little." I soon found that one didn't have to have a lot of money to be happy. I earned enough to provide the bare necessities, but our happiness was in doing things together and planning our future. We planted a large garden which provided us with more than enough vegetables for a year, and on days the mine was idle we would take a lunch and go berry-picking, getting raspberries, blueberries and saskatoons, which Dorothy preserved in glass sealers. Being a farm girl, Dorothy knew many of the tricks to make a dollar go a long way. I know, in our case, two did live as cheaply as one. There was only one flaw in this most happy time of my life and that was wondering how my family was faring on the farm. I knew they must be having lean times, although my sister Ethel had married and my brother Fred was working odd jobs.

Suddenly that winter our worrying about my family was dispelled. I heard that the mine needed a teamster. That is one who drives a team and wagon and does the chores around the mine such as hauling the ashes from the boilerhouse, freight from the railroad depot, delivering coal to the miners and work of that nature. I spoke to the manager about the job and he said that if I could get father there within a week, with a team of horses, he would have the job. I was delighted. At last here was a chance to get my people away from the miserable existence they had put up with on the farm since coming to the country seven years before.

I lost no time, and within a week father arrived at the mine with a team of horses. He was able to rent a house near the mine for a nominal sum, and within a couple of weeks the family were settled in Wabamun. Father had to sign a "quit claim" document turning the farm back to the Hudson's Bay Company. They were welcome to it! This move proved to be a turning point in the life of my parents in Canada. For the first time since coming to the country, father was able to earn wages. He now knew how much he would be paid for his work, and mother was much happier in knowing she could lay her hand on a dollar once in a while. We were able to help a little and, to make matters so much better, mother and Dorothy liked one another and got along well. Our happiness was complete even though we didn't have much of the material things that are supposed to bring joy.

The job of teamster was to be short-lived. The owner of the mine had a nephew who was on a farm; I suspect he was in the same predicament as my father had been. He asked his uncle if there was any work that he could do around the mine, and the only suitable job for a farmer was that of teamster. To accommodate the owner's nephew, father was told he could have a job in the mine, as the new man would be taking over the job as teamster. There was no choice in the matter.

Father had mining experience and could work underground, but he was past his peak to swing a pick all day. There being no union to question this injustice, father had to sell his horses and take the job offered him. The manager's word was law. If father didn't take the underground job, he could leave. This incident was another in my experience that proved that who one knew was more important that what one knew. Incidents of this kind made labour the militant machine that it is.

The job in the mine returned enough money to provide my parents with a small degree of comfort. Their needs were reduced somewhat when my sister Dorothy was married and left home to make her own way in life. In spite of only one and two days of work a week in the summer of 1937, we all managed to get along quite well without very much money.

That fall my old buddy Fred, from Cardiff days, wrote to his brother Joe, who worked at Wabamun, telling him to come to Vancouver Island. A new mine was being opened up and there would be steady work for him. Joe came to me, showed me the letter and said he'd go, if I'd go with him. I talked it over with Dorothy. We certainly didn't have much in Wabamun, but we did know what we had. If I went to the coast, I would be going without any sure bet that I would get a job, and would spend money we could ill-afford if the journey proved fruitless. Dorothy, being the person she was, didn't hesitate for one minute. She was all for taking a chance on getting another job. I told Joe I was willing to take a chance so we made arrangements to get to Vancouver Island.

It so happened that the CNR had an excursion fare to Vancouver from Edmonton for seventeen dollars return. I figured that if I took my last pay I would have enough to get me to my destination. In addition to train fare, I would require fare for the boat to Vancouver Island, and bus fare to Cumberland about seventy miles north of Nanaimo. Dorothy assured me she could manage with the few dollars that were left for her and I promised to send for her as soon as possible if I got a job. I

had a return ticket and had the consolation of knowing I could return if my trip proved fruitless.

Joe and I set off for the coast full of hope. The move I was now making was to prove a momentous one. It was the last one in my working life.

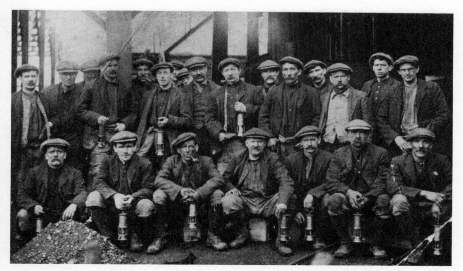

Firebosses at the Ashington Colliery, Northumberland. The man smoking the pipe in the front row, third from the left, is my father, Thomas Johnstone. (Author's collection at BCARS.)

The Johnstone farm on the Hudson's Bay settlement near Vermilion, Alberta. (W. Johnstone photo.)

The Ritland farm near Holden, Alberta, was my introduction to farming in Canada. (W. Johnstone photo.)

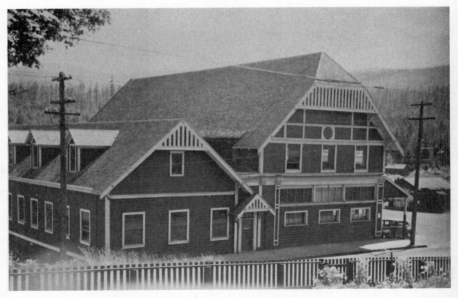

The Company offices at Cumberland where I worked before my retirement. (W. Johnstone photo.)

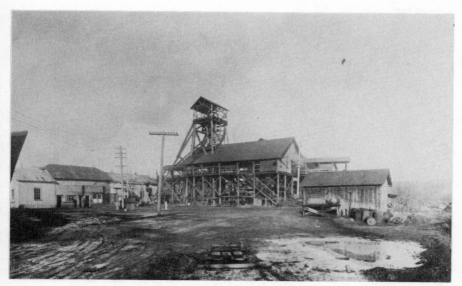

The No. 5 Mine at Cumberland was in full production when I arrived in 1937. It was one of the larger mines in the district and had been operational since before the turn of the century. (Author's collection at BCARS.)

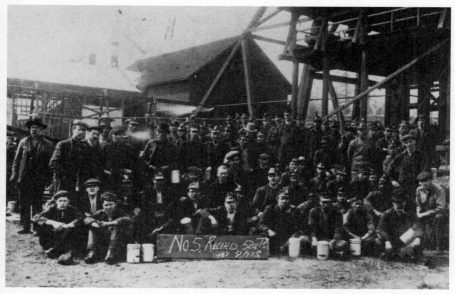

Miners at the No. 5 following record output for their shift. (BCARS 81815 E-3437.)

Ventilation for No. 8 Mine was provided by a huge Sirocco fan capable of moving 225,000 cubic feet per minute. (W. Johnstone photo.)

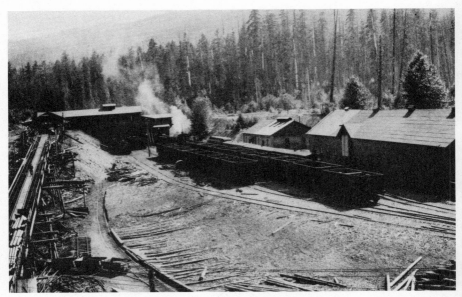

The No. 4 Mine at Cumberland was closed by the time I arrived at Cumberland. It is typical of the earlier mines in the area. (BCARS 88445.)

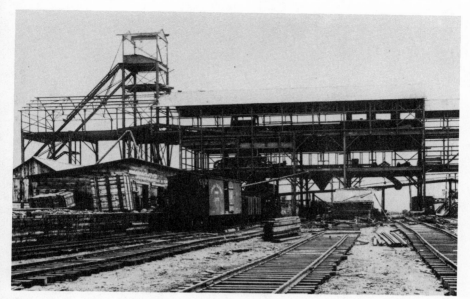

Construction of the head frame and tipple for the No. 8 Mine at Cumberland. This structure contained the screens and other equipment for sorting the coal and loading it into railroad cars. It was located directly above the main vertical shaft into the seam. (BCARS 82199.)

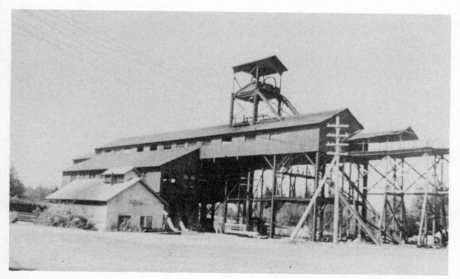

The No. 8 Mine as it looked when I began working in the mine in 1937. (W. Johnstone photo.)

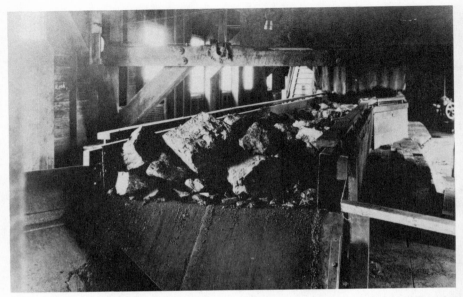

The picking table over which the coal was passed and screened into different sizes. (Author's collection at BCARS.)

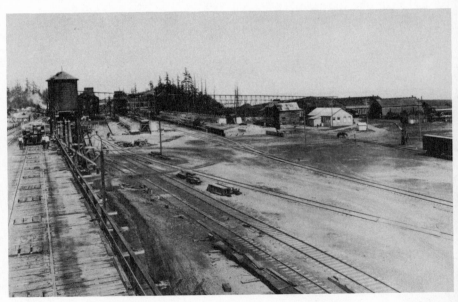

Union Bay, the site of the Company's major shipping facilities. The photograph, taken from the long loading wharf, shows the complex of coke ovens, machine shops, and coal washing plant. (BCARS 81806 E-3428.)

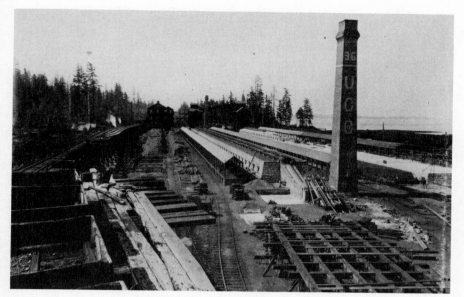

Another view of the Union Bay facilities showing the construction of the coke ovens in the 1890s. (BCARS 57215 C-9008.)

Piles of coal at the Union Bay loading docks. It was here that deep-sea ships came to load coal for markets all over the world. (W. Johnstone photo.)

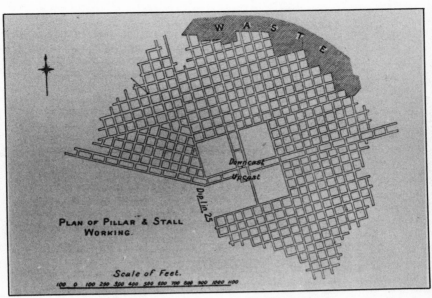

Plan of pillar and stall working of a mine. (From George L. Kerr, *Practical Coal Mining*, Charles Griffen & Co. Ltd., London, 1914.)

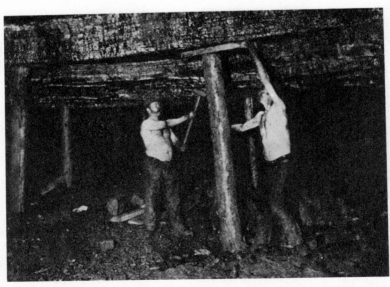

Miners work a pit prop into place in a fairly thick coal seam with stable roof. (From *A Text-book of Coal Mining*, Charles Griffen & Co. Ltd., London, 1904.)

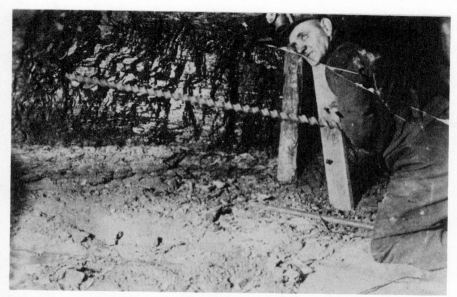

My cousin Jack Holmes, drilling by hand, into the long-wall face in a narrow seam. While photographed at the Ashington Colliery in England, this is identical to scenes in the Cumberland mines. (Author's collection at BCARS.)

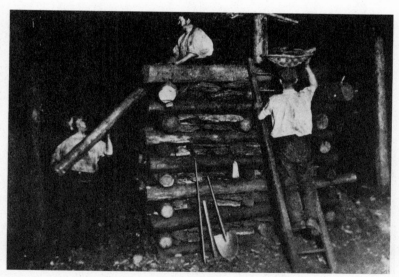

Miners constructing a cog of timbers to support the roof of the mine. The centre of the cog is filled with waste rock. (From *A Text-book of Coal Mining*, Charles Griffen & Co. Ltd., London, 1904.)

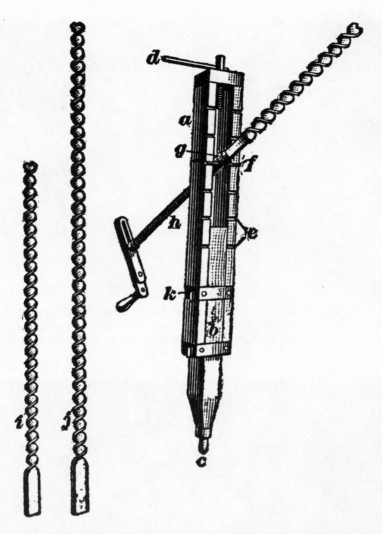

Hand augers used for drilling into the coal seams to set the charges. "The post (a) is provided with a sliding leg (b), shod with an iron point (c), which is inserted in a pick hole in the floor, or if that is soft, into a plank. This leg is easily moved out or in to approximate the length of the post to the height of the seam, and is then fastened to the stationary part of the post by iron pins (k). There is also a small jack-screw at the top operated by the lever (d), by which the post is secured against the roof in any convenient position. The face of the post is supplied with a series of notches (e), for holding a cross-bar (f), on which is supported a threaded split nut (g), through which the feed-screw (h) of the drill passes." (From *Rock Boring, Blasting, Coal Cutting, Timbering, Trackwork.* London, 1909.)

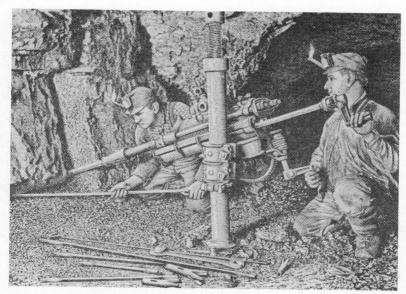

Miners at work on the coal face with hand-operated drills. (From *Rock Boring, Blasting, Coal Cutting, Timbering, Trackwork.* London, 1909.)

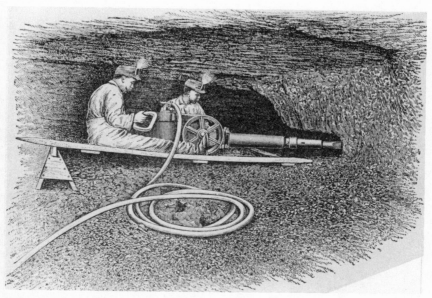

Compressed air cutting machines gradually became more common in the mines. (From *Rock Boring, Blasting, Coal Cutting, Timbering, Trackwork.* London, 1909.)

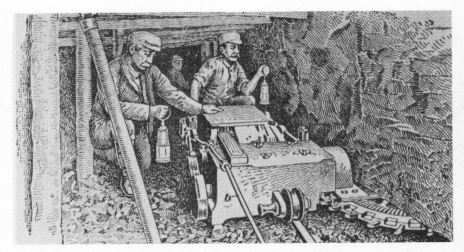

An old disc-type coal-cutting machine was used on the long wall faces. They could cut a kerf seven inches thick and six feet deep in to the coal. Note the arrangement of timbers to support the roof of the workings. (From *Rock Boring, Blasting, Coal Cutting, Timbering, Trackwork.* London, 1909.)

Company houses near the No. 8 Mine. It was into one of these homes that we moved when I started working in the Cumberland mines. (BCARS 81814 E-3436.)

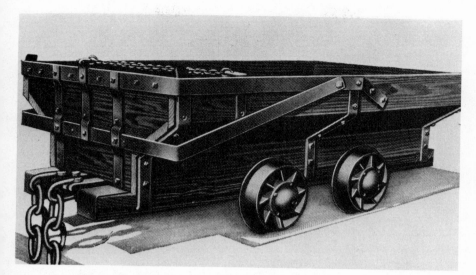

Typical coal mine car. (Author's collection at BCARS.)

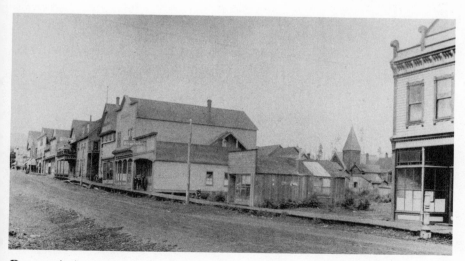

Dunsmuir Avenue, Cumberland, in the early 1900s. (BCARS 41760.)

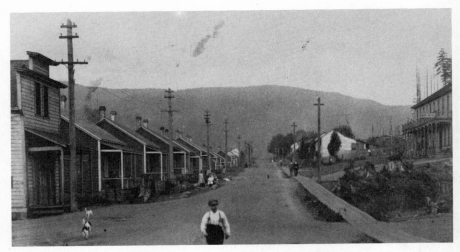

Union Road, Cumberland. The buildings on the left are typical company houses for the miners and their families. The building on the right is The Union Hotel, destroyed by fire in February 1953. (BCARS 41769 B-7605.)

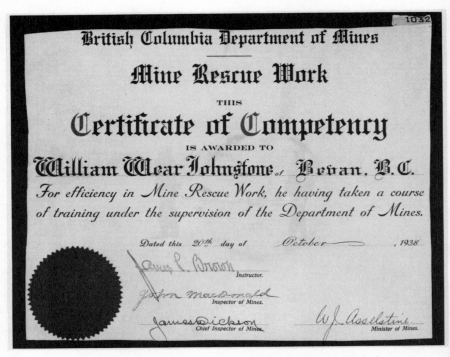

1032

British Columbia Department of Mines

Mine Rescue Work

THIS

Certificate of Competency

IS AWARDED TO

William Wear Johnstone, of Bevan, B.C.

For efficiency in Mine Rescue Work, he having taken a course of training under the supervision of the Department of Mines.

Dated this 20th day of October, 1938

Instructor.

Inspector of Mines.

Chief Inspector of Mines.

Minister of Mines.

My certificate of competency in mine rescue work.

Right: Curley MacMillan and Bob Holmes pose beside a joy loader in the Tsable River mine in 1958. The photo shows the coal seam clearly in the background. Note the timbering used to support the roof of the mine. (W. Johnstone photo.)

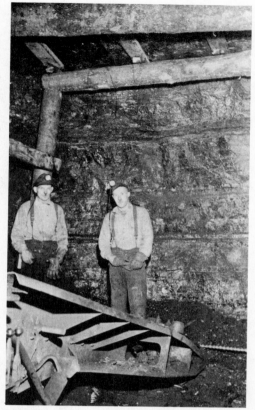

Below: Curley MacMillan and Bob Holmes have just finished drilling holes into the coal face ready for the fireboss to fire shots to blast the coal in the Tsable River mine in 1958. (W. Johnstone photo.)

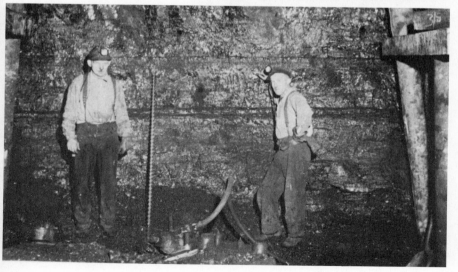

Beaufort House, the residence for the general managers of the Cumberland mines, was built by James Dunsmuir. Eventually it was closed and finally demolished. (Author's collection at BCARS.)

The miners' library and reading room at Cumberland. (Author's collection at BCARS.)

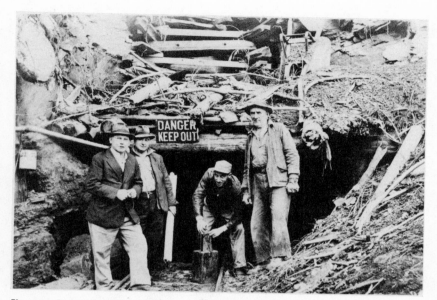

Jimmy Quinn, Bob Strachan, Bill Herd and an unknown miner pose outside the preliminary workings at Tsable River, the last mine opened by Canadian Collieries on Vancouver Island. (W. Johnstone photo.)

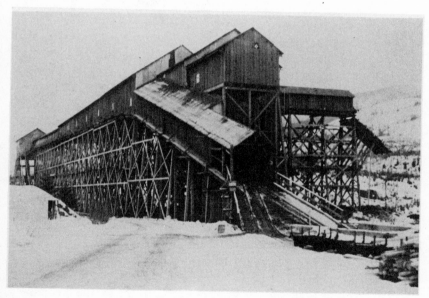

The tipple of the Tsable River mine south of Cumberland. (W. Johnstone photo.)

My wife, Dorothy, and me just before our move to Vancouver Island. (Author's collection.)

With the closure of the mines, I became responsible for the company's assets in the area. Here, I am standing beside my truck during one of my fire patrols. (Author's collection.)

COAL MINING IS MY DESTINY

It was not without apprehension that Joe and I travelled to the coast. We had quit a job that managed to provide a bare living on the chance of getting one that could better our circumstances. The move meant much more to Joe than to me. I had no children to worry about, but he had two boys to support and could not afford to be without work for too long. As the train sped along, I voiced my concern. But Joe was optimistic. I reminded him that the offer from his brother did not include me. Such were my fears; by nature I was not a gambler. I wanted everything nailed down and in order, a somewhat difficult goal in those uncertain times.

According to Fred's letter, our destination was a place called Bevan. We checked maps of British Columbia and Vancouver Island and couldn't find Bevan anywhere. We asked the train conductor about it; he had never heard of the place either. Here we were going to a place that couldn't be found on a map and one that nobody had ever heard of—something had to be amiss. In our anxiety, we began to think that Fred had made a mistake and given us the wrong directions, or a wrong name. Upon arriving in Nanaimo our fears were put to rest. We learned that we had to take a bus to a place called Cumberland; Bevan was a mining camp nearby.

The seventy-mile bus ride to Cumberland passed quickly. Seeing Vancouver Island for the first time was an experience that invited comparison with the prairie scene. The ever-changing panoramic views that

unfolded before our eyes never failed to hold our interest. The sight of giant Douglas-firs with their massive boles crowding the highway, long stretches of sandy beaches, small farms hewn out of raw forest, and an occasional glimpse of the tree-clad Beaufort Range, precluded any feeling of boredom.

It was September 4, 1937, and, after a two-hour journey, we stepped from the bus and saw Cumberland for the first time. We were expecting to see a mining camp similar to many that flourished in the Canadian west; camps built simply and economically, to last as long as veins of ore or seams of coal were viable, and then to silently fade into oblivion. But that image promptly vanished. This was no temporary mining camp we saw; it was a well-established town.

We looked with surprise at the four-block avenue of stores and business establishments, at the wide well-paved street with cement side-walks, where small groups of people were passing the time of day. There were even people window-shopping. It was a sharp contrast to the tiny village of dirt roads we had left behind.

Despite the urge to explore the town, there was no time for such things. We were job-hunting. We were met by Joe's brother, Fred, who drove us to Bevan where my friend and ex-baching partner, Andy, and his family lived. During the hard years of the depression, it was common practice among the coal-mining fraternity who were working to extend a helping hand to those less fortunate. Andy was no exception. He and his wife offered us their hospitality at once. We arranged to stay with them until we got a job, which they seemed to think was a possibility.

Bevan was a typical mining camp settlement. There were fifty houses, a hotel for single miners and a general store. It was the site of the No. 7 mine which, at that time, had been closed for sixteen years. No. 7 had been opened by the Dunsmuir interest in 1902, and there grew up around it a substantial Chinese and Japanese quarter which was completely destroyed by fire in 1922. In 1910, the Wellington Colliery Company of James Dunsmuir sold their coal-mining interests to Canadian Collieries (Dunsmuir) Ltd, who operated the mines at the time of my arrival on the coast.

In 1911 the new company built fifty miner's cottages near the mine. The following year they built a hundred more houses, a large store and a hotel that was large enough to accommodate sixty single boarders. Thus, the hamlet of Bevan was born. The houses were plain and of frame construction with siding on the outside and cedar shiplap

lining inside. Each was supplied with a cold-water tap that served a small pantry equipped with a white enamel sink. There were two sizes: a two-bedroom, twenty-eight-foot square type, and a three-bedroom, thirty-eight feet by twenty-six feet. They were painted white with green trim, and when lived in could be made quite comfortable. Each house had its own sixty by one-hundred-and-twenty-foot lot upon which was built a coal shed and a dry toilet.

As is often the case with coal-mining camps, their destiny is subject to many whims of fortune; Bevan was no exception. In 1918 No. 7 mine was having problems due to deterioration of the seam, which resulted in men being transferred to No. 4 and No. 5 mines near Cumberland. That year, Canadian Collieries moved a hundred houses from Bevan to a newly-surveyed subdivision adjacent to Cumberland. At that time, such a move was quite a feat in logistics. The houses were sawn in half, loaded onto railroad flatcars and hauled onto the site where light spur tracks had been laid. The two halves were joined together, jacked up and placed on foundation blocks and posts.

During the next few years No. 7 mine continued to have problems, which resulted in its permanent closure in 1921. The store and hotel were boarded-up and, except for a few occupied dwellings, the camp was left to the ravages of time, weather and the relentless growth of the west coast rain forest. With the opening of No. 8 mine in 1936, the fifty houses were renovated, the store and hotel were leased to private businessmen and Bevan took on a new lease of life.

The first working day after our arrival, Joe and I walked the two miles to the mine where we met the manager. He asked us about our mining experience and qualifications, and when I told him I had thin-seam experience in Britain, and a third-class certificate in mining from Alberta, he told us to keep in touch and to be patient; there would be jobs for both of us as soon as new places were developed.

Afraid of missing any job opportunities, we made a point of being at the mine every working day. In this we were not alone, for at least fifty men were standing in line. All were on the same errand, which could be expected for the country was still in the grip of the depression. As soon as the manager stepped off the cage, he would shake his head from side to side as he ran the gauntlet of work-hungry men that stretched from the shaft to the office.

After a week of daily visits, I was rewarded one afternoon by a nod instead of a shake. He told me to see the timekeeper and be signed

on the payroll as a machine timberman. The delight I felt at such good news was somewhat overshadowed by the fact that Joe, who had persuaded me to come with him, was not the first hired, and he had to wait for three more weeks before he finally got a job.

When I saw No. 8 mine for the first time I could not help but compare it to the pitheads in the prairies and Britain. It was a replica of many of the surface installations to be seen in England, which was not surprising since it had been designed by British engineers and was equipped with machinery from Europe. The headframe and tipple were of lattice-steel construction with solid concrete foundations, the whole surmounted by a pair of pulley wheels ten feet in diameter. As I looked it over I said to Joe, "This is here for keeps lad. It looks as if it will last our lifetime." He made a gesture of kicking one of the huge concrete bracing blocks, then replied, "It sure feels like it."

I have referred to No. 8 mine as new, but it was new only in the sense that it was now being made productive. While the story of the early development of the No. 8 mine is not part of my life, it is worth recounting as a background for my subsequent experiences. It first began in 1912, shortly after the Canadian Collieries acquired the Dunsmuir interests. At that time, plans to electrify all the mines began. A hydro-electric power plant was built on the Puntledge River to provide power for the mines and the surrounding district. In conjunction with the program, the development of No. 8 began. Previously, all the mines had relied on steam power plants to operate their haulage systems, pumps and other machinery.

Two shafts, each a thousand feet deep, were sunk to the No. 4 seam, the lowest in the Comox formation. While such developments created an air of optimism within the mining community, the instability of coal mining again became evident when, in September of 1912, all the work came to a halt. This marked the beginning of one of the most bitter and violent strikes in the history of Vancouver Island coal mines. It was a struggle that was to last for two years. Whether it was a strike or a lock-out remains contentious to this day.

After a few weeks, the Company opened the mines with such labour as they could muster. The cry of "Scab" or "Blackleg" was frequently heard, and animosities were born that were to endure for decades. In spite of such obstacles, the construction of the hydro-electric project and the sinking of No. 8 shafts continued, and in July 1913, after eighteen months of sinking, both shafts reached their goal.

In conjunction with the building of a new mining complex, plans were under way for a new townsite of seventy-five houses to be built near the mine. Finally the surface installations were completed; two huge electric winding hoists were installed, the main one driven by a 1250-HP direct-current motor. The townsite was completed and all that remained now was for development of the working faces for the mine to go into production. However, it was found that the No. 4 seam at the thousand-foot level had wide bands of dirt in its makeup, making it impossible to mine a clean product. In addition, faulting and distortion of the No. 4 seam proved to be greater than borehole information had indicated.

On August 5, 1914 the bombshell struck. Without any announcement or fanfare, the Company discontinued all operations at No. 8 mine. This was to be no temporary closure, for the cages were taken out of the shafts, the cables were removed from the drums of the winding engines and the shafts were allowed to fill with water. Of the seventy-five newly-built houses in the campsite, only one was occupied, this by a watchman and his family. In addition to patrolling the property, one of his duties was to keep the machinery lubricated and run the winding engines for a short time each day.

The abrupt abandonment of such a costly complex was beyond the understanding of the miners, and the non-mining populace of the district as well. It was reputed to have cost over a million dollars, and to men whose yearly income rarely exceeded a thousand dollars, such things were incomprehensible. From that day forward, No. 8 was referred to as "The Million Dollar Mystery." Shortly after the mine closed, the long labour dispute that had plagued the industry came to an end. The mines at Nanaimo, Ladysmith and Cumberland resumed operations and an uneasy peace settled over the mines, but the settlement had no effect on No. 8.

For twenty-two years the monolithic concrete buildings stood like brooding monuments in the forest clearing. The dwellings of the stillborn townsite showed the ravages of time: broken windows; doorways without doors; here and there, verandahs leaning as though weary, some with young trees thrusting their immature boles through the weather-worn floors. All were a grim reminder of the fickle fortunes of coal mining.

Then, one day in 1936, rumblings of activity were heard about the mine yard. Cables were wound on the hoist drums, cages were suspended from the headframe, compressors were set in motion to provide power for the pumps and the job of de-watering the shafts began; No. 8 was

to be reborn. To provide shelter for the expected work force, a crew of carpenters set to work repairing the houses that had suffered from twenty-two years of neglect. In the spring of 1937 the mine came into production, but with a difference. This time it was the No. 2 seam, at the 700-foot level, that was to be developed, not No. 4 seam, as had been originally planned when the shafts were sunk.

The workmen were transported from Cumberland, via Bevan, to No. 8 by a company train consisting of a steam locomotive and two passenger coaches. The coaches were lined with tongue-and-groove V-joints and painted a dull barn red. Two rows of plain wooden benches ran the full length of each coach. They were hard and a bit uncomfortable, but very practical for dirty pit clothes and even for good clothes if one brought a newspaper to sit on. These coaches bore little resemblance to the cushioned elegance of our transcontinental trains. Such luxury would have been out-of-place and impractical. There were no pithead baths, so the miners brought their pitmuck home with them.

It was not without a feeling of diffidence that I waited for the train that first day. Being a stranger, I came under the scrutiny of the curious and bore the indifference of the stoics as I walked past them to find a seat. In addition to meeting new work mates, I could not help but think of the unknown mine. Regardless of how much experience one may have, each mine has its own characteristics and there are new things to learn. Roof conditions are not the same in every mine, even the texture of the coal can vary. Then there are the company's special rules—rules that satisfy the requirements of a mine and are part of the Coal Mines Regulation Act—and new methods of work, all add to a newcomer's apprehension.

On reporting to the mine office I was handed a brass disc that was stamped with my payroll number. This disc was a small but important part of the record-keeping system. It served as a check against duplicate names and was used to record the number of men underground each shift. The tally was handed to the lampman upon receiving a headlamp and was returned to the miner when he came off shift. This system ensured the number and identity of the underground workers could be established at any time. When I was equipped with an axe, saw, gloves and knee pads—supplies kept at the mine office and paid for by payroll deduction—I was ready to go to work.

As No. 8 was a gaseous mine, open-flame lamps and smoking were prohibited. Before we stepped on the cage, a random search was

made for cigarettes and matches, which served to remind us to empty our pockets of such things before going on to the tipple.

The relatively smooth descent of 700 feet took less than a minute. This was barely time for my eyes to adjust from bright sunlight to total blackness, for even the most efficient lamp fell far short of the light of day. Most shafts in Britain and Europe were circular and brick-lined, but this one was a roomy twenty-two feet by eleven feet and lined with sturdy fir timber. It had three compartments; two were for cages and one for compressed air and water pipes, electric cables and signal lines. All conformed to sound mining practice.

When I arrived at the shaft bottom I was instructed by the shift-boss to wait until he had dispatched the crew. This enabled me to stand aside and survey the surroundings. An eerie blanket of silence covered the shaft bottom at the changing of shifts. The clang of signal bells was the only sound that penetrated the sombre quiet. Even the timbre of men's voices was lost as sounds were carried away in the scudding air current. Then suddenly, as soon as the last cage of men landed, as if on cue, the uncanny hush was broken by a cacophonous clatter; the rumble of minecars, the staccato cough of compressed air hoists and the shouts of mule drivers all blended to end the quiet interlude. With the crew dispersed, coal production began.

The main entry leading to the shaft was sixteen feet wide, six feet high and well timbered. It was lit by electric lights for a distance of 500 feet. Close to the shaft bottom a small room dug out of the solid side of the entry and lined with rough whitewashed boards served as an underground office where the firebosses completed their daily reports and where other records were kept.

About 300 feet from the shaft bottom another opening led to the underground stables. Here were kept the mules and horses used to pull the trains of mine cars from the working places to various assembly points in the haulage system.

These rooms were well constructed. The walls and floors were concrete, fresh water was piped to two troughs and each animal had a spacious stall with plenty of peatmoss for bedding. The animals were well cared for. They were fed hay from the Company's own farms, chopped oats and an occasional treat of carrots. After each shift, a stableman would hose the mud from their legs; and the mine blacksmith attended to their shoes. The stables had electric lights throughout. The myth that these animals were blind when they came to the surface is only that—a myth.

Periodically, the mules and horses were brought to the surface for a spell on fresh grass, while others were taken below on a rotation basis.

There were two methods of mining in the Vancouver Island mines, both dependant on certain conditions. One was the room-and-pillar or pillar-and-stall system, suitable where the seams are thick—six feet or more. The other was the longwall system; this method is used in thin-seam mining. As the No. 2 seam at No. 8 was a thin seam, the longwall system was used throughout the mine.

Entries were driven on the level contour at 300-foot intervals and these were connected by a seam-height tunnel. Once the two entries were connected, cutting machines and conveyors were installed and this became a 300-foot production face. The No. 2 seam was made up of two bands of coal eighteen inches thick, separated by a band of shale varying from one to ten inches in thickness. This meant that the working face could be anything from thirty-seven to forty-six inches high; hence the need for knee-pads; no more rock was removed than absolutely necessary. Rock had to be taken from the entries to provide height for haulage and to compensate for subsidence. These were made ten feet high by ripping the floor to maintain that height.

There are five basic operations involved in extracting coal and getting it to the haulage system—cutting, timbering, drilling, blasting and loading. No. 8 proved to be the first mine I had worked in in Canada that made extensive use of machinery. In fact, it would have been economically impossible to have worked the mine without it, because the coal was quite hard. It was mechanized to the extent of using cutting machines, shaker conveyors, rotary drilling machines for coal and percussive jackhammers for drilling rock.

A cutting machine is a powerful and rugged piece of machinery. A cutter bar armed with a toothed chain, as in a chain saw, cuts a kerf seven inches thick and six feet deep, the length of the bar. Overhead cutting bars were used in No. 9—this enabled the machines to cut out the band of shale sandwiched between the coal. The machine was pulled along the faceline under its own power by a cable-and-drum system, its speed of advance being governed by a ratchet device.

The material from the kerf was deposited on the faceline behind the machine to be removed by the muckers who threw it in the gob, or waste area. While this progressed, timbering also had to be carried out. At the end of each cross-piece of timber that the loader would have set when loading off the previous cut, a post was set by digging down through the cuttings to the solid floor. Top and bottom holes

were drilled the full length of the face, generally four feet apart in the bottom bench and ten feet apart in the top coal. The conveyor was next installed along the face and it was then ready for the loader. The fireboss would blast more as the loader continued to clean up each round of shots. Once the loader shovelled the coal onto the conveyor, his job was done and that was the last he saw of it.

My first job in No. 8 was as a machine timberman. This involved placing a light prop under the overhang cross-piece as the machine worked up the wall. There was a cross-piece every three or four feet, so I was kept busy. Low headroom made the job more awkward, because the machine timberman had to work on top of the cuttings thrown out by the machine. Depending on the thickness of the shale band, sometimes there would only be twenty inches of space between the roof and the top of the cuttings. It was not a job for the inexperienced; it was noisy, dusty and dangerous. I learned later that two of my predecessors were injured on the job, and the manager was hard pressed to find a replacement from his workmen. That was the reason I was hired.

My first day was somewhat inopportune in timing. I was sent to work on a longwall face that had suffered the phenomenon known in coal mining as the first break. This devastating roof movement takes place when a newly opened longwall has advanced to a point where the roof of the excavated area has become so large that it can no longer support itself. At first the weaker shales begin to break and crumble around the timbers, with the thick upper layers of sandstone remaining in position until they too finally begin to bend and break.

As the break begins, a creaking of timbers is heard, then posts begin to split under the relentless pressure and slabs of shale begin to fall from the roof. This is followed by whip-like cracks and hollow rumblings as the sandstone is torn apart. Usually a first break will last for twenty hours. The crushing and grinding stops only when the excavated area is completely closed, or when the roof has met the floor. At such times the object is to try and keep the faceline open to a width of at least three feet to allow passage of the cutting machine. Sometimes this cannot be done, and caving takes place right up to the solid coal.

When the gob is blocked with the fallen debris, there is no place to dispose of the waste cuttings, other than loading them out and hauling them to the surface. This was the situation that confronted me when I first crawled onto the longwall. The machine had only gone about twenty feet up the wall, and all I could see was broken rock, slabs of shale and pieces of timber, both old and new, lying about the cramped quarters.

117

At first I couldn't see any coal, but an old hand, recognizing me as the new man, told me not to worry, and that I would see it when the mess was cleaned up. It took us four days to cut and timber the 300 feet of face, a job that could be done in normal conditions in eight hours. Once over the first break, the roof could then be controlled by systematic timbering. While it is an experience that every miner should have, it is a frightening one, and one that will instill a respect for the forces of nature and an awareness of the dangers that abound in a mine. From this rough initiation into Island coal mining, I always carried with me the thought that things could only get better because they could never be any worse.

The distinguishing feature of the longwall system is that the coal is extracted on each wall as a single operation. The face advancing is an unbroken line with each cut. This requires larger crews than with other systems and a higher degree of teamwork. First in order is the machine crew, followed by the muckers who clear the faceline by shovelling the cuttings into the gob. The muckers are followed by the panmen who assemble the shaker conveyor used to remove the coal eventually loaded from the face. While these operations are going on, the driller has done his job and now the face is prepared for the shot-firer and the loaders. When the cut is finally loaded out, the cycle is repeated.

There were only two developed walls when I started in No. 8 and the machine crews were pushed to keep ahead of the loaders. So, for the first few weeks, I worked seven days a week, which I did not object to. I had experienced too many weeks of one and two days work to worry about such steady employment. I was paid $4.51 per day and working every day seemed like a feast after the famine.

I had been on the job for three weeks when I was notified that one of the rehabilitated houses at No. 8 townsite was available. The Company, in preparation for the influx of new workmen, had begun repairing the forty houses that had been left to the elements in 1914, and now one was ready for me. I lost no time in writing to Dorothy, telling her to make arrangements to move to the coast, assuming that it would be two or three weeks before she would arrive, which would give me time to clean up the mess left by the carpenters and prepare the house for furniture.

One week after sending the letter, my complacency was shattered when I received a message that Dorothy had arrived in Cumberland and was waiting for me to pick her up. To say I was surprised would be an understatement, I hadn't reckoned on her tenacity and resourcefulness.

As it was Saturday evening when she arrived there was little time to make plans. We wanted to settle in our own place as soon as possible, so our friends drove us to Courtenay that evening to try and get some furniture. One merchant in the town, Mr Pearce, would supply furniture without a down payment. All he asked was that one have a job. It proved to be good business because many families were moving to Bevan and No. 8 and, for many, employment was their only asset.

We told Mr Pearce of our situation. I had a job and a house at No. 8, but didn't even have a teaspoon. Without any humming and hawing, he told Dorothy and me to get what we wanted, then we would work out a deal. This was a tempting offer, and seeing all the beautiful furniture was a strain on our collective willpower. However, common sense prevailed, and we kept our purchases to necessities— a new cook stove, a new bed and mattress, a second-hand kitchen suite and the minimum of small items we needed to begin housekeeping, such as two cups, two plates, knives, forks and spoons. These, with a few linens, formed our first order. With Mr Pearce's promise to deliver them on Sunday morning, we left with a light heart for new things to come.

Our total purchases that evening came to less than $150.00, and although it was tempting to increase our indebtedness by getting an easy chair, or linoleum to cover the floors, we were so afraid of debt that we were prepared to suffer some discomfort until this bill was paid. We took stock of our position and found that by careful management we could be debt-free by springtime. I owed my friends two weeks' board money which would be paid on receipt of my next pay. Then, other than the furniture bill, we were all clear. All we asked was that we maintain our health and that the mine continue to provide regular work.

Up to this point, Dorothy and I had had little time to talk, and I was bursting with questions about how she had managed during my absence. I learned that the situation at Wabamun hadn't improved, and that men were leaving the mine in search of work elsewhere. She had been unable to sell our small house and left it in the care of my parents. Between the sale of our meagre furniture, and the produce from our very productive garden, she had managed to scrape together enough money to pay her fare and the freight on a large box containing our smaller household effects and a few other things.

She obtained the box by trading a dresser, knowing that she would need some kind of large container. That box had a somewhat nomadic history, having been built in Britain for the same purpose as it was now

being used. It was four feet long, two feet wide and three feet high. Into this went all our worldly goods—linens, pots, pans, dishes, and last but not least, all the fruit and vegetables that Dorothy had preserved during the year. These were too precious to leave behind. It is not difficult to imagine the weight of that box when loaded to the brim, yet it had to be transported from our house to the railroad depot, a distance of four city blocks. There were no movers in Wabamun and one couldn't afford to bring them in from Edmonton to move a box four blocks. But knowing the resourcefulness of Dorothy that box was going to the coast come hell or high water.

The chap who owned the garage agreed to transport the box to the station for two dollars. Although Charlie hadn't a truck, he did have a heavy car with a large luggage rack on the back of it. One of the four men who came to help, walked around it and noticed the handles on each end. Turning to the others he said, "No problem fellers; we'll have it down to the station in no time." Taking hold of a handle he gave a heave to test the weight, first a gentle tug, then, when nothing happened, he tried with more force, and again the box didn't move. Turning to Dorothy, he cried, "There's no pots and pans in this world that weigh that much. What in hell have you go in it, cannon balls?" When she told him it contained a year's supply of preserves he said, "You know lass, you're not going to the north pole; they have stores where you're going."

After much grunting and heaving, the four men managed to get the box to the luggage rack. They carefully placed it on the car, and to the consternation of Charlie, who was in the driver's seat, the weight lifted the front end of the car off the ground. Finally, after some discussion, they got under way. The trip to the depot was said to be like a funeral cortege. The car was travelling at a snail's pace with three men riding on the hood, Charlie with his head sticking out of the window and my friend Tom walking behind. So delicate was the balance between the men and box that any bump or pothole brought the front end off the ground. But it did get delivered, and the incident was often referred to as the day Dorothy moved THE BOX.

The camp at No. 8 wasn't much to look at in the early stages of its rebirth. It was a typical coal-mining settlement of company-owned houses. Four rows of look-alike frame houses stood in defiance of the elements, their shabby facades attesting to their twenty-two years of neglect. What had once been gravel streets were now narrow trails through the mat of salal, salmonberry and ferns.

Our house, like the others, stood on its own scrub-covered lot. It showed the signs of man's attempt to repair the moil of weather and time. Here and there the underbrush lay flat where workmen's tread had passed by. Small mounds of earth showed through the growth where water pipes and drain pipes lay. The house stood like a forlorn waif amidst the greenery, the patchwork of new boards contrasting sharply with the weather-beaten gray of the old ones.

The inside of the house did nothing to lift one's spirits. Wide boards of cedar shiplap lined every room, their dusky hue only adding to the gloom. The once-painted ceilings of V-joints were ten feet high, lending a cavernous air to the empty building, while the fir floors, now dirty, scuffed and full of slivers, left much to be desired. I expected Dorothy to be dismayed when she saw it, but, shades of her pioneer forebears, she casually remarked that there was nothing there that soap, water and elbow grease wouldn't cure.

The redeeming features of living at No. 8 were many. The Company provided heavy felt building paper, wall paper and paint for each tenant to decorate his house. The rent was only $7.00 per month, the first 30 kilowatts of electricity were free, and there was no charge for water. With such a low overhead, one could put up with some discomfort.

We set to work to clean out the kitchen and bedroom to have them ready for the furniture. By that night we had a habitable abode. Our wants were simple, we were young, we had our dreams, our health and each other. In looking back, it was one of the happiest periods in our lives.

The winter of 1937-38 we tried to save all we could. Until our debt was paid, Dorothy scrubbed the bare floors on her hands and knees, using lots of soap and wood ash which made them white and spotless. But we knew it would not be long before linoleum would cover those bare boards. We had papered the kitchen, pantry and bedroom in decorative paper adding a touch of brightness to the living quarters. Those first months were spent at home, knowing that to reach our goal we would have to forfeit social activities and a few comforts. Much of our leisure time was spent playing crib. A worn-out deck of cards was silent testimony of the hours spent at the game.

I worked six and seven shifts a week that winter and, with frugality and careful money management, we paid off the debt by the end of the year. We then purchased linoleum for two rooms, an easy chair and a radio. It was the first radio I had ever owned since coming to Canada ten years earlier. Fortune was beginning to smile upon us. With

the floors covered, walls papered and more furniture, we were now able to enjoy a little comfort. In addition, with the arrival of THE BOX, our larder was well stocked.

In the few months we had been at No. 8, Dorothy had managed to save $100.00. She named this our sickness fund. With this amount in reserve, she figured we could live for three months without going into debt; the scars of the depression were far from healed. That money gave us more than its monetary value in peace of mind and well-being.

Being newcomers with few acquaintances and no children, our first Christmas was a quiet one, passing much like any other day. But New Year's Eve turned out to be very different. I hadn't reckoned on 'first-footing', the traditional custom of those people of Scottish and Northumbrian origin. This ancient custom was a peculiarity of the north of England and Scotland. I never heard of it being observed in the southern counties.

A few minutes before midnight on the last day of the year, the doors of the house were locked and were not opened to anyone but the chosen 'first-foot'. Only a dark person could be the first-foot, and he must not enter the house empty-handed. Traditionally he carried a lump of coal in one hand and a bottle of whiskey in the other. These symbolic proceedings were steeped in superstition; the dark male entering the house brought good luck to the family for the year, the piece of coal brought warmth and plenty and the whiskey brought fellowship to family and friends.

The first New Year's Eve we went to bed as usual, but, shortly before midnight, we awakened to loud knocking on the door. Hurriedly pulling on a pair of pants, I opened the door. Standing there were four couples, with my friend Vic in the lead waiting on the verandah for the first seconds of the new year to pass so that he could be our first foot. They all followed Vic, and we celebrated our first new year in north-country style. It was a warm party and God knows there had been few parties in my life up to that time. Perhaps such an auspicious beginning augured well for our start on Vancouver Island.

CUMBERLAND

In 1937 the city of Cumberland was the county seat and administration centre of the Comox Valley. While other settlements had a rural economy, Cumberland's was based on coal. It was a working man's town, a place without ostentation, a place the majority of those who worked in the mines called home.

It all began in 1852 when Joseph W. Mackay, an employee of the Hudson's Bay Company, slashed his way from tidewater to the rugged hills near the present site of Cumberland to discover outcroppings of coal. But, due to the active development of the newly-discovered coal seams at Nanaimo and the remoteness of the Comox field, Mackay's outcroppings lay untouched for years. Then, in 1869, a group of eleven men, encouraged by the Provincial Government's offer of a hundred acres of land for every thousand dollars invested in coal development, formed the Union Company, from which the early settlement took its name—Union.

This first venture could be called successful in a prospecting sense as several outcrops were found, but a lack of capital hampered any large-scale development. After struggling along without any real progress for several years, the syndicate sold its interests in 1883 to Robert Dunsmuir, the coal baron of Nanaimo. That year, Dunsmuir formed the Union Colliery Company and by 1888 coal mining in the Comox coal field was at last on a sound footing.

A shipping port was built at Union Bay and a standard-gauge railway was built from the huge wharves to the Union mines. As the mines grew, so did the settlement. Rows of crude houses were built to house the influx of workers who flocked into the new camp. They came to this tiny hamlet from all corners of the world. There were people of African, Asian and European descent who populated Union.

Being a population of such diverse races, it was inevitable that ethnic colonies would be established. On the rim of the main settlement there grew a large Chinatown, two "Japtowns," a "Coontown" and a place on Comox Lake called "Little Italy." Industry found a place for the Chinese labourer, as he was hard working and docile; also, the Chinese were paid less than the white workers. These factors were desirable to the employer, so thousands of Chinese found work in the coal mines, railroads and shipping docks of Vancouver Island.

Cumberland's Chinatown was at one time reputed to be the second largest in North America with a population of nearly 3,000, only San Francisco having a greater number at that time. In its heyday, it was a hive of activity. There were twenty-four grocery stores and five drug stores that carried imported herbs and oriental medicines. There were two four-hundred-seat theatres that imported attractions direct from China. As well, the lonely Chinese had the choice of ten fantan houses to while away their leisure hours. There were also a number of benevolent societies that exerted considerable influence on the people. They laid down rules of conduct and attended to the needs of their members when they were sick or unable to work.

Even Chinese politics reached this tiny outpost of China. One building served as the headquarters of the Chinese Nationalistic League. This was formerly the Hung Mun secret society which, after 1912, was formally recognized as a political party, mainly because of its help in overthrowing the Manchu Dynasty. In 1923 the Hung Mun was renamed Chinese Man Chi Tang, meaning Chinese People Governing Party.

With the building of the coal wharves at Union Bay, coal production rapidly expanded. By 1891 the output from the Union mines had reached 114,000 tons. In 1893 discussions took place on the merits of laying out a townsite. Surveys were ordered, filed with the Provincial Government, and in 1897 Cumberland, named after the English county, was incorporated as a city. At its incorporation, it was reputed to be the smallest city in Canada, and the westernmost city in North America. This was a rather unique honour to a place that only a few years before was

a rugged wilderness. Two years later the population had risen to 3,000, most of whom were dependent on the mines for their livelihood. The street names were taken from places in County Cumberland: names such as Maryport, Windermere, Derwent, Penrith and Keswick, but one avenue was selected to be named Dunsmuir, after the community's founder.

During these growing years, a hospital was built to become the third on Vancouver Island. Each denomination was represented by its church. There were four churches to provide food for the soul, and five hotels to nourish the thirsty. All the basic services were available to the citizens—grocery stores, hardware and clothing stores, barbers and poolrooms. A volunteer fire department, and two doctors and dentists, were on hand to provide care when needed. One service that was not available was that of a lawyer. Perhaps miners were so law-abiding that they never needed one, and not being wealthy, there was little need for litigation. Under such circumstances, a lawyer would have starved to death.

As the market for coal expanded, so did the city. A succession of mines were opened which resulted in a dramatic growth in the economy of the Comox Valley. Cumberland provided a market for farm produce. The demands of the increasing population required the establishment of new business enterprises.

In 1896 the *Cumberland Islander* newspaper was published and printed in Cumberland, and was the forerunner of the present day *Comox District Free Press*. For a time the city boasted of having its own brewery, a business well suited to such an isolated region. In the early years the only access to the outside was by company train to Union Bay, then by steamship to Nanaimo or to the mainland.

But it takes more than bricks, mortar or lumber to make a city. It takes people. The people of Cumberland, coming from diverse backgrounds and bound by the common bond of their work with its inherent hazards, were unique in many ways. Their sturdy independence was forged through adversity, strikes and disasters, and their fierce loyalty to their city and parochial pride in its institutions were sometimes a source of wonder to the stranger.

With the decline in the use of coal, forces of change were in motion that were beyond the control of even these staunch citizens, and in 1958, sixty-one years after its incorporation as a city, Cumberland reverted to village status. Today without any industry, the village is now a residential site for the thriving Comox Valley.

No. 8 Days

By the spring of 1938 there were more than two hundred men working in No. 8. New longwall faces were in production, while others were being developed for further expansion. It was the largest mine I had worked in since coming to Canada, and was operated by one of the largest coal companies in western Canada. I was now familiar with the pecking order of the mine, and soon realized that if I didn't speak up, I would remain at the dirty, dusty job of machine timberman forever. So, after five months on the job, I requested a change to the classification of a loader. The rate of pay was the same, but loading, although hard work, was much less arduous. Within a week of making my request I was notified of a change of jobs, and without regrets I left the machine crew and became a loader.

The hardest part of the loader's work was breaking through the back of the cut. As the conveyor ran close to the face there was little room to work until that had been done. Once a space about three feet wide and six feet deep was made, the loader had room to work for the rest of his shift. The shot holes located at four-foot intervals were blasted as required. Inching along on his knees, the loader shovelled the coal onto the conveyor. As soon as there was space to set a timber, this was done. In systematic timbering a post was set every four feet—closer if necessary—as the cut coal was removed, and consisted of a prop placed four feet from the face with a six-foot long cross-piece tightened by a long tapered wedge.

I hadn't been loading for many days when I discovered that some of the other men on the wall were being paid more than me; some as high as $6.00 a day. I spoke to the fireboss about this, and pointed out that I was loading as much and more than some of the higher paid men, and was entitled to more than $4.51. His reply nearly floored me, "You're just a new man here; you don't expect to get the same pay as men who have worked longer with the Company." Pressing my case I was told I'd have to talk to the pitboss.

The Cumberland mines were not unionized, which was unusual for an operation of this size. I had been raised and had worked where miners were paid according to the amount of coal they produced, not by their time with a company. When the pitboss came down the wall and I spoke to him of my grievance, he told me there was nothing he could do. I would have to see the manager. As the manager didn't visit each wall every day, I expected a few days to pass before I would see him; so I waited my time. Two days after speaking to the pitboss, the manager came down the wall. He usually rode the conveyor, just saying good day to the men as the conveyor carried him by. But when I saw his light approaching, I waited and told him I wanted a few words with him. Before I had a chance to say a word, he said, "I know what you want; you're after money." I said, "That's it, Mr Quinn." The same exchange as took place between the pitboss and me was repeated. The manager ended the discussion by saying he would see what could be done.

I told the fireboss that if length of service and not production was the criterion of payment, then I would give $4.51 worth of work in relation to that given by those who were paid higher wages. Of course this was only talk; I could no more change my work habits than fly, but my persistence bore fruit for my next pay statement showed a daily rate of $5.25. Arbitrary and discriminatory wage rates are the anathema of the trade unions, but being non-union, this practice prevailed throughout the Vancouver Island mines.

It was unusual that such an important group of mine workers as those of Vancouver Island did not belong to the United Mine Workers of America (UMWA)—the coal miners' union. The Crow's Nest Pass miners had belonged to this union since 1903, and the miners of Lethbridge, Alberta had joined in 1906. The UMWA had made several attempts to organize the Island mines, but had been unsuccessful. Finally, after nearly ninety years of non-union or company-union operations, on November 18, 1938, the coal company and the UMWA signed their

first agreement. With the signing of this document, discriminatory wage rates ceased, and all men doing the same class of work were paid the same wage. In the case of loaders, their wage was established at $5.30 per day. This clause alone did much to remove the discontent generated by unequal rates.

From the beginning, the history of coal mining on Vancouver Island was one of strife. In 1850, before there was any sign of a union, a handful of British coal miners working at Fort Rupert on the northern end of the Island went on strike as a protest against doing labourer's work. Two of them were put in irons for six days, the others managed to stow away on a ship bound for the California gold fields.

In the early years of the industry, conditions were far from satisfactory. Vancouver Island mines were the scenes of the first attempts to form organizations in an effort to fight against the autocratic rule of the mine owners. Safety was a vital question where the Vancouver Island coal mines were concerned. The Island's mines were considered amongst the most dangerous in the world, and the records show that death was a constant companion of the miner. Eight separate disasters over thirty years—beginning in 1879—killed 426 men, and these were part of a labour force that supposedly didn't exceed 4,000 at any one time.

As a result of the fight for better conditions, strikes occurred in 1871, 1874, 1876, 1891 and 1903. These were the years of the Dunsmuir regime. Robert, the founder of the empire, who died in 1889, was a product of the times and tolerated no complaints from his workmen, as the number of strikes under his ownership testify. It would be unfair to place all the blame on the shoulders of the Dunsmuirs, for in 1912, two years after they sold their mining interests to Canadian Collieries (Dunsmuir) Ltd, the big strike occurred. This was a culmination of many grievances, and was one of the most bitter and longest strikes in the miners' fight for rights. So adamant was the Company in its efforts to prevent the workers from organizing with the international union, that they resorted to having the government call in the militia to quell the surging unrest that grew during the long confrontation.

With such a heritage it is not difficult to understand why the coal miner acquired the image of being a disgruntled troublemaker. One need only look at the records of fatalities and accidents over the years to realize why the miner was the way he was. Even by the late 1940s, an average of sixty-eight miners were killed by accident in Canadian coal mines each year, and British Columbia had a high proportion of these casualties.

I had not been long at the mine when I noticed a disparity between the Vancouver Island miner and the miner of the lignite fields of Alberta. Part of the distinction in the attitude of the miners was due to a difference of backgrounds. Because the prairies were not open to settlement until the late nineteenth and early twentieth centuries, the prairie miner had no long community traditions. The prairie mines were, for the most part, seasonal. No only were there more mines for a man to seek work in, but there were also better opportunities for alternate work, such as farm jobs in season. Such circumstances precluded the establishment of a traditional mining class, such as could be found in Britain, the Crowsnest Pass fields of British Columbia and in the older mining communities of Nova Scotia.

The Island miners had a background of mining from the 1850s, and many of them were descendants of those early miners brought out by the Hudson's Bay Company. They brought tradition with them and passed it on to their children. Sons followed fathers into the mines much the same as in England, and, once entrenched in the industry, they were reluctant to leave. I worked beside men who were born in Cumberland, and a few whose parents were born there. Cumberland was the only place they called home; and from this grist the pride of job and community was milled. It was in this entrenched industry that I said, "This is where I stay; this is where I will raise my family, and move no more."

Although they belonged to one union, the Island miners were paid twenty-six cents a day less than those in the Crow's Nest Pass mines. One company official—during wage negotiations—defended this differential by stating that it was worth less money just to live in such a pleasant climate. By following this kind of reasoning to its illogical conclusion, the workers in Hawaii should be willing to work for food and shelter only.

In fairness to the operators, I must say that the Crow's Nest Pass mines were more productive than those on Vancouver Island where mining was more difficult and costly. But the Island mines had the benefit of being near deep-sea ports, thereby eliminating high transportation costs. It was this advantage that kept these mines in a competitive position.

One day, in the spring of 1938, the mine manager got off the conveyor at my working place saying he wanted a few words with me. This was unusual, he was a busy man and had not time for idle chit-chat. The gist of his talk centred around my continuing to study for a

third-class certificate in British Columbia. He told me there were opportunities with the Company, and suggested I enrol for a course in mine rescue with a view to obtaining a certificate in that branch of mining. Before anyone could be granted a certificate of competency as an official, he had to be the holder of a St John's Ambulance certificate and a certificate of competency in mine rescue.

I had the benefit of my earlier studies through Bennett College while I was at Wabamun, and was still enrolled for correspondence lessons; therefore, I was not unprepared to attempt the British Columbia Department of Mines examinations. However, I would have to enrol in the classes in mine rescue that were held at Cumberland at the government rescue station there. I told Dorothy of my talk with the manager and her enthusiasm at the news was a great boost.

Moreover, all about me were men fifty years of age and older who had done this kind of work all their lives, and the more I thought about it the more I knew I would never be content to be a loader for the rest of my life. This was all the impetus I needed to begin studying in earnest for a fireboss' certificate. This certificate was the lowest in the range of certification and was termed in the Coal Mines Act as a third-class certificate of competency.

That spring of 1938 I began attending the mine rescue classes and also stepped up the tempo of the Bennett College course, with a view of trying the government examination for a British Columbia third-class certificate. The government examinations for mine officials were held twice a year, usually in June and November. It was now April, but since I had studied in Alberta through my course, I decided to send in an application for the June sitting.

The mine rescue course proved to be a most informative and interesting episode in my study of mining. Mine rescue work is essentially the rescue of men and the recovery of bodies in the case of cave-ins or explosions or other underground disasters. In the larger mining centres of the province, the Provincial Department of Mines maintained mine rescue stations, fully equipped and manned by qualified instructors. Their function was not only to train new men, but to provide continuous training for those already proficient. These stations also served as centres where crews could be mustered and directed to any disaster in the area.

Fourteen new men began the course with me. Before any of us donned the breathing apparatus, we first had to learn of the gasses

found in coal mines and how to detect them. The most important ones are methane, carbon dioxide, carbon monoxide, hydrogen sulphide and nitrogen. The presence of methane in the atmosphere of a mine is detected by its action on the flames of a safety lamp. When methane is present, a pale blue halo is formed above the oil flame of the lamp. A trained man can estimate with a high degree of accuracy the percentage of methane present by the height of this halo.

Carbon dioxide can also be detected by observing the flame of a safety lamp. In the presence of this gas, the flame of the lamp loses its intensity and takes on a yellowish tint. At one time, carbon monoxide was detected by taking canaries underground, but now an instrument is used that can detect minute quantities of the gas. This device consists of a small barrel to which are attached two small glass tubes; one is the detector tube and the other is the colour scale. The detector tube is filled with activated iodine pentoxide. When an air sample is drawn through it, the sample takes on various shades of green if it contains carbon monoxide. Then the shade is matched against the colour tube to determine the percentage of carbon monoxide in the sample. Excess nitrogen is detected in the same way as carbon dioxide, both gasses displace oxygen and have the same effect on the flame of a safety lamp. Hydrogen sulphide is readily detected by its odour. It has the smell of rotten eggs, even in minute quantities.

Only after having mastered this part of the program were the students allowed to learn about the self-contained breathing apparatus. They were taught how to take it apart piece by piece and learn the function of each part, then how to reassemble the machine before being allowed to wear it. There was no room for subterfuge in this course, for each man had to assemble his own machine and wear it in a room filled with sulphur smoke for fifteen minutes. Any leaks in the machine or the goggles were soon revealed by the eye-watering and coughing of the student.

Following proficiency in wearing the apparatus, the remainder of the course was done in a model mine, working as a team in simulated disasters. In addition to rescue training, every man was taught how to use resuscitation equipment—a useful adjunct in rescue work. Upon completion of the course those who wanted to could become part of the regular rescue team. They were paid an extra $2.50 a month, and were required to attend the rescue station once a month for practice.

At the end of the course I was chosen to captain a six-man team to represent No. 8 mine in the novice event at the Provincial Mine

Rescue competition. Although somewhat reluctant to take on the task, and suffering from butterflies in the stomach, our team won the shield as the best of five teams entered. Despite the team's jubilation, I pointed out that we only competed against novices, and probably would have got nowhere against experienced teams.

When the course was finished the manager told us that twenty-five percent of his men were now trained in mine-rescue work. Considering that there were two hundred and fifty men employed in the mine, it was a creditable record. Although all were not active in the program due to health and age, it showed a remarkable dedication of men who, without any thought of personal gain, were ready to lay their lives on the line to save the lives of their fellow men.

Meanwhile, the No. 8 mine continued to expand and new long-wall faces were being developed. The 300-foot longwall faces at No. 8 mine usually had a crew of nine loaders. If there were no major tie-ups, this was enough men to load off the cut, also it was about the capacity of the conveyor. But it was sometimes difficult for the last man to find room to shovel his coal onto the shaker because it would be full from the loaders above him. As a rule each man would load twenty tons of coal a day, and set eight or nine props.

Working under the newly exposed roof, the loader had to be on his guard at all times. But nothing could take the place of experience. Familiarity developed an unthinking awareness, an instinct for danger that is the mark of an experienced miner. Those whose lives are spent on the surface may shudder at the thought of working on their knees in places only three and four feet high. But there are advantages to such low workings. One didn't have to bend and straighten one's back when shovelling in the kneeling position compared to shovelling when standing. Also, in low seams, one's head was close to the roof at all times. In this position the slightest roof movement or sound could be detected at once; an advantage lost in seams seven feet or more in thickness. Although I didn't mind my job as a loader, the course I had taken in mine rescue had whetted my appetite for more knowledge of mining. I knew I would not be satisfied unless I tried to see how high I could go in the mining industry, and I worked hard preparing for the coming third-class exams.

As so often happens, the fear of the examination was worse than the actual event. When I wrote for the third-class papers in June, in a one-day session beginning at 9:00 a.m. and ending at 5:00 p.m., I had little difficulty. I waited keenly for the results which would be known

within one month. There were six candidates for the third-class examination that day and we all waited with anticipation. Then to end the suspense, on July 8, 1938, I received word that I had passed; I had reached the first rung of the ladder.

In the meantime Dorothy and I had managed to acquire more furniture and other items to make our home more comfortable. However, one thing that had not improved was the lack of washing facilities at the mine, which was surprising in an operation the size of No. 8. Even small mines in Alberta were compelled by law to provide bath-houses at the pithead. But even in 1938 there was no law requiring coal companies to provide such facilities at the Vancouver Island mines. Consequently, I was back to where I started as a boy in England sixteen years ago, washing in a tub set in the middle of the kitchen floor. However, these were minor inconveniences we could tolerate providing the mine worked regularly and we kept our health.

As the mine continued to expand and new longwall faces were developed, men were transferred from the older mines of Nanaimo to work these new faces. In view of this increase, after only having my third-class certificate for one month, I was promoted to fireboss. With this appointment, my future was to follow the path I had hoped for when I had begun studying at the Colliery School in England fourteen years before.

Although firebosses were classified as officials by the Company and the union, they were not on salary. Like the miners, they were paid by the day, yet as officials they could not be members of the UMWA. The duties of a fireboss were many and varied, but his first concern was the safety of the men in his charge. All working places and roadways leading to the faces had to be examined and found safe before any workmen entered them. It was his responsibility to see that the miners had sufficient supplies of timbers on hand to maintain the working places in a safe condition. In addition, he was required to do all the blasting in his section. He was the only one allowed to carry detonators and the only one who had the shot-firing battery. In short, the fireboss had to work for a maximum of output with an optimum of safety.

The regalia of a fireboss was something to behold; he had more paraphernalia hanging on him than a Christmas tree. He wore a headlight, its battery fastened to a belt around his waist; hanging from a belt, was a shot-firing battery and a safety lamp used to detect methane; slung across his shoulder, he carried a stiff leather satchel containing fifty to

seventy-five detonators, which was forever in his way when he was working in a tight place; over his other shoulder he carried a seventy-five foot coil of blasting cable; if that were not enough, he had to carry a copper tamping rod in one hand. All were necessary for him to do his job; yet all were an impediment to his freedom of movement.

When I began the job as fireboss I was placed in charge of a newly developed longwall face with a crew of nine loaders, three haulage men and a faceman who looked after the operation of the conveyor. The fireboss was also responsible for the timber supply for each loader; he would put posts and crosspieces on the conveyor and the loaders would take them off as they needed them. Before firing a shot, a man was dispatched along the face with sacks of finely ground limestone which he scattered around and about the workings. This was done to neutralize the hazard of coal dust which was highly explosive.

Once the men were in position, the day's routine of firing shots began. Each man carried a powder can holding four pounds of explosives and, beginning at the first man at the top of the wall, I would examine the vicinity for explosive gas—methane—then blast enough coal to keep him busy until I could get back to him. As the drillholes were four feet apart, usually two shots for each man would suffice. It was the duty of the fireboss to see that every man kept his working place timbered in a safe manner. No more shots would be fired if this was not done. When the last man had been provided with shot coal, I would crawl up the wall to the first man and repeat the shot firing. This routine would be followed throughout the shift until all the coal had been blasted and the wall cleaned off, or it was the end of the shift. Before leaving the working places, I made a final examination and logged the conditions in the daily report book for the information of the oncoming fireboss.

As a fireboss, I gained much valuable experience in the elementary science of coal mining. The barometer and thermometer displayed by the mine office took on a new meaning. Previously they indicated whether it was going to rain or tell how hot or cold we were, but now differences in pressure and temperature meant possible changes in the atmosphere underground. A low barometer would have an expansive effect on the mine air. As a result, gasses confined in abandoned workings and waste areas could be forced out and into the working parts of the mine. The temperature of the air entering the mine had a bearing on its capacity to absorb moisture, thereby influencing the dust conditions of the workings.

Although coal mining is a science, all the knowledge gained from books can never take the place of underground experience. This has

been recognized by mining authorities for years, for the Coal Mine Act states: A graduate engineer from a recognized university must have three years underground experience before he can obtain a first-class certificate of competency. For those not having a degree, the time underground is increased to five years.

As a fireboss dealing with men of all types on a day-to-day basis, I learned valuable lessons in human behaviour. By experience, one becomes practised in judging men and how to gain their respect and in turn their cooperation. There was an *esprit de corps* among mining men that made them a breed of their own. Despite sometimes trying conditions, most of them—particularly the middle-aged and older men—were quite content with their lot. They were happy in mental idleness with manual work to do. They wore no frowns as they dug and shovelled, and sometimes the strains of an old ballad, hummed or whistled, were heard as they went about their work.

To many miners, there were worse ways to make a living than working underground. Most of them came from a mining background and sought no other work. If asked why, they never mentioned danger, dirt or sunless days, but only the more enjoyable aspects of their work. As one man said, "I don't have to worry if it is scorching hot; I am a comfortable sixty-five degrees; and another thing, it never snows where I work." One feature that found favour among miners was working with a partner. Very seldom did a man have to work alone. Men became accustomed to this companionship, and it was sometimes a factor in a man choosing to stay in the mines.

The supervision of miners was only intermittent. In some cases, due to distances, a fireboss would only visit a worker twice in a shift. To some, this was a plus. They often stated that they didn't want the bosses looking over their shoulders every minute of the day, like they do on construction jobs. For the most part, miners took pride in their work and were the first to criticize each other for sloppy work, particularly timbering. The Cumberland miners were experienced men. They knew their jobs and tried to give a fair day's work for a fair day's pay. Paradoxically, they would laud mining as a job, then say, "I don't want any of my sons to ever work in a coal mine."

Being a miner, I had no chance of learning the administration, financial or sales aspects of the industry. Therefore, I knew my efforts would have to be channelled toward engineering and production. This being my goal, I realized that only hard work, self-discipline and determination would see it fulfilled. The promotion to fireboss brought a

raise in pay. My daily wage was now six dollars, an increase of seventy-five cents per day. While this may not seem much by today's inflated standards, it was a most welcome increment in the fortnightly pay envelope. For the first time since being married, we could now see where a tiny dream we had could be fulfilled. With care, and frugality, we saw the possibility of building a nest egg for our future.

Dorothy was forever the homemaker, adding a woman's touch to the home that gives that extra warmth and comfort. The smell of fresh-baked bread and other culinary delights pervaded our home. We had acquired a hot-water system, thereby eliminating heating water in a copper boiler on top of the stove. Since I still bathed at home, this was an important labour saver.

We had grubbed out a garden patch that provided us with fresh vegetables. We also raised chickens, which not only gave us all the eggs we could eat, but enough to sell to help pay for the feed and have a fryer when we wanted. To make our happiness complete, Dorothy was expecting our first baby later in the year. When she told me of this, I seemed to be walking a tightrope, torn between the joy of having a child and the apprehension that something might go wrong for either Dorothy or the baby. It seems I was a worry-wart; my past had programmed me to look on the dark side.

That summer we reached a milestone. We bought our first car, a Model T Ford, for fifty dollars. It was a proud moment for us. It gave us the means to do our shopping without walking three miles to Courtenay or travelling the miner's coaches to Cumberland. It also enabled me to take Dorothy to see the doctor at almost any time. Instead of being penned in the camp all summer, we were now able to visit some of the beaches on the Sundays I didn't work. These interludes were the only break I had in my routine of work and study.

During its early years, No. 8 mine continued to expand. As new longwalls were being developed, new men were hired. Consequently, I was able to get my brother a job. This meant he was no longer dependent on our parents, and he could help them in their lean times. Dorothy and I continued to help out where we could. Each letter we sent had a few dollars in it, but not much. The little that we could spare meant so much to them. I tried to get my share of week-end shifts. We were still on day wage, and each day worked meant a few more dollars in the pay envelope.

Just a few weeks before the baby was born, an incident occurred that served as a reminder that life could not be all roses, there had to

be a few thorns also. I was doing my job this day, charging a shot-hole. The wall was about three and a half feet high and I was in the awkward position of legs astride the conveyor, knees bent and back bowed, when suddenly a piece of rock fell from the roof pinning me to the conveyor. It wasn't a cave-in, just one slab weighing around five hundred pounds, but being in such an awkward position, I couldn't brace myself against such a load.

The conveyor was shaking back and forth with its ten-inch stroke, and my first fear was that my legs would be pinned between it and the post. If that happened, my legs could literally be sawn off. Somehow I avoided that possibility, but the weight gradually forced me into a doubled-up position, which caused the headlight battery to come between my thigh and lower ribs. Something had to give, and when the men got the conveyor stopped and the rock off my back, I ended up with three broken ribs, torn rib cartilage and numerous bruises. I was lucky; it could have been much worse.

Knowing how quickly word spreads in small mining camps, I made up my mind to walk off the cage to the ambulance, even if I had to be carried to the shaft bottom. I didn't want Dorothy to hear that I had been packed out of the mine on a stretcher. It so happened that the fellow who was sent to notify Dorothy that I had been hurt could only tell her that it could not have been serious as I walked to the ambulance. This set Dorothy's mind at ease until she could visit the hospital that evening.

I was given several X-rays because the doctor seemed concerned about damage to my spine when he heard how the accident happened. However it was found to be intact; only my ribs were damaged. But they were painful, and oh, how I wanted to take a deep breath but dared not! I had been taken to the hospital in my dirty pit clothes, and that evening when Dorothy came to see me, my first words were, "Did you bring my clothes?" Of course she hadn't brought any, knowing that I would be howling to get out. Instead she told me in no uncertain terms there would be no clothes until I was discharged by the doctor. I remained in hospital for four days, then persuaded the doctor to allow me to go home, on the assurance that I would rest much easier there than in the hospital.

I had worked nearly two years at No. 8 when I had the accident and, although I worked all the shifts available to me, I had yet to have a fifty-dollar pay for two weeks work. There were times when I was

close to it, but it always happened that there would be enough deductions to stop me reaching that goal. Some of the deductions were rent, light, coal, sundries—gloves, kneepads, axes, saws—and rental for the use of the headlamp. Yes, we even had to pay for the light we used to do the Company's work. During the pay-period that I was hurt, I was working toward the elusive fifty dollars. My deductions were at a minimum and I would have worked eleven shifts that pay had I not been hurt. However, I recovered and was ready to try again.

We were waiting patiently for the blessed event. Dorothy was waddling around as big as a house, uncomfortable, but healthy. Then one night coming home from afternoon shift, I was met at the door by our neighbour, who told me that Dorothy had gone to the hospital. She had been in labour when I left for work at 2:30 p.m. that day, but had kept it hidden from me, not wanting me to worry while on the job.

In a bit of a dither, I set about having a bath with the intention of going to Cumberland to see Dorothy despite the late hour. After I had bathed and dressed hurriedly, Len, my neighbour, said that I couldn't go to see Dorothy looking the way I did. I didn't know why not until he told me to go look in the mirror. I did, and lo and behold I had forgotten to wash my face. I surely must have been in a daze.

Arriving at the hospital, I was allowed to see Dorothy for a few minutes. The baby had not arrived yet; it came two hours after I left. I saw my son for the first time later that morning, a helpless little bundle. I was assured by the doctor that Dorothy was fine and we had a healthy baby. I left the hospital on cloud nine; all was well and we had a son, William Wear Johnstone.

A LITTLE JOY AND A LITTLE SADNESS

Our son was born on September 6, 1939, in a peaceful little oasis. But thousands of miles away events were taking place that were to affect the lives of millions. On September 1, Hitler's armies smashed into Poland; two days later Britain declared war on Germany, and on September 10, Canada officially entered the war.

With the declaration of war, the economic stagnation that had plagued the country since 1929 suddenly disappeared. Like a magician pulling a rabbit out of a hat, money became available for armies, ships, uniforms, coal, steel or whatever was needed to fight the war. Yet during ten years of peace there hadn't been anything but stagnation. Not being an economist or financier, I have forever puzzled as to where the money came from; almost overnight the purse strings were loosened. Where had the dollars been all those years? There was money to build and manufacture things that were destroyed, shells and bombs to be wasted, ships to be sunk. I never got an answer to this question, at least not one that I could understand. No money for food, but plenty to buy guns; what an indictment against governments!

With Canada at war, the demand for coal increased. As in the 1914 war, young men left the mine for the services. Most of them for the same old reason; to escape from the mines. There is nothing new under the sun, only a new generation. The long lines of job seekers disappeared, and industry began crying for men. From the poverty of peace to the prosperity of war, it was the antithesis of all I had been taught.

When Dorothy and the baby came home I had arranged for mother to come and see her grandson. This would be the first time she had had a holiday since coming to Canada ten years before. She stayed with us a month, and she looked much better for the change. It was a treat to have this gentle woman with us; her mere presence filled our home with an aura of tranquillity. It was with some reluctance that she left, but there was father, my youngest sister, Ruby, and the youngest in the family, Kenneth, still at home. I learned from mother that father wasn't able to swing a pick all day, and that his health seemed to be failing. The mine was only working one or two days a week and they were having a hard time making ends meet. She left with a promise. I told her I would try and get father a job in No. 8 mine. On that note she left us with hope in her heart.

I knew that in an operation the size of No. 8, there were jobs that father could do. Subsequently, I spoke to Mr Quinn, the manager, explaining the situation. After pondering the matter for a few minutes, he told me to bring father out and he would find something for him. I have never forgotten Mr Quinn's compassion in extending a helping hand to me and mine.

I sent my father the money for his fare; a few days later he came to the coast, and was given a job he could handle. He stayed with us until he could arrange to bring mother and the two children out and, before the end of the year, they made the move. Father rented a small holding—five acres with a house and barn on it—and soon the family was settled. The tide had turned for them, and for the first time they dared think of spending money on something they didn't immediately need. To anyone who has never been in that position, they have missed one of life's little pleasures.

Once again my family was where I could keep an eye on them. Although we lived our separate lives, it was a comfort to know we were close. My two older sisters were married and away from home, and Fred had enlisted in the navy. So with only two children to look after, they managed quite well.

Now that Canada was at war, the demand for coal was intensified. The mine was working full time and a shortage of skilled miners was becoming a problem. While many left for the services, others quit to work in war-related industries that were paying higher wages. Now the tables had turned. The Company began advertising for miners, and began making application to the Selective Service Board for exemptions for men, on grounds that they were key personnel.

As the shortage of miners continued, the government revived the War Measures Act, the legal basis for such controls that were deemed necessary, and gradually some of these controls were put into effect. Other industries were forbidden to hire men for vital war industries, coal mining being so designated. Miners were frozen to their jobs. In addition, restrictions on the right to strike were imposed on labour in 1941. As the war dragged on, further sweeping and powerful laws were enacted by the National Selective Service Board.

Men could be discharged from the services to work in the mines if they had experience. Furthermore, no miner could join the armed forces either by enlistment or draft. I wonder how our present-day union leaders would react to such stringent laws. It certainly was a complete turnabout. For years the miner was low man on the totem pole without much prestige in the social scale. Then, suddenly, he was an important cog in the industrial wheel. He was needed. Such a situation could turn anyone's head.

However, such a situation was not new. During World War I, miners were released from the services to work in the pits. Surely there was a lesson to be learned somewhere; had a nation forgotten? The pitman was certainly worthy of his hire both in peacetime and in wartime. However, a subtle change was taking place. When a man is forced to do a job, he is not a contented worker. He no longer had the fear of losing his job, and no long lines of men were waiting to take it from him. He began to flex his muscles.

In the past the miner earned a measure of prestige by being acclaimed as a good miner or a good workman. But the days of autocratic bosses, and two men looking for one job, were no more. They now had a union, and there began a psychological revolution. No longer was there any need to outdo the other fellow. The strong and skilled miner began to ask himself, "Why should I break my back when another man—doing less work—gets the same wage?" Only those who had gone the route could be the judge of such reflections.

Still in memory, there were the times the boss would visit a working place, pat the miner on the back, and ask, "How are you doing today?" and if he couldn't feel any sweat on the shirt, would say sweetly, "I don't think you're doing so well; you better have a few days to rest." Or if a man failed to show for work without notifying the boss, he would be told to go home and have another shift on the Company. Such power in the hands of petty officials caused much of the ill-feeling.

The first noticeable trend in this quiet revolution was that more men were required to clean off a longwall face. The loaders were only

going to do so much regardless of conditions; in other words, a stint. This was the beginning of the swing of the pendulum to union power. The stage was being set for the era of confrontation which, in the 1970s, would see union leaders as powerful as the robber barons of the past, and just as ruthless.

In the meantime, I continued to work on the course from the Bennett College of Sheffield. However, due to lessons lost at sea, it became impossible to maintain the sequence required. So, rather than work on a hit-and-miss basis, I discontinued that course and enrolled for one from the Calgary Institute of Technology and Art, and continued my studies without interruption. While I was gaining knowledge in the theory of mining, as a fireboss I was continuing to get an education into the foibles and guile of men.

Before the war, firebosses were paid a daily wage, but they subsequently succeeded in negotiating for a monthly salary. When on day-wage, all firebosses wanted to work the extra shifts, but once on salary there were no volunteers for the weekend shifts. It seemed as if it was nobody's turn to work. This situation sometimes resulted in there being no fireboss for a weekend shift and, as I lived close to the mine, I would be called upon to fill the bill. Finally, the manager, seeing the trend and the abuse of my availability, laid down some rules rectifying a nasty practice. Greed makes a man a conniving creature and circumstances soon determine the measure of a man.

With an influx of miners and those professing to be miners from the services, the patience of the fireboss was sometimes taxed to the limit. Many of those discharged as miners had never seen a mine in their lives; they had used coal-mine exemption as a means of getting out of military service. Despite being searched for matches and cigarettes, it was found that some of the new men were sneaking a smoke underground. It was difficult to catch the culprits as the headlight heralded the approach of anyone. However this problem was solved by the men themselves; although they wouldn't report the wrongdoers, they threatened them with bodily harm if they didn't stop this dangerous practice.

One experience I had served to emphasize the gullibility and ineptness of those responsible for screening mining applications. A new man was sent with experienced men to do mucking—shovelling the cuttings from the machine into the gob—and as he climbed from the roadway onto the three-and-a-half-foot high face, he immediately froze.

As he was in my section, I was sent for. When I got there, the man was in a cold sweat and rigid. This was a new experience for me, but I talked quietly to him, and assured him he didn't have to work in the mine. After half-an-hour of friendly persuasion I finally led him off the faceline. The man was really ill and a pitiable sight, a victim of claustrophobia, which was something I couldn't understand because close places held no fear for me.

Our second child, a daughter we named Edith, was born early in 1942. Our cup was full; we had two healthy children, a boy and a girl. We had as many kinds as a king could have, and my family was close at hand. But happiness is not a constant state, and I noticed father's health began to decline. He was finding it more of a burden to go to work each day, even though he had a light job. Eventually when he reached the stage where he could no longer attend his work, he saw his doctor who hospitalized him immediately. After tests, it was found he had terminal cancer of the lungs—the fate of many miners. He fought pain for several months with grim determination, but it was a losing fight. In November, heavily sedated, he finally passed away. He was only 58 years old, and died without acquiring those things that are supposed to be the mark of a successful man. He had worked hard all his life. He had never owned his own home. His material possessions were few, but he left a legacy of honest dealing and earthy wisdom that will live as long as his descendants remember him.

Mother was now left alone with her youngest son, Ken. Ruby had left home to work in Victoria, and was soon to be married. Fred was somewhere on Atlantic convoy duty, so it remained for Ken to be the man of the house. With the death of father, other arrangements had to be made to take care of mother. According to new wartime legislation, the age at which persons could work underground was lowered to sixteen, so brother Ken was able to get a job at the mine. Being the breadwinner of the house, he was eligible for a company house. As soon as one became vacant, they moved to the hamlet of No. 8 where we could keep an eye on them; it was a big responsibility for a sixteen-year-old.

Despite the frustration of wartime restrictions, and the problems of unskilled labour, the miners managed to keep their sense of humour. As in all cases where men are grouped together, there seemed to be a cross-section of human behaviour. There was the know-it-all, the barrack-room lawyer, the perpetual grouch, the wit and the clown—but

over all, they kept their sense of humour. It was this characteristic that helped dispel some of the disagreeable aspects of coal mining.

One foreman, noted for his stern demeanour and sharp tongue, appeared a tyrant to those who didn't know him, but behind his brusque manner lurked a subtle wit. One day, passing a pair of men dismantling a conveyor, he gave his usual greeting, "Come on hurry up!" One of them straightened up and in a slow drawling voice said, "Aw man, Rome wasn't built in a day." Without a break in his stride, he retorted, "I wasn't boss then." The two men were left gaping and speechless. This foreman was noted for such quips and could be expected to come up with one to meet any occasion. Seeing a miner swing his pick to break a large piece of coal he would quip, "Hit it hard and it will break easy." Such tongue-in-cheek humour did one good.

The forties brought one important change to the coal miners of the province. The government introduced legislation making it mandatory for coal-mine operators to provide bathing facilities for their employees. Subsequently, the Company built washhouses at the two operating mines, No. 5 and No. 8. It seemed odd that so large a company would be so remiss in providing this amenity for so many years when even small mines in Alberta had done it for years. Many things could be done to improve the miner's lot, but it appeared that any innovations toward this end would have to be legislated, for they would not be introduced voluntarily by the mine owners. In retrospect, companies had sown the wind and would later reap the whirlwind.

THE WAR YEARS AND STUDY

It was now 1944, the war was at its height, when another sad event came about. Dorothy received word that her brother, Bob, a navigator in the RCAF was missing. The letter stated that his plane had been brought down over Normandy and there was a possibility that he could be with the French Underground, or a prisoner of war. With such an optimistic note we continued to hope, but a short time later it was confirmed that he had been killed.

Once again our lives were touched by death. Of course, we were not alone, for war has its price. Despite the effects of war, we considered ourselves well blessed. Dorothy was expecting again and we were all in good health. Our garden and chickens continued to furnish us with wholesome food in addition to offering an escape from the grind of work and study.

In September we were blessed with a baby girl, whom we named Ruth. With three children we felt our family was complete; there was one for Dorothy, one for me and one for the country. It seemed nature was trying to balance the books. In five years of war, three new members were added to our family and two were taken away—my father and Dorothy's brother.

I was about midway through the Calgary Institute mine course when I decided to attempt the second-class examination. It was a two-day sitting, and much broader in scope than the third-class examination. The holder of this certificate was certified to be an overman, or under-manager, of any coal mine in the province. I had attained high marks

in the course and, although not completed, I felt I might have a chance with the examination.

There were three candidates for the second-class examination, all feeling pre-examination jitters. Then after two days of mental agony, we all waited the four long weeks for the results. Toward the end of the fourth week, upon entering the house from work, my first question was always, "Any word?" Then one day when I came home from work an envelope with the Department of Mines logo lay on the table. Although it had arrived that morning, Dorothy did not open it. She wanted me to be the first to know the results. I am afraid I would not have had the willpower to leave the letter all day without my curiosity getting the better of me. But this little episode demonstrated her strength in such matters, as she was just as anxious as I to know how I had done. However, we opened the letter together and shared the good news. I had passed the examination!

Having passed this examination I took a hard look at the program of study required for a first-class certificate. This was the top one, and I know much study was needed before I could attempt this step. I enquired of other officials, and delved into past examination papers and came to the conclusion that with two years of diligent study, I could have a chance of making it.

I had only my second-class certificate when I was promoted to shiftboss, and placed in charge of the afternoon shift, 3:00 p.m. to 11:00 p.m. Such a promotion meant much more responsibility. Instead of being in charge of a section as a fireboss, the shiftboss's responsibility covered the whole mine. Much experience was gained from this position, for not only was it a production shift, but it was also the shift when the preparation of the longwall faces began.

In comparison to room-and-pillar work where men worked alone or in pairs and were dependent only on themselves, longwall work required larger crews and demanded a high degree of team effort. With the output concentrated on only a few faces, the cycle of turnover had to be maintained.

The ideal routine for a longwall face was to have a complete cut loaded off in an eight-hour shift. In this way the coming shift of machine crews could begin to cut without being held up by coal yet to loaded. With the cut loaded off, the conveyor could be dismantled, ready to be assembled in the new faceline as soon as the machine had advanced enough to make room for the muckers to shovel the muck clear of the face, and the pan-men to begin setting up the conveyor for the next cycle.

146

But conditions in a coal mine are far from ideal all the time. While one wall may be going according to schedule, another would have troubles that delayed a smooth turnover. Such delays on any shift became progressive on the shifts that followed. Many facets of face preparation took place on the afternoon shift, and as a result, there were many headaches; but it was a shift where a lot of valuable experience could be gained.

The new job was a challenging one as all phases of mining came into play; cutting, timbering, trackwork and production. In addition, this was the shift when all over-size material came down the shaft. All material longer than ten feet had to be slung from the bottom of the cage, including such things as thirty-foot-long steel rails for the underground railways, various diameters of pipes up to twenty feet long, and all of the larger timbers. While this material was being lowered, no coal could be hoisted. The result being that most of the mine cars would be full, waiting to be hoisted, thereby delaying their return to the working places. These frustrating factors all added to the pressure of being a shiftboss.

I had not been a a shiftboss long when the miners went on strike, despite wartime regulations. But this was a strike with a switch; their fight was not with the Company, but with the federal government. Their complaint was the inadequate meat ration. Even with only two people in the family, the meat allowance was far too small.

One of the contentious issues stemmed from the fact that there was no rationing of meals in restaurants. It was argued that those who could afford to dine out were getting a bigger slice of the pie, while the miner who had neither the time nor the money, was getting far less meat than those with much easier work. After a two-week shutdown, the strike was settled by allowing underground workers a larger meat ration. I mention this incident to illustrate the clout the miners acquired in the war years.

As a shiftboss, I worked five days each week on afternoon shift, but as officials were required to work six days, I had to double back on the Saturday morning shift. This quick change meant I only had about five hours sleep between these two shifts. My duty on the Saturday shift entailed the inspection of all return airways, and measuring the volume of air passing at various stations throughout the ventilation system. The velocity of the air is measured by an anemometer, an instrument having propeller-like blades so finely balanced that a mere wisp of air sets them in motion. The whirling blades activated a pointer on

a calibrated dial where the velocity could be read. The instrument was held in different places in the airway, such as close to the roof, near a side, and in the centre. Due to friction, the readings are lower near the roof and side, so, for accuracy, the average velocity was used in the calculation. The volume is found by multiplying the velocity by the area of the airway.

While this job was sometimes unpleasant, it was never dull. I examined galleries that were never used by anyone, places used only to carry air. The last lap of the inspection, was the examination of the up-cast shaft, or air shaft. Beginning at the 700-foot level I climbed a series of zig-zag steps all the way to the surface. As the return air is warm and humid, the shaft and steps were covered in a coat of slimy moisture. The utmost care had to be taken when making the climb; one missed step and it was curtains.

The air shaft is the only escape route if, for some reason, the main shaft is put out of commission. Therefore, the airshaft had to be inspected regularly. The volume of air flowing in No. 8 shaft was 220,000 cubic feet per minute. It is not difficult to imagine the velocity of the air when this quantity is flowing through an opening of 200 square feet—1,100 feet per minute or about twelve-and-a-half miles per hour. It is a task that required experience and a cool head.

Although the seam being worked was at the 700-foot level, the shaft was 1,000 feet deep. The bottom 300 feet was used as a water reservoir. To keep this water down below the 700-foot level, the night-shift hoistman had to spend part of his shift hoisting water from the shaft. This was done by a 1,000-gallon self-dumping bucket.

As often happens when two or more men have a job to do, a dispute arose amongst the four hoistmen as to who wasn't doing his share of water hoisting on the night shift. Jim Quinn decided to settle the matter once and for all. Unknown to the hoistmen, he installed a recording monitor on the hoist. When all the hoistmen had done their turn on the night shift, he showed them the graph recording the number of buckets hoisted. When the culprit who had lied about the number of buckets hoisted saw the evidence, he overcame his chagrin and said, "Well! What do you know? A mechanical stool-pigeon."

I had now lived at No. 8 for seven years, so we decided it was time to move to Cumberland. There were company houses there and I made application for one as soon as we made the decision to move. We waited patiently for a few weeks, and while others had moved, we had heard nothing about a house for us. Finally, after weeks of no

148

news, I drove to Cumberland to see the official in charge of housing. When I asked him why I had been passed by in the allocation of houses, he said, "You are the only official out there who is handy, and we want to keep you there in case of an emergency."

When I heard this I tried to argue the matter but to no avail. I told him I didn't accept his line of reasoning. I had served my time in the sticks, so let others with less seniority serve a spell living at the mine. I left him with the retort, "I'll move to Cumberland one way or another, even if I have to buy a house of my own. You can keep your company house; no house is going to be my master." I began to wonder how I got into such positions. At Wabamun I couldn't marry to get a job, and now I could not move. However, in spite of such an edict, we did move.

We purchased an old, run-down, three-bedroom house very cheaply. It wasn't Buckingham Palace, but when I saw it I knew we could remodel it. It was roomy, had full plumbing and a good garden. For the first time since coming to Canada sixteen years before, I was living in a house with a flush toilet. We thought we were in heaven, with plenty of hot water for children's baths, and an old barn where we could keep our chickens. With a few fruit trees, we felt we had arrived.

The next two years proved to be one of the busiest times of my life. I was working six days a week at the mine, and in my spare moments working at remodelling the house. Doors and windows were replaced, new siding covered the shabby exterior. Dorothy worked like a trojan papering and painting the inside, in addition to having three kiddies to look after. Once we had the house clean and comfortable, I set myself a program of study which I hoped would allow me to meet the two-year deadline I had set myself. I do know that if it had not been for the cooperation of Dorothy and her effort to give me time for study, I could never have done what had to be done.

As I was on the afternoon shift, I found the best time for study to be from when I came from work at 12:30 a.m. to 4:00 or 5:00 a.m. The house was quiet and there were no distractions. With such hours it meant I slept until noon, then had a meal and left for work at 2:00 p.m. For two years I followed this schedule, barely seeing my family. Dorothy ran the house to suit the study program. In the evenings, she went for walks in the woods with the children, where they would run off their excess energy. As a result, they would all be in bed early. While I slept in the mornings, Dorothy was able to keep the children quiet by taking them for walks, or by coping with them indoors. It was, in spite of such a busy and demanding period in our lives, a most happy time. We had

149

our dreams; I had a goal; and we were all healthy. What more could one ask for?

After two uneventful years of plodding, and with little confidence, I made application in the spring of 1947 to write the first-class examination. This was accepted and I was notified to present myself at the Government Mine Rescue Station at Cumberland on May 14. I had seen past examination papers and I knew I had set myself a formidable task. The examination, which covered the whole range of coal mining, lasted for three days. The subjects were: Mining Law, Mine Management, Ventilation, Mine Gases and Fires, Practical Mining, Surveying and Mine Machinery. The latter subject was very broad in its scope and covered theory and practice of electricity, steam and compressed air.

On the first day, four men were candidates for third-class, two for second-class and two for first-class. I had more than my usual per-exam jitters this time. I knew this one would be most difficult, would last three days, and meant so much. But I bolstered my courage with the thought that if I failed, I could try again, and the exercise would be good practice for future attempts.

After three days of intense concentration and much furrowing of brow, the test came to an end. It was impossible to assess myself. I only know I had attempted every question on the papers and it was now in the hands of the Board of Examiners. Some of my friends who saw me after the third day remarked that I looked like a washed-out rag. But all I had to do now was wait patiently for the results.

A month later, the letter I so anxiously waited for came. Dorothy and I opened it together for it concerned both of us in its significance, and once again I had passed. This was a red-letter day for us. I had gone into this with a negative attitude, and making it on the first attempt was more than I expected, but it certainly was a welcome bit of news.

The years of study had not been in vain. I had reached the top rung in the certificate ladder and was now qualified to accept the highest position the coal mining industry had to offer. The drive that had sustained me for so many years was now no longer necessary, and for the first time in years I was able to relax and enjoy a time without a book of trigonometrical tables or mining formula in my hand. Oh how I savoured the pleasure of idle moments. Passing this examination proved to be a milestone in my life; reaching this plateau would affect my whole future, and I would become part of a world that previously I had only seen from a distance.

Coal Versus Oil

The demand for coal during the war years gave the coal industry of western Canada a relatively long period of stability. There had been eight years of comparative peace and regular employment. For the coal business this was an exception rather than the rule. The story of coal mines is one of strikes, layoffs, intermittent work and shut-downs. But it took a war to stimulate the industry; in fact, so essential was coal that the Vancouver Island operators—Canadian Collieries (Dunsmuir) Ltd—were subsidized to the tune of $707,144.33 between 1942 and 1946. In addition, from 1934 to 1944 the Company received $1,157,652.00 in subvention monies, in respect to trade in coal for bunkering ships. Such stimulation produced an impetus that continued for a few years after the war. However, events were taking place that would shake the coal industry for many years.

In 1947 there were two producing mines in Cumberland—No. 5 and No. 8. In addition, the Company was prospecting in a new area along the Tsable River south of Cumberland with a view to developing a mine there. No. 5 mine was an old mine begun in 1895. The production faces were long distances from the shaft, making haulage, pumping and ventilation costly. These factors, plus the end of subsidies, made No. 5 no longer economically viable. So, in July 1947, after 52 years of operation, No. 5 mine was shut down permanently. The large tipples and related structures were dismantled and the shafts were sealed with huge timbers.

As always, such decisions created concern and apprehension in the mining community. There were over 300 men employed at No. 5,

and it was impossible for No. 8 mine, or the prospect at Tsable River, to take on such an influx of men at short notice. Some were transferred to No. 8 and a few were employed at Tsable River, but most of them, for the time being, were without work. Such situations have the capacity to bring to the fore the strengths and weaknesses of men. In the race for jobs, character is often opened to view.

The union began a seniority list for those men who had not found work and, as jobs became available, men were hired from this list; those with the most seniority were the first hired. As the wait for jobs dragged on, an undercurrent of discontent began to seep into the ranks of the unemployed. Many of those who made the most noise at past union meetings—those who preached brotherhood and solidarity—suddenly began voicing for a change of rules to suit their own situation.

At a time in the past when No. 8 mine had been shut down for a four-week period, and No. 5 mine was the dominant mine having the most employees, it was agreed at a union meeting that hiring and lay-offs would be governed by mine seniority. This meant that if a man who worked in No. 8 mine had worked for the Company for many years, he would have no seniority as far as No. 5 mine was concerned. But now that No. 5 mine was the mine that closed, the shoe was on the other foot, and many of the great spouters of brotherhood wanted to change the rules. Their cry was, "Company seniority should prevail, not mine seniority." Some had worked for the Company longer than many of those at No. 8, so why, they argued, should they be out of a job? When I saw the scheming and manoeuvring of these staunch union men who were trying to get a job at the expense of their fellow workers, I thought of Burns' words: "Man's inhumanity to man makes countless thousands mourn."

In the depression years there seemed to be a willingness to share. One would try to help others less fortunate. Now, however, with the mines having worked steadily during the war years, and the union being well established, there appeared to be a subtle change in thinking taking place among the men. It was the start of the era of greed. They had been well educated in this by past performances of the mine owners. It was experiences of this kind that made one rather cynical. Even though it was done by a vociferous minority, it left me with a jaundiced view of loud-mouthed union bosses and clamorous politicians.

While the end of subsidies hurt the coal industry, the *coup de grâce* can be summed up in one word—oil. In 1947, at Leduc Alberta, Imperial Oil Company's well No. 1 blew in; so began a new era for

western Canada. With this discovery, a frantic search began for this liquid gold, resulting in the discovery of vast oil resources. With each find, another nail was driven into coal's coffin. The advantages of oil over coal as a fuel were many. It was relatively cheap, easy to store, had no ash and was cleaner to handle. With all these factors in oil's favour, coal hadn't a chance. Railroads converted to oil-burning equipment, ship's bunkering became a thing of the past, and large industrial buildings and factories switched to this convenient fuel. Within a short time, coal became the second choice in the fuel market.

In the face of such stiff competition, many small mines and the larger uneconomical mines were forced to close. Those that continued to operate were caught in the squeeze of labour's pressure for higher wages, increased cost of mine supplies and the ever-dwindling coal market. Survival under these conditions meant only one thing—increased productivity. Mechanization was the only way that this could be accomplished. The days of the hand miner and of mule haulage were over. Even coal cutters and conveyor systems were inadequate innovations to meet the new competition.

The Company being well aware of the trend, and realizing full well that mechanization was the key to the immediate problem, had to recruit someone to develop such a program. Although there were many experienced and capable men already in the Company, none had been exposed to the latest equipment being developed. Also the fact was that change did not come easily. The acceptance of new ideas was sometimes difficult for those whose working habits had been set by a lifetime of usage.

In 1947 the Company engaged the services of an English mining engineer. He had extensive experience in our type of work in Britain, and to further his experience in our conditions, he was appointed general superintendent. In the meantime I continued as afternoon shiftboss; but, in 1949, after nearly five years of continuous afternoon shift, I felt I had reached the stage where I had earned some recognition of my studies. I had heard that there would soon be two vacancies in the Department of Mines inspection branch. So before making application I thought it was only ethical that I notify the Company of my intentions.

Subsequently I met the new superintendent and we discussed my future. He advised me to stay with the Company as expansion plans were on the drawing board and my name had been mentioned in the hallowed halls of the top brass. The upshot of this interview came one morning while working in my garden. I received a phone call to see

the superintendent in his office as soon as possible. Entering his office I was offered a chair, and after getting the state of the weather out of the way, he informed me that I was being appointed underground mechanization engineer.

He went on to describe his objectives. He was the architect of a completely new concept of longwall mechanization, and he wanted me to supervise the logistics and installation of the new equipment when it arrived.

Since obtaining the first-class certificate, I had served as acting manager on several occasions when the regular mine managers were on holiday or absent for any length of time through sickness. These short periods of management proved most valuable experience. All day-to-day problems and petty grievances ended up on the manager's desk. It was where the buck stopped. In such a complex industry where men and machinery were always on the move, and where conditions continually change day by day, the problems were many. One thing I learned was that dealing with people was much more difficult than dealing with a mining problem. A technical problem once solved remained so, but the human factor was an ever-changing one; emotions often took the place of common sense.

With my promotion to mechanization engineer, my life changed remarkably and I entered a world I had only seen from a distance. All my life my working day began when I entered the mine and ended when I came to the surface. Now part of my work day was spent in the office, a place where the unseen part of mining is carried out. I had always imagined that the offices of a company were places of sweetness and light, but I soon learned about office politics.

As part of the mechanization program, I had drawn a detailed plan and profile of the new longwall belt installation, showing all requirements to scale. I presented it to Jim Quinn who had been promoted from mine manager to district superintendent some months before, and was part of the production team. He looked at the drawings and, with an odd look on his face, told me to do the drawings again. According to Jim, they were too well done, too professional. He told me that if he took them to the engineering department the head would have thought me after his job.

At first I thought Jim was being facetious, and sort of laughed the suggestion off. But when no responsive smile crossed his face, it dawned on me that he was serious. To save any arguments he told me to just make a sketch with the measurements on it and let the engineering department do the finished plan. Being new to the office, I complied with his request, but I have often thought of the incident, wondering

what kind of system it was that required sloppy work to build the ego of another. Being older and wiser now, if such a situation arose today I am certain that the outcome would be much different.

Under the new plan of mechanization, the belts were to replace shaker conveyors on the longwall faces and gate belts replaced track haulage wherever practical. In addition, new loading machines were introduced to eliminate hand loading in the development headings. The first step in the program was the elimination of all horses and mules from the haulage system. The old-timers thought this was crazy. Horses and mules had been used in the Cumberland mines since the mines began, and the idea prevailed that due to the irregular undulating nature of the seam, animal haulage would always be needed. However, due to the use of small portable hoists, the use of animals underground became a thing of the past; the last mule came to the surface in 1949. While the elimination of animals in mining may not seem much of a step in mechanization, it was a complete switch as far as Vancouver Island mines were concerned. Mules and horses had been an important part of mining for eighty-five years.

When the machinery arrived from England, a representative of the manufacturer came with it. There were some two hundred tons of material and it was my job to familiarize myself with each component, its function and how the whole thing was assembled. The man who came with the machinery was an expert in the field and I lost no time in picking his brains. Because I was a willing pupil, he helped me in every way possible.

One feature of the new face conveyors was extraordinary. Most belt conveyors deliver the product on the top belt running on rollers, with the return belt running underneath, hidden by a frame; this face conveyor was the exact opposite. All it consisted of was a drive unit and a return-tension unit with no framework or rollers between. The belt ran along the floor, with the return running on one-inch pipe rollers suspended from the cross timbers of the faceline. As the coal came to the delivery point, a blade, set at an angle across the belt, ploughed it off onto the gate belt, thereby leaving a clean belt to enter the driving drums.

As the first unit was being installed, word soon spread around the mine about the crazy conveyor without any rollers. There was much head-shaking; the sceptics were out in droves. Even some of the officials swore it could never work. How could it work without rollers? Friction would beat it. Despite such scepticism, the general superintendent never argued the point. Instead, he went quietly about the introduction of his plans.

Although I had a high-sounding title, the job of coordinating the delivery and installation of the equipment meant hours and hours of hard physical labour. I was no longer tied to a shift, but would be at the mine at any hour of the day or night. I also had to ensure that enough belt and conveyor sections were delivered to the mine each day from the stocks held at Union Bay. To find out where the new program was leading, I had to keep performance records of each longwall face and of each loading machine. This was a most interesting and informative phase of the work; one that gave me a wealth of experience on the overall operation of the mine and the new equipment.

Although the introduction of bottom-belt conveyors still meant that coal had to be shovelled on by hand, the theory behind the bottom belts was that the miner did not have to lift a shovel full of coal to put it on the conveyor. Shaker conveyors were twelve inches high, so every pound of coal the miner loaded had to be lifted to this height. Using the bottom belts, a considerable amount of coal fell onto the belt when each shot was fired, and secondly the loader could use a scooping motion in putting coal to the conveyor. Theoretically, if he did not have to lift his shovel, his productivity should increase.

The Joy Loader was a different type of machine. It was used to develop the narrow entries that are a necessary adjunct to longwall mining. This machine actually loaded material, having a large scoop in front with two rotating arms that pulled the coal onto the scoop. The Joy Loader then carried the coal to a chain conveyor, which in turn elevated it into mine cars. The machine was some twenty feet long and was moved into the piles of coal by activating its caterpillar tracks. The only hand loading with this machine was in tight corners or behind timbers where the loader's arms could not reach.

The industry was fighting for its life, and the mechanization program did its part to help it stay alive. The output per man at the mines was increased, and some pruning of non-production personnel took place. Cost cutting was the order of the day. Only by such measures were the mines able to continue operating.

In January 1950, my friend and mentor Jim Quinn died at the age of fifty-eight. He held the position of district superintendent and had been one who had encouraged me in my studies. It was he who gave me my first job when I came to the Island, and extended his hand to mine when he gave father a job. I felt his passing as a friend and not as a boss, and yet unknowingly his passing would bear on my future.

WHIPPING A DEAD HORSE

The mechanization program continued to function but a point was reached beyond which further improvement in tons per man could not go. Nearly all of the longwall faces had been equipped with bottom-belt conveyors and an increase in output should have resulted with less effort required to load the coal. But it soon became obvious that the one who was benefiting the most from the program was the loader. Instead of taking advantage of not having to lift the coal to produce more, he set a stint, and that was all that would be done each day. While the results were better than the shaker conveyors, they should have been better than they were. The men had a union, and consequently power. Now the efficiency of the good worker was pooled with the inefficiency of the poor, and in due time the standard of a fair day's work became less and less.

One day in July 1952, I entered the office to make my usual daily report to the general superintendent. When I stepped through his door, he closed it behind him—something he had never done before. I sat down somewhat nervously, expecting a dressing down for something I had done or not done. Then without any preliminaries, he told me he was being promoted to general manager of the Company, and was appointing me district superintendent of the Cumberland operations.

For a moment I was speechless. The position was so far removed from my mind that I never dreamed it would be offered to me. But

after the initial shock I found my tongue and expressed my concern about my competency. He told me not to worry; he'd be around for a while to help me through the first months and I was the man he wanted.

So after all the years of work and study I had reached the top rung of the ladder. It was a far cry from the fourteen-year-old boy who began mining thirty-one years before by opening and closing trap-doors. Despite being overwhelmed at such news, and a little fearful of the job, I could not help but feel proud that I had been chosen, and that my studies had not been in vain. Now that I had the position, I was determined to learn all I could, and give it the best that was in me.

As district superintendent, I was part of the production team responsible for mine planning and the efficient coordination of all departments in the division. I received reports from the mine managers and department heads and made visits to all parts of the division, including trips underground two or three times a week at the mines. While I was finding my sea legs in this undertaking, the new general manager was true to his word; when I made mistakes he was there to help me correct them. He set a standard of integrity and honesty in management that all could follow, and while he was firm in his demands, he was fair. It was he who opened the door to higher management to me, and showed me the other side of the mining industry. It was a side most of the men in the pits never saw.

The title of district superintendent was more impressive than the salary of $475.00 a month that went with it. Considering the qualifications and the responsibilities, such a wage was small even by 1952 standards. It should have been no surprise, for in western Canada coal-mining circles, Canadian Collieries had the reputation of being parsimonious with their operating managers. There were, however, some redeeming features that made the position more acceptable. Part of the job required considerable mobility and a company-owned automobile went with the position. In addition, my home telephone was paid for and one of the better company houses was available at a nominal rent.

With this promotion it was inevitable that certain changes would take place in our way of life and in our circle of friends, despite the desire we had to maintain the status quo. The monthly salary was one change that was felt almost immediately. After being accustomed to a pay envelope every two weeks, the time between paydays now seemed interminable. Instead of twenty-six paydays a year, there were now only twelve. It may seem like a minor item, but old habits are hard to break.

When I accepted the job of superintendent I knew that a thin line would separate me from my underground workmates and miner friends. I was now on the other side of the fence, and a basic tenet of labour, embedded by hundreds of years of class warfare, was that workers do not fraternize with the bosses. Unfortunately, this would influence future relations with many old acquaintances. In the past, Dorothy and I held open house for all our friends on New Year's Eve. With this in mind, I told my friends that if they felt uneasy at visiting my home during the year, this was one time I hoped they would call and continue to celebrate the season as always. This they continued to do for many years, and though the barrier was too formidable to break, I did manage to dent it a little.

The maxim of non-fraternization was not confined to the union or the workman, it even reached into the classrooms of the schools. One day our daughter Edith came from school and asked her mother what I worked at. Dorothy, sensing something unusual, asked Edith what had happened to bring up such a question. Apparently, during a discussion in class about what their fathers did, Edith had said I was a miner and had been called a liar by some of the students. To their way of thinking, I was now a boss—not a miner.

Dorothy hadn't told the children of my work. As far as they knew I was still a miner. This policy was intentional. She wanted them to attend school without false values and mix with others without any distinctions of class or rank. So, Dorothy had to explain our new circumstances to Edith. She told Edith that no matter what others might say, I had to attend to my job just the same as the other children's fathers did, and that I often went down in the mines too.

Once the children understood the non-fraternization code of the miners, and consequently of their children, they found no problems in coping with any disagreements that arose due to my position. They were more astute than we gave them credit for, and were able to survive their school years without incident. Had this been a generation earlier, the superintendent's children would have been sent to private schools and have had no contact with the workers' children. But times were changing, and I like to think that my family placed more value on what a person is rather than how much money he had or what work he did.

Coal-mining towns of the nineteenth and early twentieth centuries were a fertile field for the propagation of social stratification. With labour on one side of the fence and management on the other, and

businessmen and professional people in between, it was inevitable that those of like interests would form tightly-knit groups. The propensity of the Dunsmuirs for building castles and stately homes demonstrated their desire to foster the Old Country tradition of the manor house with its squire. Even the tiny new-born city of Cumberland was not to escape this visible monument to rank.

In 1897, on a high piece of ground overlooking the city, James Dunsmuir had built Beaufort House as a residence for the general manager. It was far above any other building in the district in style and size, having nine bedrooms. Throughout the house were numerous fireplaces, each faced with differently patterned imported tiles. Situated on ten acres of landscaped grounds, it was the showplace of the Comox Valley.

General manager Little was the first occupant; he was followed by John Bryden. From 1923 to 1938 it was occupied by Lieutenant-Colonel Charles Villiers and his wife Lady Kathleen. It was during their residence that Beaufort House became the social centre of Cumberland. They entertained many famous contemporary personalities including three governors-general. In 1926, Baron Byng of Vimy, while a guest at Beaufort House, met the returned veterans of the Comox Valley at a reception held on the grounds.

It was during "The Colonel's" tenure as general manager that the Company built a library and reading room in Cumberland for the miners. This was followed by the construction of a large recreational hall for gymnastics, badminton and basketball. He also encouraged the organization of soccer teams, and at that time Cumberland could boast of having one of the best in Canada.

The miners were assessed a small fee for the use of the library and the gymnasium. This also entitled any member of their families to use the facilities. The recreation hall became the centre for dances, social events and political meetings. One couldn't help but think the Company had some ulterior motive in providing these amenities. They kept the miners busy and active in sporting events at a time when there was considerable unrest and agitation to unionize the mines.

In 1938 Lieutenant Colonel Charles Villiers died and that marked the end of the Beaufort House era. The miners had finally reached their objective of unionizing the mines the year before. The time was now ripe to discontinue the upkeep of such an extravagant establishment. The fine old house was boarded-up and included in the rounds of the Company's night-watchman, but as the economy of coal mining began

to take a downturn, the watchman's services were terminated. As a result Beaufort House became a bonanza for vandals and these, together with an earthquake in 1946, spelled the end of this fine old building. It was torn down and the site sold to the school board where a fine new junior secondary school was built. As events turned out, it was my job to supervise the demolition of the old mansion.

The closure of the Big House, the unionization of the mines and six years of war brought about changes to the class-oriented structure of Cumberland. Although the rule of non-fraternization continued unbroken, there was a better understanding and respect displayed by all tiers of society. With such an atmosphere it was not difficult to make the change from underground to office, a situation that could have been quite thorny twenty years before. Now I could socialize with my peers and still retain the respect of my former workmates.

I had only been on my new job two months when word was received that mother was very ill. She was living with my youngest brother Ken at Port Alberni, where they had made their home. A few days after I received word of her illness, she passed away. She died of a heart condition that no one knew about. She kept it to herself as was her way.

Needless to say, we were saddened by the loss. She had lived to see me reach my goal and of this she was proud. She had lived a life without too many of the material things that are supposed to be the measure of success; but she had something money couldn't buy—a graciousness that endeared her to all who met her, and an aura of inner peace that sustained her all her life.

Being in the office and having access to cost records, it was not long before I began to find the truth about the plight of the coal industry. I now had operating costs in front of me. These, with sales figures, were enough to convince me that we had serious problems. The inroads of oil were being felt and coal markets were shrinking. In spite of adverse financial reports by the Company, labour was demanding its fair share of the economic pie. Looking at it from their side, who can blame them? The logging industry was now paying higher wages than mining. In the past it had been the other way around. So the miner figured he was entitled to as much as the logger whether the industry could afford it or not.

Union leaders and miners alike refused to believe the financial picture shown by the coal companies. They were inured to such stories, having heard them for years. Many of the old-timers had grown up in the Dunsmuir era when the family was building castles in Victoria

while still pleading poverty to their workmen in Nanaimo, and blocking any requests for increases in wages. Regardless of how well-founded were the miners' doubts, this time the stories of financial difficulties were true. Forces were at work beyond the control of men or management. To meet demands of higher wages, the price of coal had to be increased, thus widening further the gap between oil and coal. We were whipping a dead horse.

In February 1953 the Company decided to discontinue operating No. 8 mine. After two months of salvaging material and equipment from the workings, the cages were dropped to the bottom of the shafts; their service was at an end. With the life-line to the underground workings broken, only the gaping shafts remained to show where they had been. The final rite was the pouring of a two-foot thick slab of reinforced concrete over each shaft opening. These remain today, a silent monument to an era of mining and a breed of men who would soon be no more. A few weeks later I stood by the mine, which sixteen years before had seemed so solid and permanent to me, and watched as the torches of the salvage crew cut into the huge steel structure to bring it toppling to the ground. Thus came the end of a mine with a colourful past.

The closing of No. 8 mine threw some four hundred men out of work. Some found work in the new Tsable River mine; others had to forsake mining and find work in other industries. The exodus of miners to other industries soon established the reputation that they were good workers. Ex-miners were soon in demand by employers. Once having worked in a coal mine, a man could fit in other work with a will that was admired.

With the reduction of payrolls, the little city of Cumberland began to feel the effects of the mine's closure. Gradually it began to lose its importance as the centre of the Comox Valley. Courtenay, with its central location and proximity to the Island Highway, became more and more the business hub of the Valley. Ultimately the Provincial Court House and offices were moved to Courtenay, and in 1951 the City of Cumberland reverted to village status after having been a city for sixty-one years.

Now that there was only one operating mine left in the Cumberland field, staff cuts became necessary. The huge complex of wharves, machine shops and the coal-washing plant at Union Bay had been geared for larger volumes than were now being produced. They had been designed when cheap Chinese labour was plentiful, and were therefore very labour-intensive. While the use of modern coal-handling

machinery had been investigated, it was found that the uncertainty of the coal market and the limited output did not warrant the expenditure of the large sums needed to do the job.

Just one example illustrated the impossible situation we were caught in. We had to maintain a locomotive to have the washed coal moved from the washing plant to the loading boom on the shipping dock. This meant that the wharves had to be maintained in sound condition to support a hundred-ton locomotive, and they were only as safe as the weakest timber in the structure; costly repairs were unavoidable. This was a highly inefficient system, but we had no real alternative. However, lay-offs did occur. The railway from No. 8 mine to Union Bay was disbanded and the rails sold as scrap to Capital Iron of Victoria. However, yard trackage around Union Bay, and to an interchange with the Esquimalt and Nanaimo Railway, was maintained.

Those officials who were retained were given added duties and responsibilities. The administration of two hundred company houses fell to me. This was a headache that was to haunt me for another six years. Mine problems I could handle, I had been trained for that, but handling the housing problems of two hundred women took the wisdom of Solomon and the patience of Job.

The company houses rented for nominal sums of between $4.50 and $12.50 a month. It had been the practice for years for the Company to supply wallpaper and paint to the tenants without charge. As part of the economy measures, this benefit was discontinued, and it fell upon me to proclaim this new measure. Did I ever walk into a hornet's nest! I had broken years of tradition and now I was the Scrooge and Simon Legree of the year. But time healed the tenants' wrath, clearing the way for new problems to come.

One incident shows how vulnerable I was to the distaff temperament. While I was sitting at home one evening, I was called to a fire in one of our houses. When I arrived on the scene the fire department was there. The fire was minor and it was already extinguished, but both the firemen and I were at a loss as to the cause. While I was in the house, a neighbour began to berate me unmercifully about the 'lousy Canadian Collieries' wiring'. Having no defence I left her shouting her head off, and the next day instructed the electrician to examine the wiring throughout the building. He reported it satisfactory and not damaged.

The sequel to this story came some weeks later when the irate woman came to my office and offered profuse apologies for her angry

outburst. She had discovered that one of the boys in the house had been shooting matches from an air rifle at the wall, and one had hit a crack and ignited the paper. To give her credit, she had the courage to come directly to me. Her apology was as contrite as her anger had been audacious, so there were some gratifying moments with the job.

Fortunately my life was not all work and worry. We had acquired a cottage at Kye Bay, our favourite beach on the Comox Peninsula. It had a large expanse of warm sands, making it an ideal summer playground for our children. We also had a small fishing boat. We spent many happy hours at Kye Bay with our family, far removed from the trials of coal mining. Here the children learned to swim and, with their pals, spent many happy hours at wiener and marshmallow roasts on the beach.

During the next few years the coal market continued to dwindle as wages and costs increased. In the face of such persistent pressures, the Company, whose sole interest in the past was coal, began looking in other directions. One of their ventures was participation in an oil-drilling program in Alberta. I guess they figured if you can't lick 'em, join 'em. The net result of this first step in diversification was a subsequent step into the lumber industry. They acquired sawmills at Port Moody, Squamish and Surrey, then built a plywood plant in Surrey to round out their timber interests. With the acquisition of sawmills, they came into possession of large tracts of forest land as well. Thus, after fifty years of being known as a coal company, Canadian Collieries was becoming better known as a wood products company.

As the Company's interest in timber and lumber grew, coal became less important. Finally in 1960 they notified their largest consumer, the Ocean Cement plant at Bamberton, that they were discontinuing operations. Such a move was necessary to allow the plant to make other arrangements for another supplier or for conversion to oil. Subsequently, on April 14, 1960 Canadian Collieries (Dunsmuir) Ltd produced its last ton of coal.

Four hundred employees were thrown out of work by the closure of the Tsable River mine and all its auxiliary facilities. The economic impact was felt throughout the district. But one ray of hope shone through the gloom. A local syndicate made arrangements with the Company to operate the mine on a smaller scale. The new operators employed about a hundred men, which helped to ease the unemployment situation. But this proved to be the last gasp of the coal industry and, after struggling for six years, they were forced to abandon the project. In 1966 coal mining

on Vancouver Island came to an end, after a hundred and thirty years, the first coal having been dug at Suquash in 1836.

Although coal mining continued to 1966, my connection with the industry ended in 1960 when the Company ceased to operate the mine. In view of the events, it seems I had reached the top of the industry at the wrong time. While I had the problems of production, I also had the problems of retrenchment. Since becoming mechanization engineer in 1947, in a span of thirteen years I had played a part in the closure of three mines. It recalled to mind the words of Winston Churchill, in one of his less prophetic moments, "I have not become his Majesty's First Minister to preside over the liquidation of the British Empire." And I did not become a mine superintendent to supervise over the closing of mines, but both things came to pass. The tides of change are relentless.

After the end of the war, the average age of miners continued to increase. With layoffs governed by seniority, and no young men coming into the industry, this was inevitable. Most miners had spent their lives mining and were in the awkward position of being too old to get other work, and too young to retire. It so happened that many of the older men managed, for a time, to obtain jobs as maintenance workers at the airport at Comox, while men under forty found employment in the woods, with the provincial highways department or in other industry.

I was fifty-two in 1960. I had spent thirty-nine years of my life in mining, and was at the point where I had to make a decision for the future. The one I made was to serve me to the end of my working days.

THE DUST IS SETTLED

Although the mines were closed, the Company still had many interests in the area. They had extensive timber tracts, including a 30,000-acre tree farm, nearly a hundred small lots and land parcels for sale and over a hundred ground leases from which rents were collected. In addition, there was the disposition of over seventy years possession accumulation of buildings, machinery and material at Union Bay. The Company asked me to remain as their representative in the Cumberland District to oversee its remaining holdings. The salary offered was less than that of district superintendent. Before accepting their offer I talked the matter over with Dorothy; she was the one who would have to manage the household.

After carefully considering the matter, we came to the conclusion that money wasn't as important as it used to be, and that I would accept the job. Our son, now married, was no longer at home; Edith was in her last year of nursing school and Ruth had one more year of high school. We owned our home, and had no debts. Consequently, the less-worrisome but lower-paid job seemed to be the right one at the time.

One of the first tasks of the new job was selling and dismantling company buildings. Again, my role was that of the wrecking crew. One may wonder why the buildings were not used for other purposes. The answer is simply that no one had any use for them where they stood.

For example, the Cumberland office would have been ideal for storage in conjunction with a moving company as it was roomy and had a freight elevator. But it was six miles from Courtenay, which was now the business centre of the Comox Valley, and in the moving business, miles meant money. Several attempts were made to interest other industries in using the facilities available in Cumberland, but those six miles from the main highway proved a barrier.

The first months of the new job were busy. As the buildings were emptied of their contents, they became fair game for thieves and vandals. And, since they were scattered at Cumberland, Bevan, No. 8 and Union Bay, it was impossible to police them effectively. With the sale of company buildings, my home became my office. Many women wouldn't have put up with such a situation. Dorothy's home was no longer her castle. People were continually knocking at our door, either enquiring about property for sale or paying ground rent. When I asked her how she could tolerate all the traffic in our house, she said that there were so many years when she hardly saw me that it was now a pleasant change to have me around.

The day finally came when all the material and buildings were sold. There remained only the routine collection of ground rents and fire patrol of the tree farm. In the beginning, the fire patrol was a rather futile effort. I was expected to guard an area of 30,000 acres against fires—an area interlaced with both logging trails and public roads. The clincher was that I was expected to do this with a five-gallon back-pack tank, a shovel and pulaski—a type of mattock. I used my own car for which I was paid mileage, but it was far from adequate. However, with the help of the forest service and the local fire department and a lot of luck, I managed to keep fire damage to a minimum. I continued to ask the logging division of the Company for a truck and better equipment, but mine was a lone voice crying in the wilderness. I was a little toad in a big puddle.

After four years of this frustrating and unsatisfactory arrangement, a change came about that finally solved the problem. In 1964, after being in business for forty-four years, Canadian Collieries Resources Limited, which succeeded Canadian Collieries (Dunsmuir) Ltd in 1957, sold all their interests to Weldwood of Canada Ltd, a growing and progressive timber-products company. With the change of ownership, somebody in his ivory tower must have heard my cry, for it was not long before I was provided with a four-wheel-drive truck, tanks, a pump

and hoses. This gear enabled me to do my job the way it was intended. Even with such equipment, the area to patrol was so large that I still relied to some extent on the cooperation of the public. It became a habit of the older miners to take walks on hot days during the summer. Several times I was notified of small fires by these strollers, and was able to control the fires before they became serious. While my remaining years of work were largely uneventful, they were never dull. In one day I could sell a lot, collect rent, chase garbage dumpers and fight a fire. If variety is the spice of life, then mine was well seasoned.

During these years I took that long walk up the aisle of the church to give away our two daughters. And while the frantic preparations for two weddings went on, I felt, as I'm sure most fathers do in like circumstances, like a fifth wheel. This was a woman's domain and woe betide the male who dares intrude. With our children gone, we were now back to where we started, with just two of us in a large house without the chatter of teenagers to liven things.

The day of retirement came at last, I had worked four months beyond my sixty-fifth birthday and now thought it was time to enjoy the fruits of fifty-two years of answering bells, buzzers and whistles. The Company, in appreciation of my thirty-seven years service with them and their predecessor, arranged a local farewell banquet in the Bayshore Inn at Vancouver, where I met some of my coal-mining colleagues who had retired or found other fields to conquer.

When all the recollections of the rough times had been rehashed, it was time to say farewell to my colleagues, past and present. It was now time to savour the luxury of doing nothing. It was a time of reflection as well. Dorothy and I talked of the hard times at the beginning of our life together, and agreed in retrospect they weren't so bad after all. There had been many trying periods in my work, but there were times also to be remembered. The times Dorothy accompanied me on fire patrol, when we would stand on a mountaintop, alone with our thoughts, and gaze at the grandeur of the country below. In such magnificent vistas, one felt as if he could reach out and touch the hand of God.

Habits of a lifetime are not tossed aside easily. It was not long before the work of doing nothing began to pall. Within two weeks of idleness I decided to do something about portraying Cumberland's part in the building of the province and its mining heritage. There was so little in the village to depict the part it and its people had played in the development of our country.

The logical place to begin was the local chamber of commerce and the small museum building they had acquired. My first project was building a scale model of a coal mine showing the surface arrangements, shafts and underground tunnels. This is still on display. Continuing the coal-mining theme, I built a life-sized mannequin, clothed it in my old mine clothes and, through the courtesy of the Provincial Department of Mines, obtained a complete set of miners' rescue apparatus, which is worn by the mannequin for the interest of visitors. One of the most rewarding undertakings was the compilation of the names of all the men who were killed in the Cumberland mines from 1888, when the first fatality occurred. The list is on parchment in the museum, and contains 296 names; a high price had been paid for the coal. Later, I was also able to provide information to the Royal British Columbia Museum (formerly called the British Columbia Provincial Museum) on the workings of the mine that was used in the construction of highly-detailed dioramas depicting a turn-of-the-century Island coal mine.

The day is fast approaching when that breed of men who produced coal from the point of a pick, will be no more. They will be forgotten and an era will have passed. This much-maligned worker was no better than, and certainly no worse than, any other workman in society. But as one of the most underrated and underpaid workers in the hierarchy of labour, his value will someday be recognized in the history of the province. This leads me to wonder, in light of the present interest in coal, where the new breed of coal miners will come from. I doubt whether the young men of today will go underground and work in the thin seams that someday may have to be exploited.

What inducement can the industry offer? High wages will not be enough in this age of affluence. The wages required to entice new blood into the mines would result in coal being dispensed in pill boxes over the drugstore counter. Why, in the mid 1970s, bags of coal were displayed in grocery stores at fifteen pounds for $1.89, and that represents one shovelful, or nearly $255.00 a ton. That's some price for a product that I was once paid fifty cents a ton for digging.

In the past, tradition played its part in manning the mines. But today that is gone. Traditions that took hundreds of years to build disappeared in one generation—victims of oil and the strip mine. To mine the thin seams in the future, scientists and engineers will have to put on their thinking caps. Underground gasification of coal is the probable

route that may well be taken. Working with coal will always be a dirty job, for coal is black. Grandmother once told me of a "lady" who asked her what her husband did for a living. When she told her he was a miner, the woman put her nose in the air and said "that filthy job."

Grandmother, bristling, retorted, "Yes, it's a dirty job, but the money is clean, and that's what matters most to me."

Seeking a change of scene and lifestyle we sold our home, and after thirty-seven years in Cumberland said good-bye to our many friends and moved to Victoria, the retirement capital of Canada. Because I wanted to tell my story, and that of the coal miner, I thought Victoria would be a suitable place to do it. But the cry of coal was not silenced. Now nearing that three-score years and ten allotted to man, I was to be challenged once again. Coal, half-forgotten for nearly a quarter of a century, was again coming to the fore.

With the revived interest in coal I was asked by the Company in 1976 to supervise part of their resource-evaluation program. My part being to go underground, beyond the zone of oxidization, to obtain ten-ton samples for testing. The area examined was in the heart of the Comox and Campbell River fields. In this short span of ten years from the closing of Tsable River mine, not one man with coal-mining experience could be found to work at this project. So, I, like an old firehorse who hears the siren blow, donned my hard hat and with my motley crew headed into the hills.

There was a certain satisfaction in being part of such a program. I thought that my efforts, however small, may someday be instrumental in re-establishing the coal industry of Vancouver Island after I had helped to close it down. When asked why, at my age, I had taken on such a job, I concluded that I couldn't forget the black rock of my forefathers, and that there must still remain a little coal dust in my blood.

GLOSSARY

Some of the following terms or phrases are not used in the text of this book, but are included here to provide a more complete reference on some of the specialized terminology used in coal mining.

Adit — A nearly horizontal passage from the surface by which a mine is entered and through which water is removed. It has just sufficient slope to insure drainage.

Afterdamp — A gaseous mixture resulting from an explosion.

Air crossing — An overcast. A bridge (tunnel) that carried one airway over another in a mine.

Air door — A door for regulating the air current throughout the workings of the mine.

Air-shaft — A shaft used expressly for ventilation.

Airway — Any passage through which air is carried in a mine.

Anemometer — An instrument used for measuring the velocity of a ventilating current by means of a revolving vane wheel.

Anthracite — Hard mineral coal formed of almost pure carbon with few volatile hydrocarbons. Burns slowly with little flame.

Band — A thin stratum of clay or stone in a seam of coal.

Barrier pillar — A solid block of coal left unworked between two mines as a protection against an influx of water.

Batten — A piece of board used in timbering; usually an inch thick and eight to twelve inches wide.

Beehive oven — A circular, arched, brick oven in which coke is made without the recovery of any byproducts.

Bench — The bottom part of a seam when the holing has been done in the middle.

Bit — The cutting tool of a mining machine.

Bituminous — A soft mineral coal, low in carbon content, yielding many volatile hydrocarbons. Burns with a yellow, smoky flame.

Blackdamp — A mixture of air and carbon dioxide (CO_2) or air with an excess content of nitrogen (N_2).

Blast — To bring down and shatter coal or rock by explosives.

Blasting cap — Detonator; a small, metal cylinder containing fulminate of mercury, set in high explosives to ignite the charge.

Bloom — The oxidized and decomposed outcrop of a coal seam, or indicating traces of a coal bed.

Blow Out — In blasting; a charge that blows out the stemming without dislodging any material.

Blue-cap — The blue halo of ignited methane around the flame of a safety lamp.

Bone — Slatey or carbonaceous shale found in coal seams.

Bonnet — The metal cover for the gauzes in a safety lamp.

Booster fan — A fan used to suck in the intake air on an airway and force it further into the workings.

Brass — Iron pyrites in coal (term used in north of England).

Brattice — A canvas cloth used to deflect air currents; usually used near the working face and is of temporary nature.

Breast auger — A drilling auger; driven forward by a breast plate which rests against the miner's body.

Bait — Lunch carried to the mine (term used in north of England).

Briquets — Fuel made of fine coal pressed into brick form.

Brown coal — Lignite; a fuel between peat and bituminous coal.

Bug dust — The fine coal produced by a cutting machine.

Buggy — A small mine car.

Buntons — Horizontal timbers in a shaft which carry cage guides; also used to support the walls of the shaft.

Brusher — One who works at blasting and removing the rock of a brushing.

Brushing — A thickness of stone removed to make sufficient height in a roadway to provide clearance for moving miners, mules and machinery.

Cabin — A small room in a mine for the use of officials.

Cage — A platform on which men and mine cars are transported in a vertical shaft.

Cage guides — Vertical lengths of timber or steel on which the cage runs to prevent it swinging from side to side.

Cager — The person who puts the cars on the cage at the top or bottom of the shaft.

Canch — Same as brushing (term used in north of England).

Cap — A short piece of flat wood used in timbering and placed on the top of a prop. A cap piece.

Cap rock — A layer of carbonaceous rock often found between the coal seam and the true roof of the mine; usually varies between two to six inches in thickness.

Car — A wheeled vehicle used to transport coal from the workings to the surface.

Carbide — A compound of carbon and calcium which, with the addition of water, produces acetylene gas; used in miners' lamps.

Carbide lamp — One which uses carbide and water to produce an acetylene flame for illumination.

Cartridge — A waterproof paper cylinder filled with explosives; the charge for blasting.

Cave or Cave-in — A collapsing of the roof in a mine.

Cavils — Lots drawn by the hewer and putter on piecework each quarter year to determine their working places in the mine (term used in north of England).

Charge — Amount of explosives used in one blast or shot.

Charging the ovens — When the coke ovens are filled with raw coal to produce coke.

Check — A metal token used to identify each underground worker; or a token to record each car loaded by each particular miner.

Check-weighman — A man appointed and paid by the miners to check the weighing of coal at the surface.

Chock or Cog — A square pillar for supporting the roof; constructed of timbers laid up cross-ways in alternate layers, the centre being filled with waste material.

Chock — A tapered piece of wood placed in the kerf to keep it open until ready for blasting.

Cleat — Vertical cleavage in coal seams.

Coal cutter — A machine used to undercut a coal seam; one who operates such a machine.

Coal dust — Very finely powdered coal.

Coke — Carbon left after the volatile materials in coal have been driven off. This was done in coke ovens where the coal was roasted to produce coke. Coke is used in smelting.

Colliery — The whole mine plant, including the mine and all adjuncts.

Conglomerate — A sedimentary rock often found in the strata of coal fields; consists of pebbles and rounded rocks cemented together with finer materials; sometimes called millstone grit.

Coursing the Air — Conducting air through the workings by means of doors, and brattices.

Creep — The upheaval of the floor, due to a tender or unstable floor, or the sagging of the roof of the mine due to the weight of the unsupported rock.

Crosscut — A tunnel driven through or across the rock strata from one seam to another; a small passageway driven at right angles to the main entry to connect to a parallel entry or counter entry.

Curtain — A sheet of brattice cloth used to deflect an air current.

Cutter bar — That part of a cutting machine that works its way into the coal carrying the cutter chain with its cutter bits.

Damps — See Blackdamp, Firedamp, Whitedamp and Afterdamp.

Dead Work — Work that is not directly productive, such as cleaning up rockfalls and retimbering airways.

Detaching hook — A self-acting mechanical device for releasing the winding rope from a cage when the latter is raised beyond a certain point in the headframe; the rope being released, the cage remains suspended in the frame.

Dip — A down-sloping entry tunnel.

Dobson hoist — A small, compressed-air hoist used on Vancouver Island; built in Nanaimo.

Dog — A short, heavy, iron bar, used as a drag behind a car or trip of cars when ascending a slope to prevent them running back in case of an accident.

Downcast — The opening through which the fresh air is drawn, or forced, into the mine; the intake.

Drift — A tunnel driven in rock from one seam to another.

174

Drippers — Water percolating through the roof of the mine into the working areas.

Driver — The worker who drives horses from a gathering point to the mechanical haulage (term used in north of England). On Vancouver Island used more generally for anyone who drives mules or horses underground.

Droppers — Water dripping from the roof.

Drummy — When the roof of the mine sounds loose, open or weak, when struck by a tool to test the condition of the roof.

Engine plane — An incline where the hoist is at the top and the trips are hauled up by power and lowered by gravity, pulling the rope after them.

Entry — A main haulage road, gangway or airway; an underground passage used for haulage or ventilation.

Face — The place where the coal is actually being worked, either in a room or in longwall.

Fault — A fracture that breaks the continuity of the coal seam.

Fireboss — A section foreman responsible for blasting and supervising a loading crew, haulage crew and several brushers on a longwall face. The total crew might be 16 men. Also inspects the mine for gas.

Firedamp — A mixture of air and methane gas (CH_4).

First break — When the roof of a new longwall face first subsides as the areas of gob or unsupported roof become too large to support the weight of rock above; movement of the overlying strata in the areas where the coal has been extracted. Sometimes called creep or squeeze.

Friable roof — Very unstable materials in the roof of the workings; easily crumbled rock material in the roof.

Gathering point — Place in the mine where trips of cars are made up for their journey to the shaft bottom.

Gob or Goaf — That part of the mine from which coal has been mined; the space that is left is usually filled with waste.

Hang the Monkey — Term applied when the mine cage is lifted too high and the safety hooks leave it suspended in the head gear above its normal level.

Headframe — A structure of wood or steel erected over a shaft to support the pulley wheels by which the cages are raised and lowered; also called Headgear.

Heaving — The gradual lifting of the floor of a seam where coal has been removed.

Helper — A miner's assistant, or one who works under a trained workman.

Hewer — A collier who cuts coal by hand pick.

Hoist — A machine used to hoist coal underground or to haul the cages in shafts; normally driven by electricity or compressed air.

Holing — The portion of the seam removed by hewing or cutting to facilitate the breaking down of the coal.

Inbye — In a direction inward toward the workings, or away from the shaft bottom.

Incline — A rising entry tunnel (haulage road).

Iron Man — A cutting machine.

Keps or Keeps — Catches to hold the cage when it is at a landing other than the shaft bottom.

Kerf — The undercut made to assist the breaking of coal.

Kneepads — Leather or rubber protection worn over the knees when working in thin seams.

Lagging — Timber planks or slabs used for immediate support at the face; used as crosspieces on longwall timbering (see Strap).

Latches — A synonym for railway switches or turnouts used in the mine trackage.

Leg — A wooden prop supporting one end of a cross-timber.

Level — See Entry.

Lignite coal — Soft coal or brown coal; the more recently deposited carboniferous materials; often retains a wood-like structure and forms a fuel with properties between peat and bituminous coal.

Loader — Miner who shovels coal onto the conveyors along the longwall face or in the stalls.

Longwall — A system of working a seam in which the whole seam in extracted, leaving only pillars supporting the shafts and main roads. The longwall is often 300 or more feet long. This system is used in thin (2.5-5 foot) coal seams.

McGinty — Three sheaves—wheels in a pully or block—over which a rope is passed to take a course like a letter M. The friction causes the rope to slide with difficulty. Used for lowering loaded cars from the face down steep roads.

Manhole — A refuge hole cut in the side of an entry as a place of refuge in case of runaway trips.

Measure — A series of rock strata having some common feature; a general term for the sedimentary rock within a coal field.

Miner — A worker in a mine with a valid certificate of competency as a miner.

Mucker — One who shovels the bug dust, or fine coal, produced by the cutting machine clear of the face in longwall mining.

176

Naked light — A candle or any form of light that is not a safety lamp.

Niggerhead — A hard concretion of carbonate of iron found as boulders in seams of the Comox coal field.

Nut coal — Small coal that will pass through screens with openings that vary from one-half to two inches.

Open cast — Coal mining on the surface of the ground, i.e., without any cover.

Overcast — A passageway through which the ventilating current is carried over another roadway.

Overman — One who is in charge of the mine when the men are in it.

Overwind — To hoist the cage over or into the headframe.

Packwall — A wall of stone or rubbish built at the side of roadways to support the roof.

Pea coal — Small pieces of coal about one-half to three-quarters of an inch in size.

Picking table — A shaking or movable platform on which shale is hand-picked from the coal; a sorting table.

Pillar — A section of the seam left between stalls or rooms while the coal in the stalls is being extracted. Pillars can be 30 to 50 feet in width. Ultimately as much of the pillar as possible is removed after the original stalls are worked out. The size of the pillars is determined by the stability of the surrounding rock.

Pillar and room — A system of working by which solid blocks of coal are left on either side of the entries and the rooms where the coal is extracted to act as supports. When the rooms are worked out, the pillars are mined. Used to mine thick coal seams; sometimes called pillar and stall.

Pit — Term for a colliery; the coal mine in general.

Pitboss — Holder of a second-class mining certificate and in charge of a shift in a particular mine; second to the manager in authority and deals with the day-to-day problems in the mine; an under-manager.

Pithead — The complex of buildings comprising the headframe and tipple of the mine; the coal-handling facilities at the surface of the mine.

Pit prop — A round piece of timber used as a temporary support for the roof of the mine.

Pop shot — A shot in a shallow hole in which only a small amount of explosive is used.

Puncher or Punching machine — An undercutting machine, driven by compressed air, that breaks the coal with a reciprocating action.

Putter — The worker who drives the pony hauling loaded cars from the face to a gathering point in the mine (term used in the north of England).

Regulator — A door in a mine with a shutter that can be opened or closed to vary the volume of air in a section of the mine.

Return air — Air that has passed through the workings.

Rib — The sides of a pillar or roadway.

Room — A stall, breast, or working place, where coal is mined.

Safety lamp — A lamp in which the flame is protected by fine mesh gauzes so that a mixture of firedamp can be detected by its burning inside the lamp; generally used to detect the presence of dangerous gases in the mine by the miner observing the colour and character of the flame.

Scab or Blackleg — A worker who works contrary to union order or during a strike.

Scraper — A tool used to scrape the dirt from a borehole.

Screenings — The fine coal that passes through the screens when it is being sorted to various sizes.

Screens — Device or system for separating coal into different sizes, or grades, for marketing.

Seam — The deposit of coal in the strata.

Seepage — Ground-water, or run-off, entering the mine workings and accumulating in the lower levels.

Set of timber — Usually three pieces of timber, consisting of two legs and a crosspiece, used in supporting the roof of the mine along the haulageways or other passageways.

Shaft — A vertical or nearly vertical hole in which the men and material are hoisted and through which air is drawn into the mine.

Sheaves — bundles of cut grain bound in the middle for drying, loading and stacking.

Shiftboss — Miner in charge of a particular shift, e.g., afternoon shift; under the pitboss in the hierarchy of mine supervision.

Shooting — Blasting in a mine.

Shot lighter — A man appointed by the manager to fire the shots in a section of the mine.

Slack — Fine coal; the fine coal resulting from handling and degradation of soft coal.

Slickenside — The polished face of a fault plane in the strata.

Slope — A roadway driven to the dip of the seam as opposed to an incline.

Sprag — A short wooden prop set at an angle to support the coal during the operation of holing; a short piece of hardwood pointed at the ends to act as a brake when placed in the spokes of a car.

Squeeze — The gradual downward thrust of the roof of the mine where the coal has been removed.

Stall — A working compartment in a coal mine usually used in seams 6 feet or more in thickness (stalls would be approximately 14 feet wide); sometimes called a room.

Stemming — The material, usually clay or rock dust, used to tamp shot holes when blasting.

Stook— (noun) an upright arrangement of sheaves, intended to speed up drying in the field.

Stook — (verb) to build such arrangements of sheaves.

Strap — Pieces of wood, usually six feet long, six inches wide and two inches thick, used as crosspieces in timbering over the props on a longwall face; also used between the stringers and entries or levels; also called lagging.

Stopping — An airtight wall built across a passageway to seal it off; or, in a crosscut tunnel, to prevent short-circuiting the flow of air in the mine.

Stowing — The debris of mining thrown into the waste area behind the face to help support the roof.

Stringer — The crosspiece of timber of a three-piece set used in supporting the roof of the mine; also called collar or baulk.

Tamp — To fill a drillhole, after inserting the charge, with clay or lime dust which is rammed hard as it is put in the hole.

Tamping bar — A copper-tipped bar for ramming or compacting the material used in tamping to prepare for blasting; also called a tamping rod.

Three-piece-set — A support, comprising two legs and a crosspiece, used to prevent subsidence of the roof in entries or levels.

Throw — The vertical distance between two ends of a seam displaced by faulting.

Timberman — One whose job is exclusively setting timbers, usually of a repair nature in haulage roads and airways.

Tipple — The dump trestle and tracks at the mouth of a shaft or slope, where the output of a mine is dumped, screened and loaded; also applied to the whole structure of the headframe containing the tipple.

Trapper— A boy employed underground to attend ventilation doors, opening and closing them as cars pass through (term used in north of England).

Trip — A number of coupled coal cars taken at one time.

Trip Rider or Rope Rider — A worker who rides on a trip to attend to rope attachments and signals.

Tub — A mine car.

Tugger — A small portable winch.

Turnout — A siding or passing place on a haulage road.

Undersea workings — Workings that follow the seam under the sea. (Some mine workings at Nanaimo extended under the sea.)

Upcast — The shaft through which the return air ascends.

Washer (Washery) — Plant where the coal is washed and graded; heavy waste material is separated while light waste is floated off.

Water money — Extra pay given to the miners for "working wet," i.e. in places there is water in the mines. (In the first contract at Cumberland between Canadian Collieries (Dunsmuir) Ltd., and the United Mine Workers of America, the differential was fifty cents per day.)

Whitedamp — Air in a mine containing carbon monoxide (CO); a product of incomplete combustion; extremely poisonous.

Working — General term used to describe the areas in which coal is being mined.

Working wet — Where the working areas of the mine are particularly wet from seepage, (see also Water money).

IMPERIAL TO METRIC CONVERSION CHART

Imperial to Metric Units

Length

1 in	=	25.4 mm
1 ft	=	30.5 cm
1 yd	=	0.914 m
1 mile	=	1.61 km

Volume

1 in^3	=	16.4 cm^3
1 ft^3	=	0.0283 m^3
1 yd^3	=	0.765 m^3
1 bushel	=	0.0364m^3

Mass

1 oz	=	28.35 g
1 lb	=	454 g
1 ton	=	1.02 tonne

Volume (fluid)

1 fl oz	=	28.4 ml
1 pint	=	568 ml
1 gallon	=	4.55 litre

Area

1 in^2	=	6.45 cm^2
1 ft^2	=	929 cm^2
1 yd^2	=	0.836 m^2
1 ac	=	.405 ha
1 sq. mile	=	259 ha

Temperature

°C	=	5/9 (°F - 32)

in	=	inch	mm	=	millimetre
ft	=	foot	cm	=	centimetre
yd	=	yard	m	=	metre
oz	=	ounce	km	=	kilometre
lb	=	pound	g	=	gram
ac	=	acre	ha	=	hectare
sq.	=	square	ml	=	millilitre
°F	=	Fahrenheit	°C	=	Celsius